LEONARDO

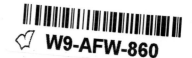

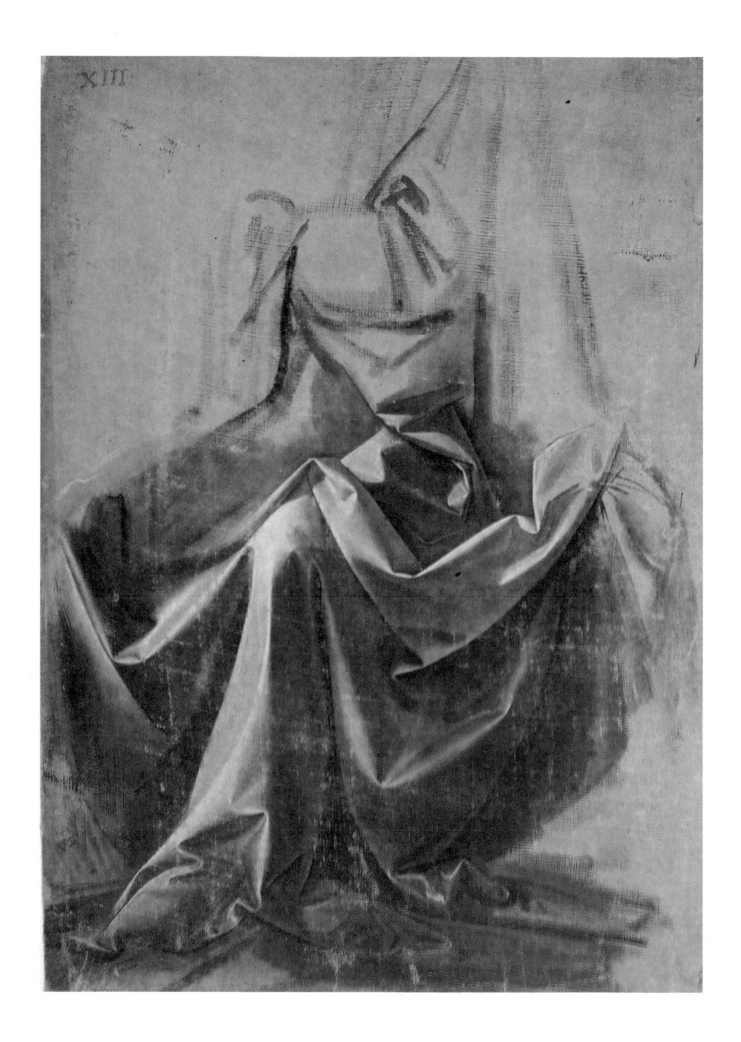

JEAN-CLAUDE FRÈRE

LEONARDO

Painter

Inventor

Visionary

Mathematician

Philosopher

Engineer

TERRAIL

Cover

Mona Lisa
(detail)
1503 and 1506. Oil on wood.
77 x 53 cm. (30 1/4 x 20 7/8 in.).
Paris, Musée du Louvre.

Opposite

**Portrait of a Lady
from the Court of Milan,
called La Belle Ferronnière**
1490-1495. Oil on wood.
63 x 45 cm. (24 3/4 x 17 3/4 in.).
Paris, Musée du Louvre.

There is every reason to believe
that the model for this portrait was
Cecilia Gallerani, the Lady with an
Ermine so strikingly similar are
the likenesses. This picture was
unfortunately confused with the
portrait of King François I's mistress,
also called La Belle Ferronnière.
The pure features and alert gaze are
remarkably rendered.

Previous page

Study of Drapery
Paris, Musée du Louvre.

Editors: Jean-Claude Dubost and Jean-François Gonthier
Art director: Sibylle de Fischer
Iconography: Fernando Valmachino
English adaptation: Jean-Marie Clarke
Composition: Graffic, Paris
Filmsetting: Compo Rive Gauche, Paris
Lithography: Litho Service T. Zamboni, Verona

English edition, copyright © 1995
Worldcopyright © 1994
by
FINEST S.A./EDITIONS PIERRE TERRAIL, PARIS
A subsidiary of the Book Department
of ⦿ Bayard Presse S.A.
ISBN: 2-87939-036-2
Printed in Italy

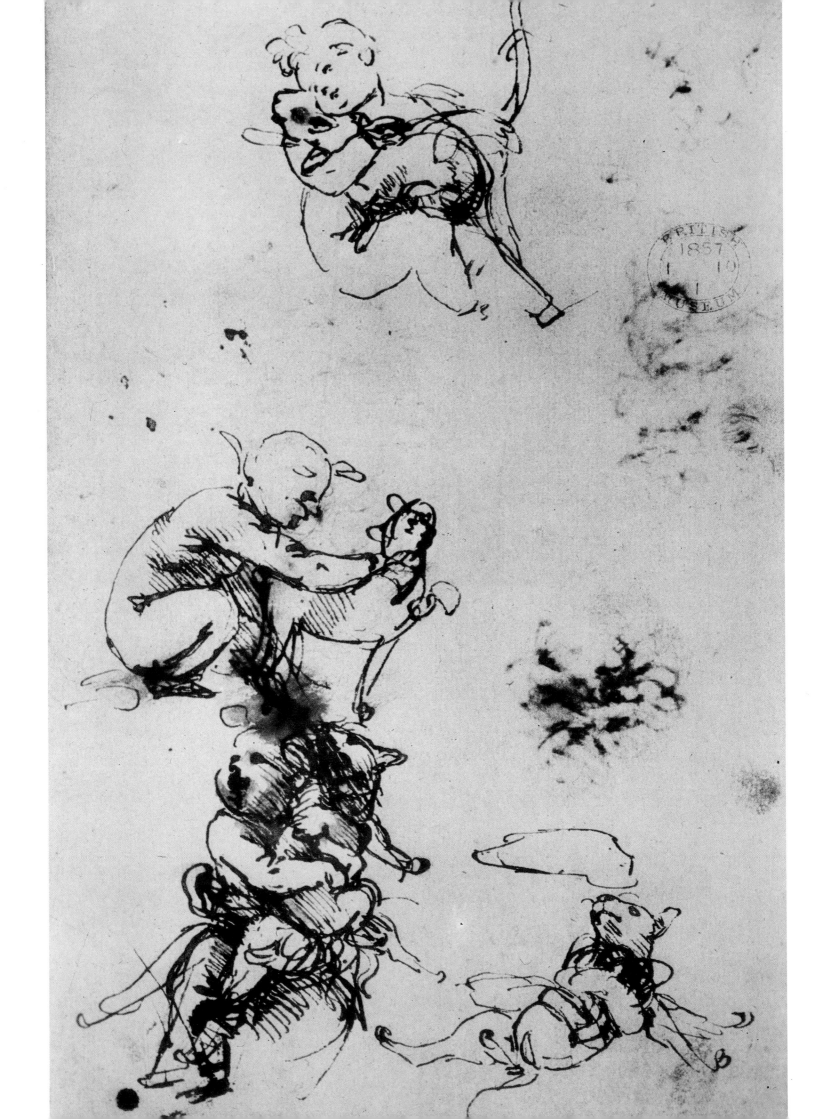

TABLE
OF CONTENTS

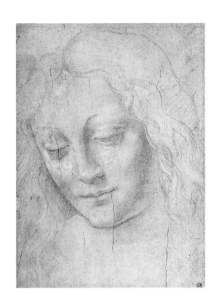

Preface : The Last Supper at Santa Maria delle Grazie 9

1. A childhood in nature 29

2. The Saltarelli Affair 47

3. From war machines to anatomy 73

4. An imaginary Orient 101

5. The Anghiari fiasco 125

6. "I shall continue" 145

7. The abduction of Mona Lisa 167

Conclusion : "I, Leonardo" 181

Leonardo da Vinci: Selected Notes on Painting 192

Bibliography 202

Biography 204

Head of a Woman
Drawing. Bayonne, Musée Bonnat

Opposite

Study for the Virgin with a Cat
London, British Museum (fa. Scala).

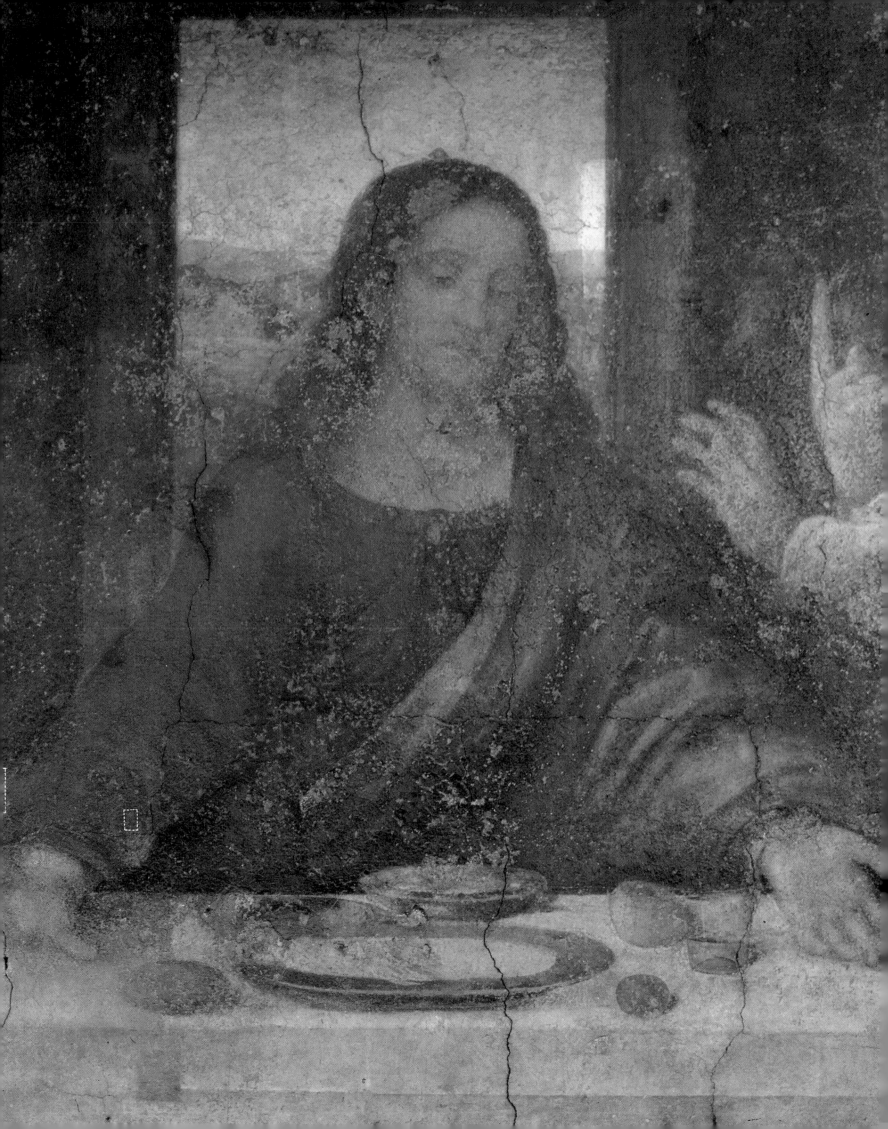

PREFACE

The Last Supper at Santa Maria delle Grazie

One night in 1943, bombs from American B-25s destroyed the walls and ceiling of the refectory of Santa Maria delle Grazie, nearly obliterating one of the world's greatest masterpieces of painting: Leonardo da Vinci's **Last Supper**. The only thing that saved it from irreparable damage during the bombardment were the sandbags piled up in front of it. But then, even when it was barely finished, more than four centuries before, it had shown signs of extreme fragility and required constant upkeep.

In painting it, Leonardo da Vinci did not work with the fresco technique (pigments applied *a fresco*, when the plaster is still moist) that was commonly used in handling such large wall surfaces. He had wanted to experiment with a completely new way of executing murals. The large area to cover and the nature of the surface prevented him from painting with oils, which would have permitted him to recreate the vast and subtle range of light and dark tones that characterized his easel paintings. Endlessly in quest of innovation and originality, he tried out his own technique of painting with tempera on a dry surface. This consisted of applying a mixture of plaster, pitch and mastic, which was supposed to furnish a resistant, water-repellent and adequate base for his pigments. Unfortunately, this base was not as waterproof as expected, and the paint began to flake off only a few years after the mural was finished. He had hoped to create a timeless work, and had been willing to experiment with his own recipes, but they were technically inadequate to the task.

Opposite and overleaf

The Last Supper
(detail)
1498. Fresco.
460 x 880 cm. (15 x 29 ft.).
Milan, Convent of Santa Maria delle Grazie (Refectory).

Because Leonardo used previously untested techniques to paint his fresco of The Last Supper, it has repeatedly had to be restored since its completion in 1498. The subject was a traditional and expected theme of religious painting, often depicted during the Middle Ages and Renaissance. Leonardo gave a novel interpretation of the scene by putting Jesus and the Apostles into a realistic setting. They are no longer symbols, but plausible beings of flesh and blood. Although scrupulously adhering to the biblical passage that relates the betrayal of Judas (Matt. 26:20-30), Leonardo took his inspiration from scenes and faces observed in everyday life. Thus the impression of intense liveliness and animated discussion given by the whole. This feeling of movement is emphasized by the concentration of figures around the centrally-placed Christ – so many around so small a table –, as well as by the diversity in gestures and positions. Leonardo's Last Supper is imbued with powerful tragedy because of the presence of Judas, who turns away from the others, a sombre and brooding figure, foreshadowing the mortal danger that he is about to bring upon the assembled disciples.

When the painter and art historian Giorgio Vasari visited the Convent of Santa Maria delle Grazie in May 1556, the deterioration was already so pronounced that he reported seeing only a "mass of stains." He may well have been exaggerating, for, another half-century later, and before the first restoration was effected, the painter Peter Paul Rubens, visiting from Antwerp, gave a much more evocative description of what he saw: "In short, after profound reflection, I would say that he has achieved so high a degree of perfection that I am unable to find the words to describe his painting, much less try to imitate him."

Apart from the natural deterioration due to the inadequate base, the first overt damage incurred by Leonardo's incomparable work came in 1652, when a doorway was cut into the middle of the wall, taking away a piece of the tablecloth. This passage was later sealed, but the damage had been done. Attempts by restorers to stem the massive flaking away of the paint were undertaken in the eighteenth and nineteenth centuries, but they only rendered the paint-layer that much more fragile.

During the two years in which Leonardo worked on the **Last Supper**, his life was an intense creative adventure. He was obsessed with creation, "his" creation. And he was supremely ambitious. He wanted to endow his work with a spiritual power that had generally been lacking in the works of his predecessors or contemporaries, no matter how fervently they had endeavoured to represent the profound mystery of this sacred meal. As usual, he spent more time meditating on his work than sitting down to paint, even if he did sketch a face here, a face there, and work out the background.

His ambition was to create an exemplary work, one that none could surpass. To succeed, he needed time, a great deal of time. His deadline was already long past. But what did it matter? Leonardo was engaged, body and soul, in an ideal creative process. Which brings us to the riddle of his chronic inability to finish his works. To bring a creation of such universal scope to an end is – finally – to lose it, to be dispossessed of it. Not to finish it means to be in a perpetual communion with the spiritual essence of the work, and all the more so when the subject-matter is so rich in mystical resonances.

The prelates of the Church and even the Duke of Milan himself, Ludovico Moro (the Moor), his patron, often paid visits to Santa Maria delle Grazie with their suites to admire the painter absorbed in his task.

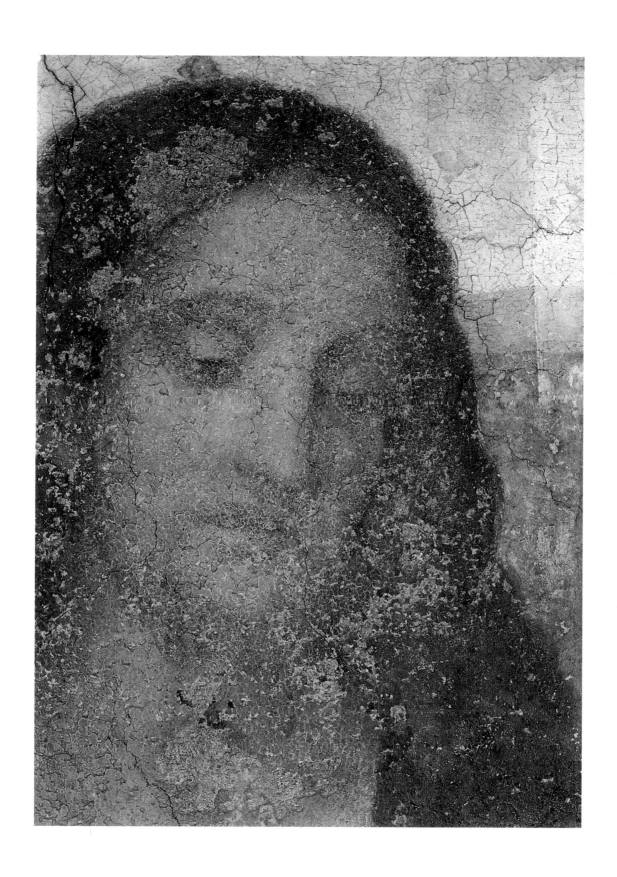

One day, however, the Prior of the monastery, Vincenzio Bandello complained to the Duke that Judas and Christ, the two main protagonists of the scene, were not even sketched in. Ludovico was troubled, but Leonardo retorted with supreme self-possession: "What do clergymen know about painting? How can they judge an artistic creation? I spend two hours of every day working on this composition." "How can that be," the Duke replied, "when you do not even show up at the convent?" Leonardo's answer: "For the last year or more, every morning and evening of every day I go to the Borghetto, where the dregs of Milan dwell, in search of a face that expresses Judas's treachery. And so far I have not found it." He then added: "I could of course use the features of this prior who has seen fit to complain to His Excellency; they would be perfect. But I have refrained until now from making him the laughing-stock of his own monastery!" This quip pleased the Duke, who could only agree with him. From then on, the rebuffed prior left Leonardo in peace and decided to tend his vegetable garden.

Vasari had this to say about the slowness with which Leonardo worked on his **Last Supper**: "He [Leonardo] spoke of the arts, and told the Duke how those possessed of elevated minds in fact work the most when they seem to be doing the least; for they are mentally searching for wholly new things, and when they have found the perfect form for their ideas, they can give them a visible shape through the labour of their hand."

In order to grasp the full extent of this work's mystery, we must turn to the evangelical source in the Gospel of Matthew (26: 20-30):

"Now when the even was come, he sat down with the Twelve.

And as they did eat, he said, Verily I say unto you, that one of you shall betray me.

And they were exceeding sorrowful, and began every one of them to say unto him, Lord, is it I?

And he answered and said, He that dippeth his hand with me in the dish, the same shall betray me.

The Son of man goeth as it is written of him: but woe unto that man by whom the Son of man is betrayed! it had been good for that man if he had not been born.

Then Judas, which betrayed him, answered and said, Master, is it I? He said unto him, Thou hast said."

And as they were eating, Jesus took bread, and blessed it, And brake it, and gave it to the disciples and said, Take, eat; this is my body.

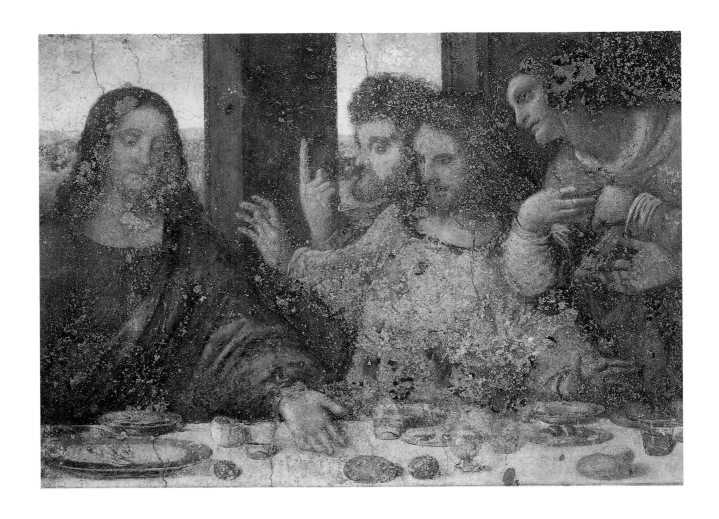

And he took the cup, and gave thanks, and gave it to them, saying, Drink ye all of it;

For this is my blood of the new testament which is shed for many for the remission of sins.

But I say unto you, I will not drink henceforth of this fruit of the vine, until that day when I drink it new with you in my Father's kingdom."

Now, to return to the Quattrocento. At the time that Leonardo painted his **Last Supper**, it was a subject much in favour and often represented in refectories – for obvious reasons. It was traditionally part of the fresco cycles relating the Life of Christ, in particular the Passion. Leonardo must have known Taddeo Gaddi's rendition of the **Last Supper** in the **predella** of the **Crucifixion** (1350) that he painted for the Monastery of the Holy Cross in Florence. By the middle of the fifteenth century, the Last Supper as an independent subject had become very popular and was depicted on huge panels.

Leonardo must also have known and intensively studied the perspective representations of the room in which the Last Supper takes place, as in Andrea del Castagno's version at Sant'Appolonia's (1450). Domenico Ghirlandaio's fresco for the Monastery of Ognissanti (1480), which can still be seen in Florence today, was also a very characteristic treatment of this episode. In his composition, he depicted the same columns and vaults as in the room where the mural could be seen. Leonardo adapted this novel device in his own mural in Milan.

He chose to represent the moment when Christ announced: "Verily I say unto you, that one of you shall betray me." The dramatic intensity of his composition comes from the variety of reactions to this terrible prediction. The way in which Judas's hand reaches into his plate refers to the clue that Jesus gave: "He that dippeth his hand with me in the dish, the same shall betray me."

At the same time, when the Messiah gestures towards the wine and bread, we readily identify the seminal theme of the origins of the Eucharist. Peter, making a sudden forward movement, forces Judas aside, pushing his face into shadow – a formal device for singling out the traitor. Peter holds a knife, which could be a prefiguration of the incident in which he cuts off a soldier's ear when Jesus is arrested. The outstanding achievement of Leonardo da Vinci's **Last Supper** is that he was able to condense all of these references into a seemingly simple and natural composition.

One of the conventions of this scene was to isolate Judas at one end of the table, at a remove from Christ and his disciples; another was that John rested his head on Jesus's breast. Ghirlandaio respected both of these traditions when he painted his **Last Supper** for the Ognissanti Church in 1480.

Another formal scheme adopted and perpetuated by painters from Giotto in the Scrovegni Chapel in Padua (early fourteenth century) to Fra Angelico in the Convent of San Marco in Florence (mid-fifteenth century), was the placing of the Apostles on both sides of the table. This arrangement enabled the artist to dispose the thirteen figures in space and create a convincing feeling of depth. On the other hand, this scheme had the major disadvantage of limiting the personification of the figures shown from the back. Such a limitation could scarcely have been tolerated by a genius of Leonardo's stature. And indeed, it is because he characterised each of the Apostles and diversified their sudden, unrehearsed reactions, that his **Last Supper** has such a strong emotional impact.

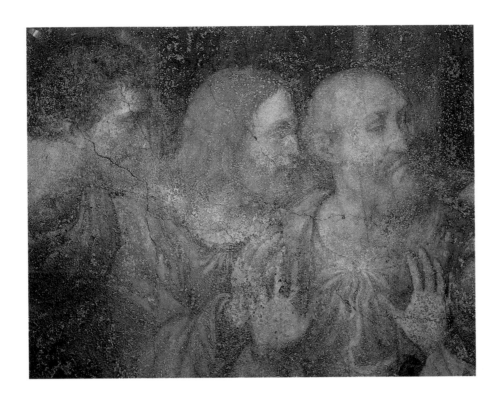

Above, opposite and previous pages

The Last Supper
(details)
1498. Fresco.
460 x 880 cm. (15 x 29 ft.).
Milan, Convent of Santa Maria delle
Grazie (Refectory).

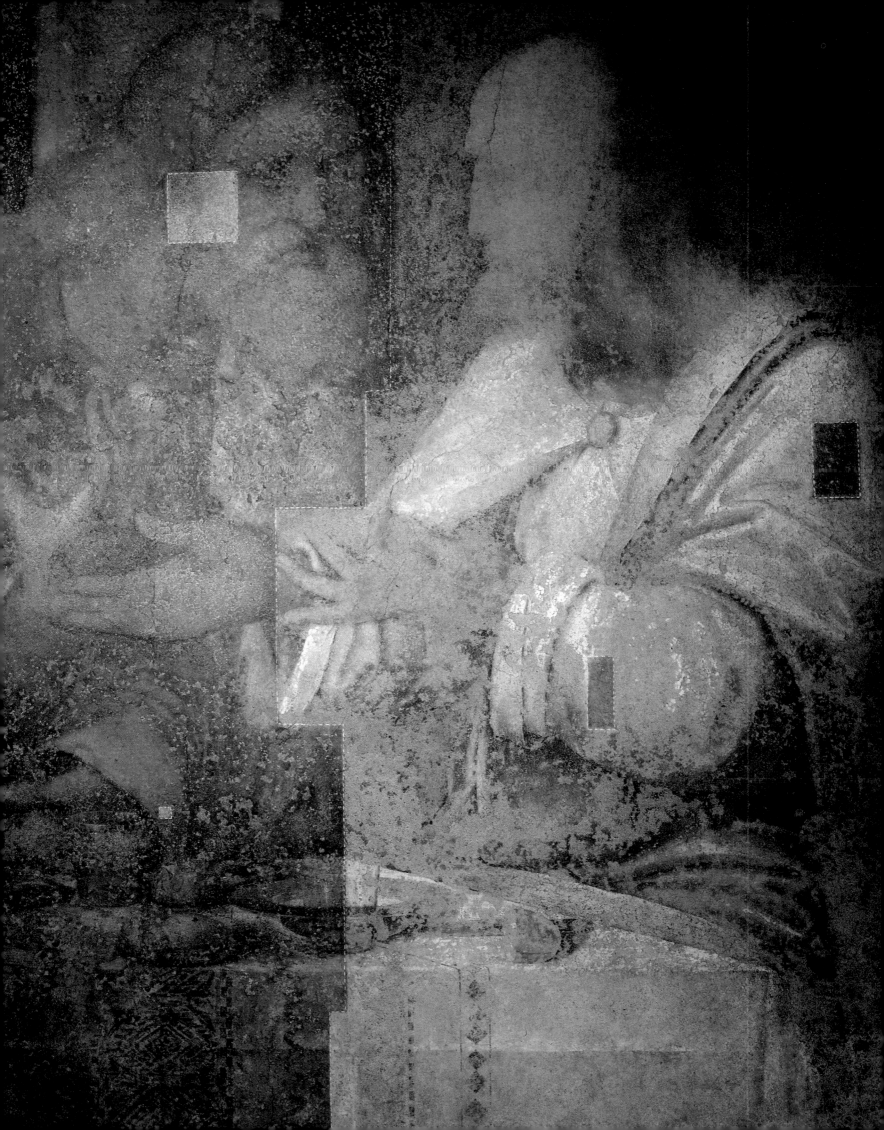

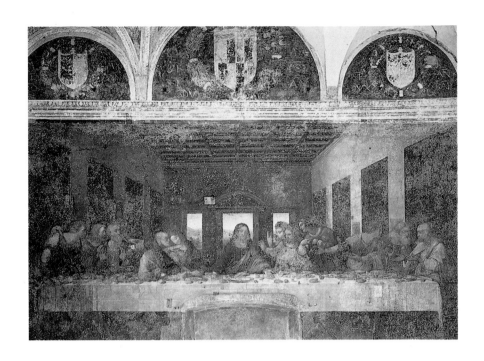

Unfortunately, today, the deterioration of the paint is so extensive that it is almost impossible to make out all of the faces. Only five finished studies of the figures of Judas, Philip, James the Great, and Bartholomew have come down to us; proof that Leonardo worked out each of the figures in detail. He did this not only so that the spectator would be able to recognize all the protagonists, as in the conventional representations of the past, but also so that he could discover the individual reactions of the disciples to Jesus's announcement: "...one of you shall betray me."

This concentration on the immediate consequences of Jesus's prediction of the betrayal constituted a profoundly moving innovation and a radical break with the works of those who had depicted the **Last Supper** in the past, and had somewhat naively stressed the figure of Judas. Here, on the contrary, Judas has been edged into a strange twilight zone, enveloped in chiaroscuro. Our attention is drawn to him only because his face is shaded, almost blackened, and because he gives an impression of impassivity that is anything but reassuring.

In this way, he contrasts with the other disciples, all of whom give vent to great dismay in their expressions. Yet their faces are wreathed with light, and we can well imagine them as vessels filled with the radiant message of the Holy Spirit. Leonardo's decision to magnify this moment, and present it as if suspended in time, in parallel to the sublime tragedy to

come at Golgotha, surely came out of his long study of the physiology of the passions and emotions and their expression in bodily attitudes and facial features. This desire to capture the telling outer details of inner states is expressed in many of his notes: "Paint the figures such that the spectator can easily read their thoughts by their postures, and if you depict an honest man, try to make his movements speak of his honesty in the same way as his words. And... if you make the portrait of a brutal man, show him in the throes of violent action..."

In his **Treatise on Painting**, the artist repeatedly remarked on the variety of expressions that emotions could produce in individuals. Our admiration, respect, or fascination for his other great works notwithstanding, we must admit that nowhere else has he more fully mastered and directed the

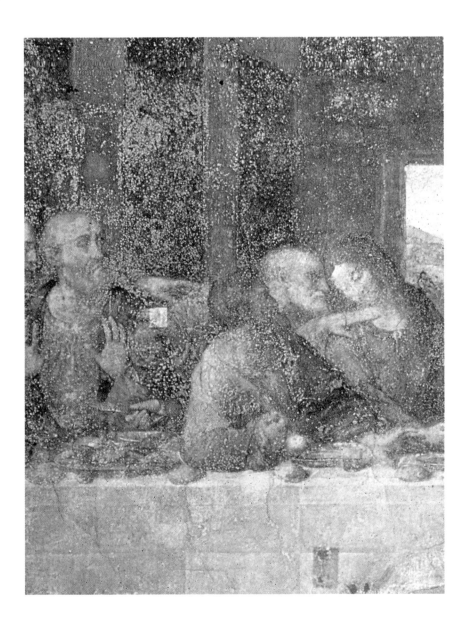

Opposite, below (details)
and overleaf

The Last Supper
1498. Fresco.
460 x 880 cm. (15 x 29 ft.).
Milan, Convent of Santa Maria
delle Grazie (Refectory).

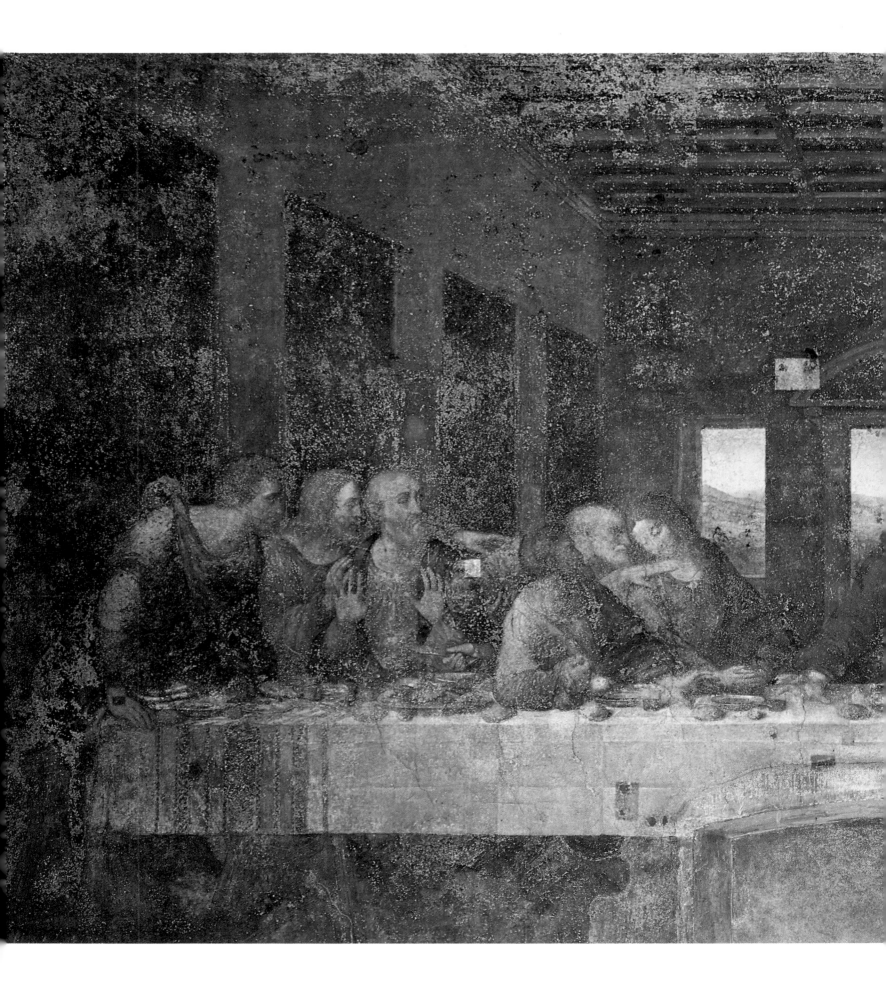

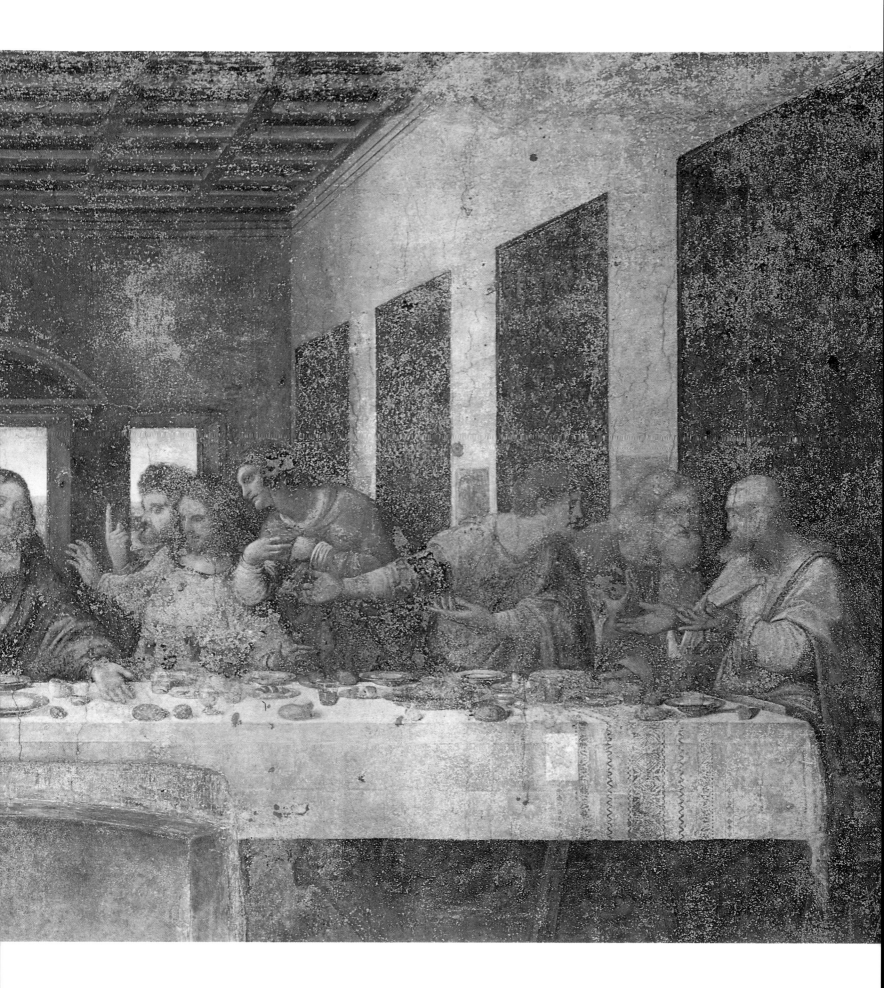

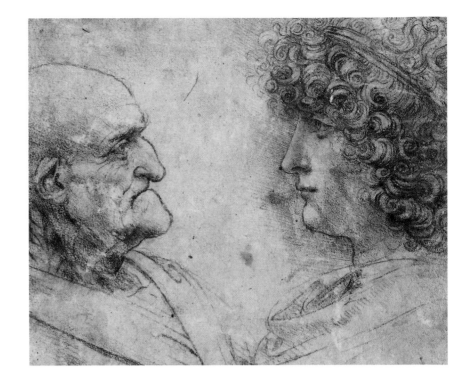

Two Heads
Florence, Uffizi,
Print and Drawing Collection.

profound, subtle, not to say ambiguous, expression of his figures as here. In this respect, and in spite of its poor state of preservation, his **Last Supper** is doubtless his absolute master-piece. Using quite simple means, he managed to express not only the disciples' fleeting state of mind but also their entire being. That is, as he imagined them to be, as he pictured them to himself when, after a long phase of contemplative inactivity, he took his palette and brushes in hand again.

This remarkable creative achievement coupled with a technical **tour de force** may perhaps be explained by two visual artifices, the first of which is the deceptive simplicity of the composition. Indeed, the clear arrangement of the disciples in a symmetrical scheme on either side of Christ, assembled lengthwise at a single, long table, might at first glance seem dull, wanting in inspiration, or at least lacking in the artistic imagination that had characterized the conventional representations of this subject since the days of Giotto, when the Apostles were seated on both sides of the table.

Not only that, but the composition as a whole, with its three centrally-disposed windows, the middle one – which is slightly larger than the others – exactly framing the central figure of Christ, is even more dogmatic in its symmetry.

However, if we look more carefully, we notice that the artist made no concessions to simplicity, any more than to

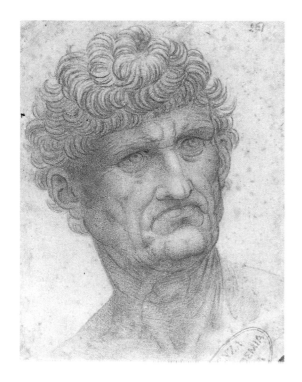

Head of a Man
Venice, Accademia.

facility, in his disposition of the figures, which he has deployed in two groups of three on either side of Christ. In the first such group, starting from the left, we see Bartholomew, James the Less and Andrew. The emotional charge is channelled through the figure of James, who reaches behind Andrew to touch the shoulder of Peter, attached to the second group at Christ's side. Peter himself leans forward to whisper something to John, who leans his head to one side to listen to him.

The interconnection of these movements, along with the direct lighting of the faces of Peter and John, underscore – without insistence – the fateful exclusion of Judas. The latter is suddenly thrown into the shadows, cut off from the emotional flow of gestures and faces united in a tragic solemnity so variously and finely inscribed in the frieze of figures stretching from Bartholomew to John.

Starting now from the right side, we see Simon, Thaddeus and Matthew, who is turning toward the other two, expressing great incredulity, as if to say: "How is this possible?" The counter-movement that Matthew makes with his arms provides a visual link to the following group, which includes Philip, shown standing, James the Great, with arms spread wide apart, and Thomas, who points upwards with his index finger. We might remark in passing how often Leonardo used this same enigmatic gesture to convey a message of

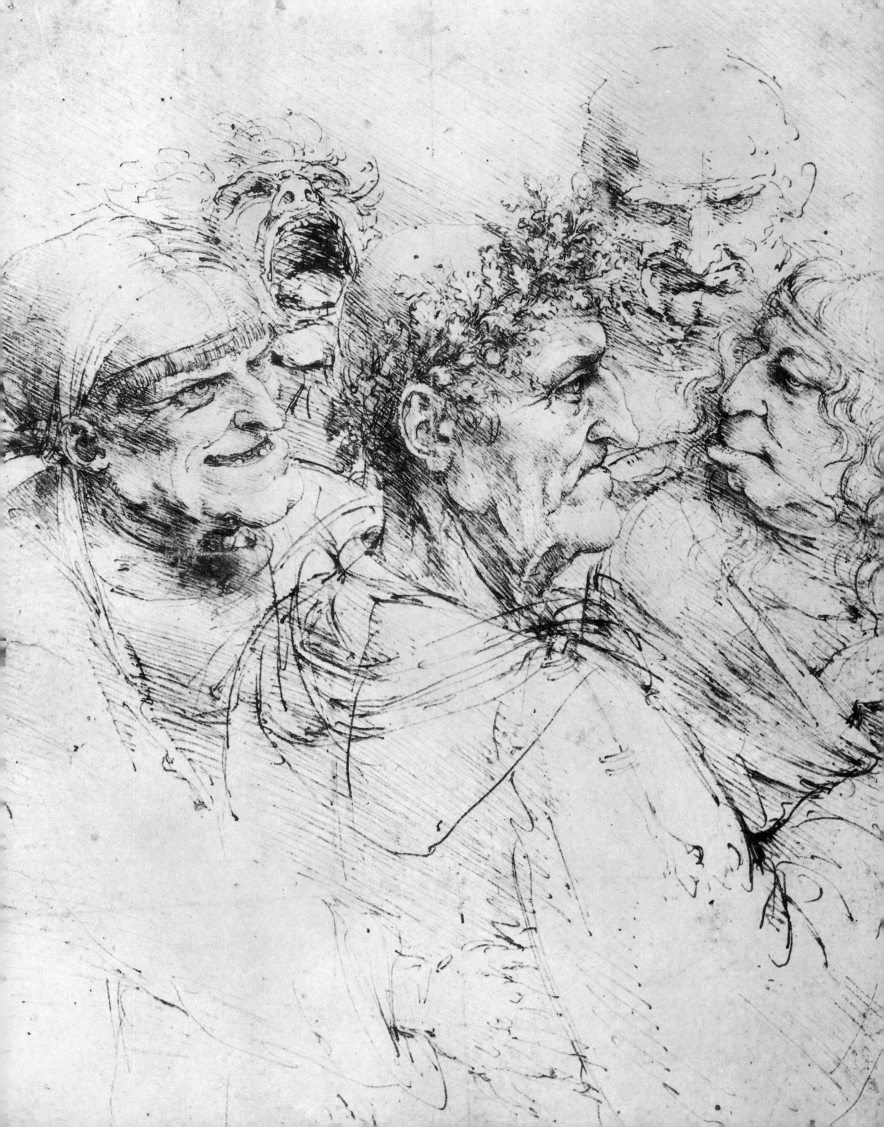

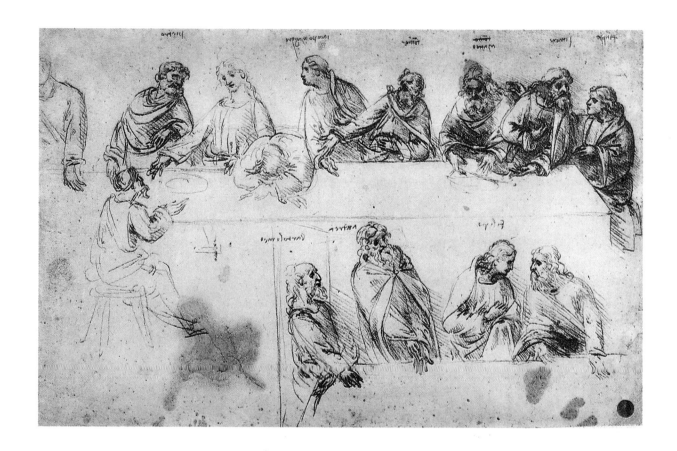

**Study for the composition
of the Last Supper**
Venice, Accademia (fa. Scala).

Opposite

Studies of Grotesque Heads
Around 1490.
Windsor Castle, the Royal Library
(fa. Scala)

Leonardo's caricatures were studies
of facial expressions with exaggerated
features and telling details that were
supposed to reveal the figure's
psychology and nature.

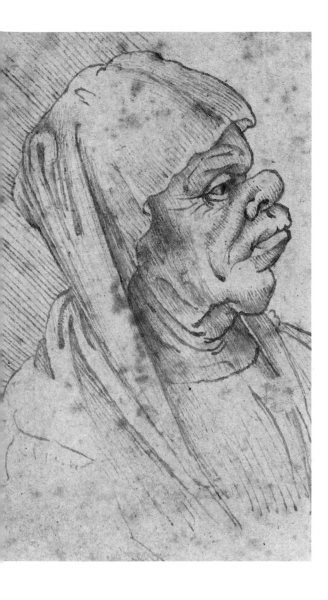

Five Grotesque Heads
(detail)
Venice, Accademia.

Opposite

Above

**Studies of Expression
and caricatures**
Venice, Accademia.

Below

Five Grotesque Heads
Venice, Accademia.

transcendental import: among the many works are the **Adoration of the Magi, The Virgin and Child with St. Anne and the Infant St. John** (also called the "London Cartoon"), and the 1509 panel of **St. John the Baptist** that is today in the Louvre.

At first glance, the **Last Supper** seems to present a quite simple architectural scheme. This impression, however, is not borne out by closer inspection. Leonardo in fact elaborated the seemingly plain architecture in subtle and effective ways to highlight the drama of this peak moment in the mystery of Christ's earthly existence. Thanks to this visual strategy, the beholder's attention is inevitably drawn to the variegated spectrum of the disciples' reactions.

And suddenly, as in a great revelation that pushes us to the limits of our understanding of this religious event, the composition presents itself in all its complexity. It appears then as an ambitious and visionary psychological exploration full of subtlety – and no little malice – that attempts to represent the visible aspects of human character suddenly confronted with the majesty of the god made flesh, the man who was both divine and mortal. Filled with the awful knowledge of what awaits him on the morrow, he presides already far above the vain flurry of passions that accompany him along the incomprehensible path leading him to the ultimate sacrifice. Calm though he may appear, Jesus, the Lamb of God, is fully vested with his sacred mission.

Despite his outward show of noble serenity, the "mortal God" is already the absolute Being, prepared to suffer the blows of his unknowing tormentors, the same who unwittingly fulfilled the Scriptures and charged them with a new meaning: "Suffered under Pontius Pilate, was crucified, and died, was buried, descended into Hell and was resurrected from the Dead on the third day; was raised to Heaven, and sits at the right-hand side of God the Father." Supremely inspired as it was on the spiritual plane, Leonardo's **Last Supper** was no less a marvel of technical – one is tempted to say even "scientific" – representation. Had it not been for the great gifts of the artist, this very banal scene of diners seated around a table would not have risen above the dull depiction of an evangelic episode, seemingly known to all, but never probed sufficiently in depth to reveal its hidden language. It is true, then, that the evocative power of a painting, that which sets it

off from all the others in its category, is often a matter of technical knowledge and mastery.

And so, however formal this observation might seem, one could venture to say that the dramatic intensity of Leonardo da Vinci's **Last Supper** hinges on a deliberate trompe-l'oeil effect. An analysis of the perspective of the room in which Christ and his Apostles are represented shows that the eye-level is situated at about twice the average height of a spectator seated in the refectory of Santa Maria delle Grazie. The reason for this choice of viewpoint is evident. For we must consider the fact that the depiction of this key Christian episode so high up on a wall, using a perspective adjusted to a spectator standing below, would normally have made the upper surface of the table invisible. The eucharistic gesture of Christ indicating the bread and wine would therefore have been lost from sight also. More subtle still are the proportions of the figures in relation to the table itself: not only is Christ visibly larger than his disciples, but the table is in fact far too small to accommodate so large a group of diners.

In his composition, Leonardo very deliberately deviated from the scientific naturalism of the system of linear perspective to concentrate the spectator's attention on the essential: the all-important figure of Christ in the centre who is gesturing towards the bread and the wine, while displaying an outer calm that is in stark contrast with the distraught reactions of his bewildered and incredulous disciples.

The spectators are therefore literally absorbed into a contemplative fusion with the work. Should they behold it truly with the eyes of the soul, they must enter into a state of profound communion with it. It is this emphasis on the essential truth – as opposed to the literal truth of visual appearance – that charges all of Leonardo's major compositions with such an irresistible power of evocation.

The other masterpieces by Leonardo – who was forty-five years old when he painted **The Last Supper** – will be discussed in a later chapter. But first, let us review his life.

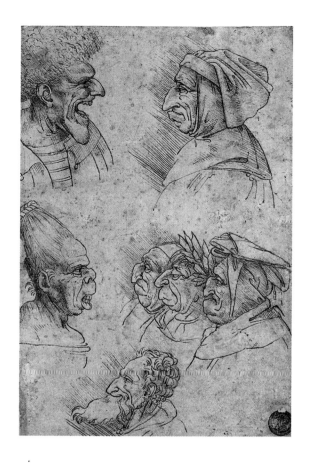

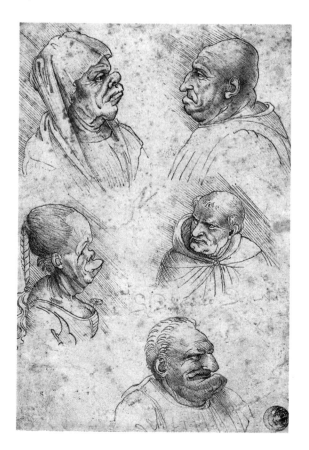

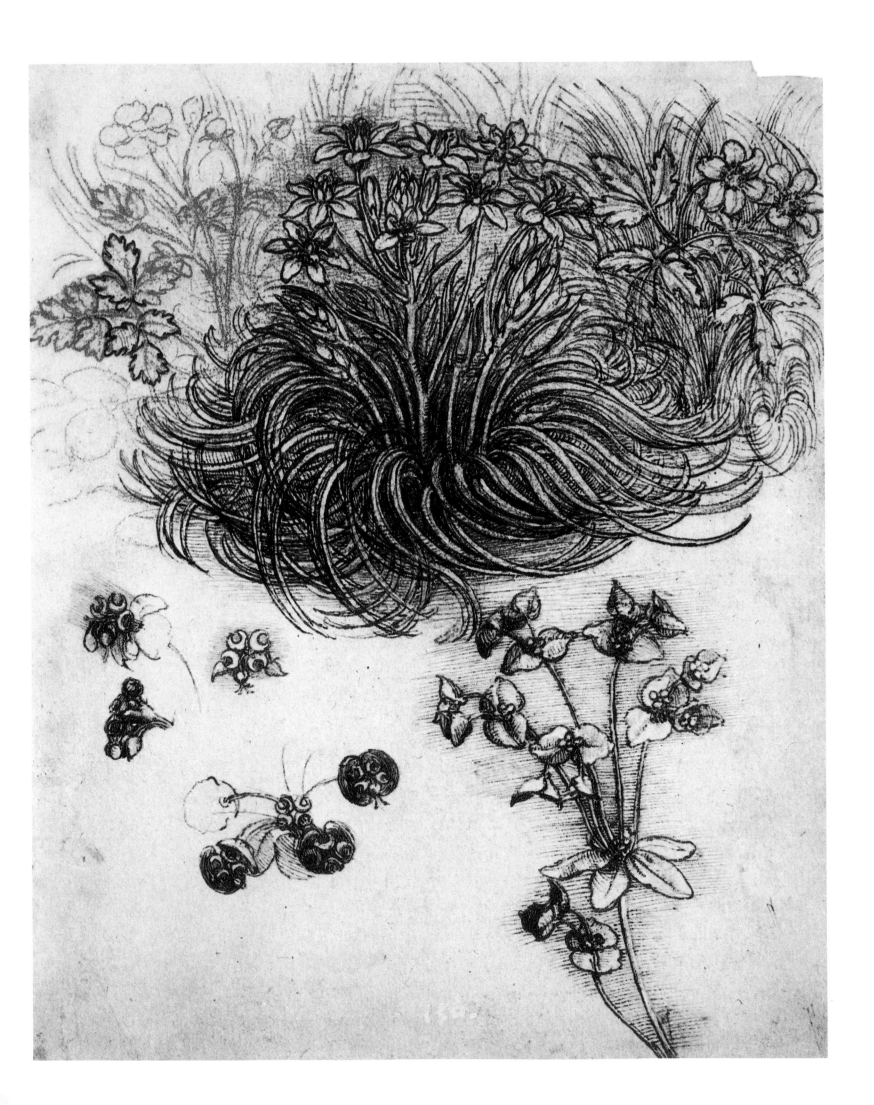

1

A childhood in nature

Leonardo's house in Vinci

This is Leonardo's presumed birthplace
and the house in which he spent
his childhood.

Opposite

Study of Plants
Above
Ornithogalum umbellatum
Below
Euphorbia
Red chalk, pen and ink.
Windsor Castle, the Royal Library
(fa. Scala).

Probably preparatory studies
for the Virgin of the Rocks.

Leonardo was born in the small Tuscan town of Vinci, which would never have had any claim to fame, were it not for the birth on Saturday, 15th April 1452, at three o'clock in the morning, of a male child who was given the name of Leonardo (or "Lionardo," as he would write it). Nor did anything in particular destine for glory this illegitimate child of the notary Ser Piero di Antonio (whose reputable and worthy ancestors had exercised official functions in the town since the thirteenth century), and a peasant woman, Caterina. Leonardo came into the world a bastard. Then, in the same year, his father wedded the sixteen-year-old Albiera Amadori, a well-endowed girl of the finest bourgeois stock.

The mother of the infant Leonardo in turn soon found consolation in marrying a local peasant named Acattabriga di Piero del Vacca. Although born out of wedlock, and therefore outside the Church, Leonardo was given the rites of baptism with no little ceremony in the church of Santa Croce.

In those days, in areas other than the free and light-filled Tuscan countryside, some would surely have found cause for scandal in granting a sacrament to an infant born outside the bonds of holy matrimony. But this was also at a time when Italy seemed to be changing the face of Europe and of the world – and even the popes were confessing to their illegitimate progeny.

The infant born under circumstances that fell short of the bourgeois standard, had an unusual upbringing: at the age of five, he was taken away from his mother and given into

Studies of Flowers
Around 1485, Venice, Accademia.

Leonardo's keen eye noted similarities
between different types of plants
and flowers, as if he were trying
to establish a classification – something
no one had ever thought of doing
before. In this way he was able to
achieve a formulation of the general
laws regulating the form and growth
of plant life.

the care of his stepmother, who in the meantime had proved to
be barren. Because of this, one assumes that she cherished and
treated him as if he were her own child. But this did not
prevent the sensitive Leonardo from experiencing affective
traumas at an early age; which could explain why he so
eagerly turned to those things that endured and could not be
taken away from him - in a word, Nature.

Leonardo is said to have lived until the age of
seventeen in the austere reddish-stone house perched on a
hillside above Vinci that can still be seen today, surrounded by
vineyards and olive groves. He must have been happy there,
carefree even. He must have felt suitably protected by his family
which, apart from his father and stepmother, included a gentle
paternal grandfather who devoted the last years of his life to
raising the boy; a grandmother; and a twenty-two-year-old
uncle called Francesco. But in 1464, his uncle Francesco left,
and in the following year Albiera, his stepmother, died. In 1468
(or 1466, according to some authors), he was sent to Florence
and placed in the **bottega** (studio) of the sculptor and painter
Andrea di Francesco di Cione, better known today by the
name of Verrocchio (1435-1488).

This is about all that the archives have to tell us
about the formative, and probably most decisive, years of the
genius who became the archetypal **uomo universale**.

Born the incidental offspring of a brief dalliance, the
fleeting encounter of two blood lines, one springing from a
notarial office and the other from a farm, Leonardo could have
contented himself with making the best of the resulting mixture:
a balanced physical and intellectual base, solid health,
refinement and vigour. Anyone else would have settled for that
and found happiness, or at least the foundations of worldly bliss.

But Leonardo was made of an altogether different
moral fibre. He was not one to follow staidly in the family
footsteps. One thing that immediately strikes the reader of his
notes and writings is his own perception of himself as being
"different" or "other." Throughout his life he was consistently,
persistently different, an alien in the literal sense of the word,
passing through, observing and leaving his indelible stamp on
whatever came into the ken of his interest. To be sure, he was
born with a difference, and it seems that very early on he
became perfectly aware of what this difference implied.

It may be that he first felt the full brunt of this
difference, of his profound and robust originality, at the onset
of adolescence. He made a point of cultivating his apartness,

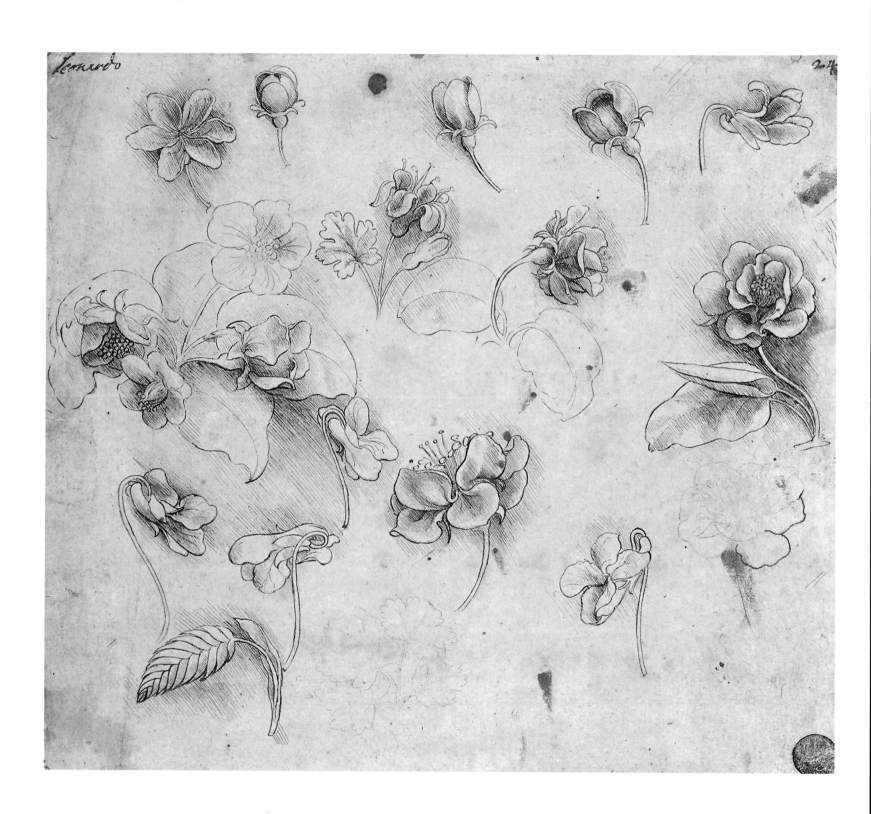

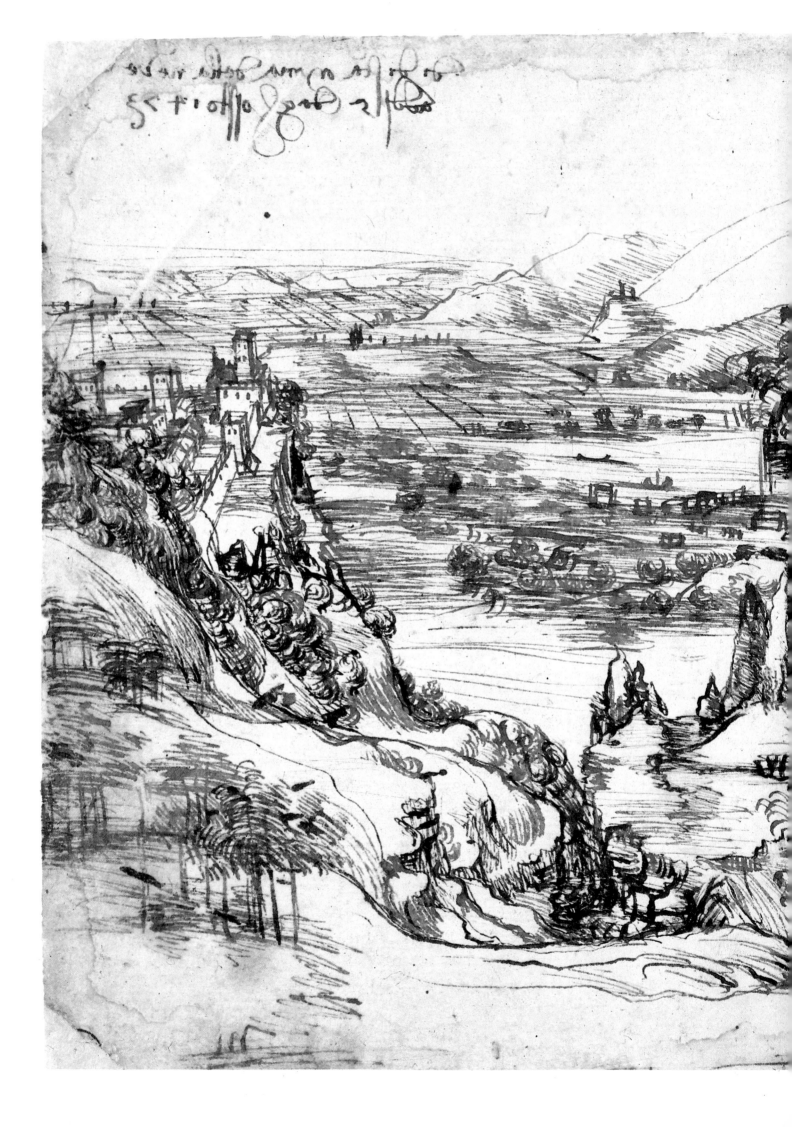

Leonardo

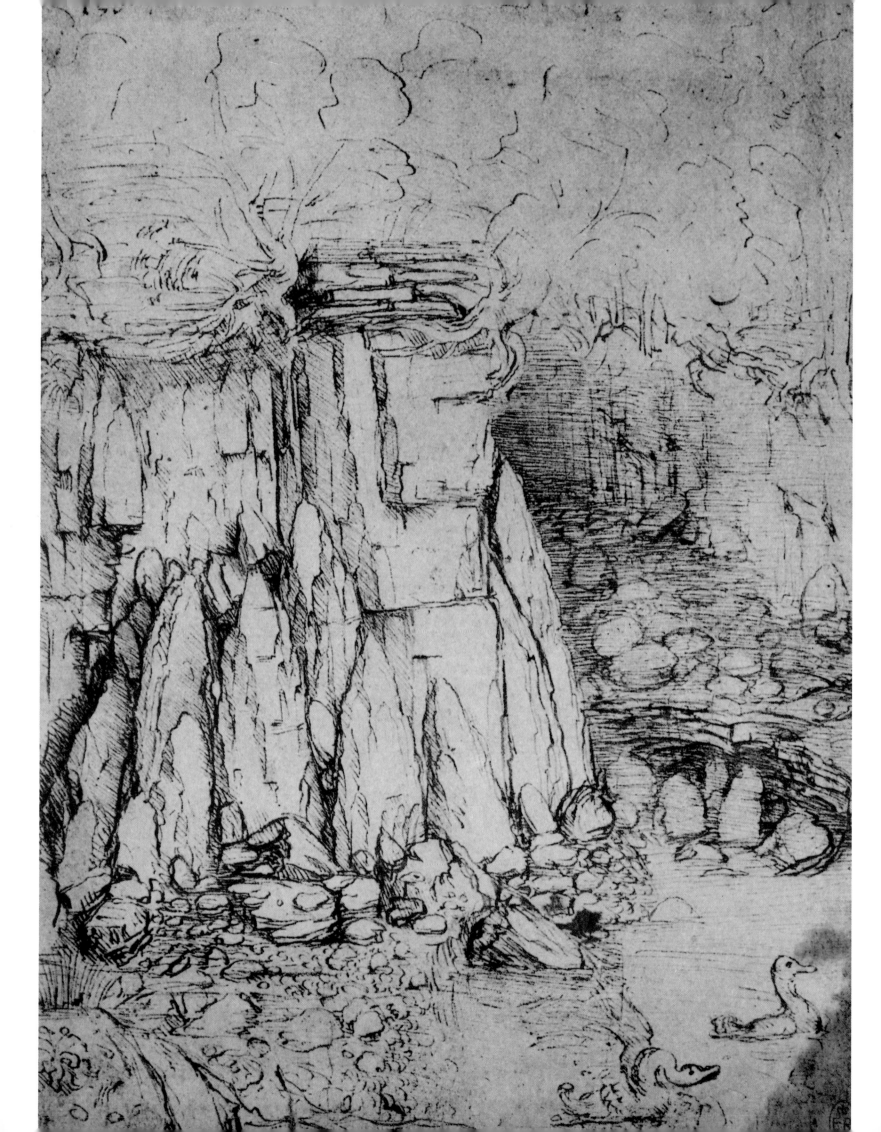

and never mixed with those who were content to think like everyone else. Given that, he could well have become an outsider, a tormented soul relentlessly pursued by the scorn and diffidence of his contemporaries. But this was not the case. Thanks to his intelligence, his grace, his beauty, his eloquence and his innumerable talents, he easily won the hearts and minds of all.

He lost no time in demonstrating his ability to master not just one but a variety of disciplines. His major assets were daring, originality and a talent for improvisation. He learned to draw, paint, sculpt, sing and play the lute, surpassing even the best masters of his day. Not only that, but he was an accomplished and handsome athlete, able to ride the most spirited steeds better than any of his peers and, according to Vasari, capable of such feats of strength as bending a horseshoe with a single twist of his hands. No wonder he was able to charm the best society in Florence, the court of Milan, and even the kings of France!

His earliest memory, which he mentioned in the course of a scientific disquisition on the flight of birds, is already the stuff of legend: "I remember once, when I was still in the cradle, that a kite (**nibbio**) swooped down on me and opened my mouth with its tail."[1] In an aside, he added, "Such was my destiny." Freud took this childhood memory as the starting point for his famous psychoanalytic interpretation of Leonardo,[2] which is undermined somewhat by the fact that he mistakenly translated **nibbio** as "vulture." Be that as it may, the important thing to keep in mind is that Leonardo was a child of his times, and so not above believing in omens and premonitory dreams: he knew that being different meant that he was one of the chosen few.

This image of a great black bird swooping down out of the sky continued to haunt the imagination of the grown man and creator. Seen from the outside, it may appear as just a fantasy; yet it would be erroneous to take it merely as a product of his unconscious. For Leonardo, it was nothing less than the call of fate, a sign that he was destined to tread a path where no one had ventured before.

1. The large body of writings left by Leonardo are preserved in various institutions throughout Europe. The Madrid Codex and the Windsor Codex are the major collections of these manuscripts, but there are also significant portions at the Louvre, in the Vatican Library and at the Ambrosiana Library in Milan. A comprehensive list of these manuscripts may be found at the end of this book.
2. FREUD, Sigmund, **Leonardo da Vinci; A Study in Psychosexuality**, Eng. trans, A.A. Brill, New York, 1916.

Preceding pages

Landscape in the Arno Valley
Drawing. Pen and bistre with watercolour shading.
196 x 280 mm. (7 3/4 x 11 in.).
Florence, Uffizi, Dept. of Prints and Drawings.

Mountains and a castle (left) in a wide valley. The inscription upper left reads: "On the day of Sta Maria della Neve, August 5th, 1473," making this the earliest-known drawing dated by Leonardo.

Opposite

Rocks and Water Fowl
Pen and ink.
Windsor Castle, the Royal Library (fa. Scala).

Probably a study for the Virgin of the Rocks.

Leonardo stressed the analogies between the Earth and the human body: "Thus, we could say that the Earth has a vegetative soul, and that its flesh is the soil itself, its bones are the assemblages of rocks that make up the mountains, its tender parts are the tufa, its blood the watercourses, and the large quantity of blood around the heart is the ocean. Its breathing and the increase and decrease of the pulsation of blood beneath the skin, are the ebb and flow of the sea; and the heat in the heart of the world is the fire infused within the Earth; and the dwelling-place of the vegetative soul is the fires which, in various places on the Earth, manifest themselves in hot springs, sulphur mines and volcanoes."
(Ms Leic. fol. 34).

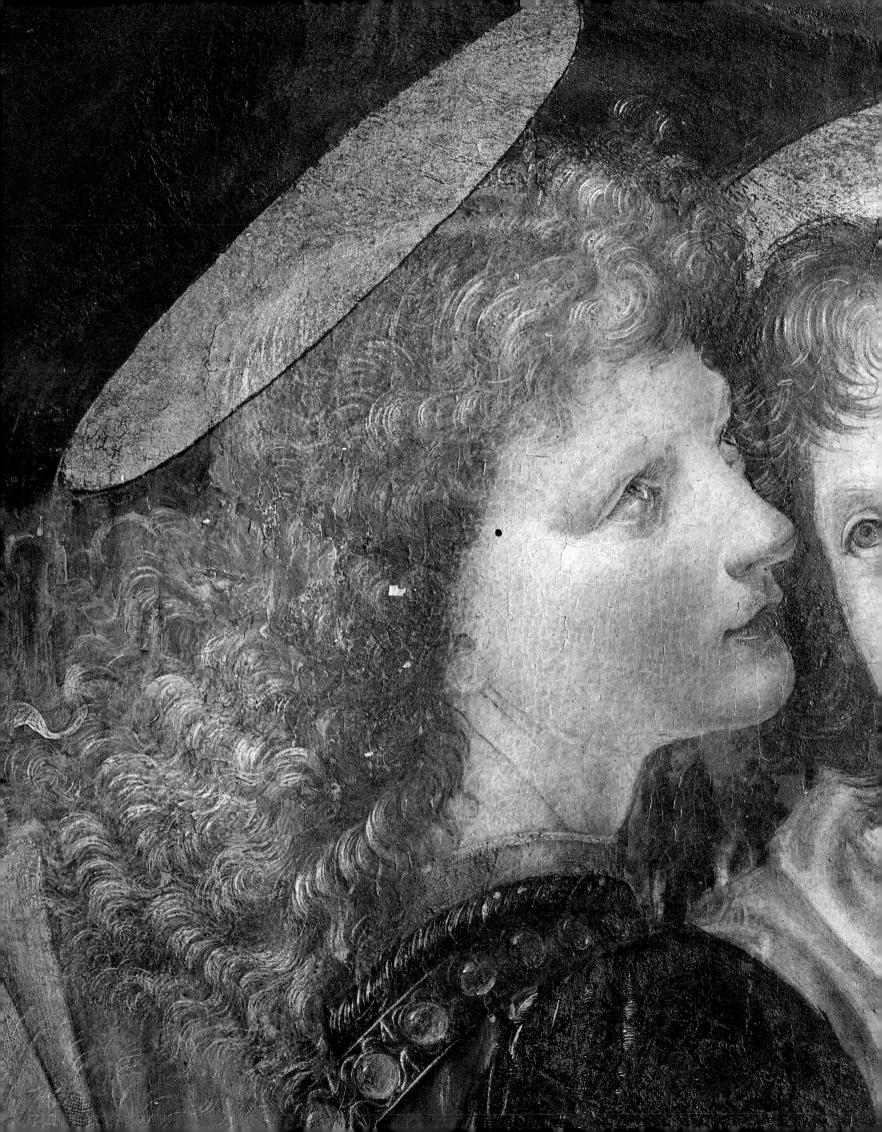

One concept that keeps coming up in any discussion of Leonardo, whether the child or the man, is that of Nature, which he himself defined as Pure Reason. As he once wrote: "He who expects from experience what it lacks parts company with Nature and with Reason," and elsewhere: "In Nature, there is no effect without a cause; understand the cause, and you can do without the experience." The boy acquired from his father's side strong intellectual faculties: method, probity, a great capacity for attention and study, curiosity and a fondness for collecting; and from his mother, the common sense and wisdom of the peasant. Had he been educated in a sheltered city environment, entrusted to a venerable tutor steeped in the humanities and swearing only by abstruse abstractions, would Leonardo's invocatory signature – "Io, Lionardo" – have resounded so enduringly down the centuries? His guardian angel must have stood watch over him and guided his instruction. The ideal place for him to develop his unique potential was far from the madding crowds, in the Tuscan countryside, where he had the good fortune to be born.

The young Leonardo daydreamed and roamed his beloved countryside, wending his way between the shimmering light and the shade of the gnarled olive trees. In the distance he spied the sharp, towering silhouettes of the cypress trees standing out against a serene blue; or a lowering sky heralding an imminent storm. He was never to forget the formidable storms. In his drawings, he depicted over and over again these natural spectacles, perfect subjects for his **chiaroscuro**, or the mysteriously evocative **sfumato** with which he rendered landscapes in so many of his works. The **Mona Lisa** is one of the best examples, with its distant mountains, valleys and torrents seen as if through a window, bathed in a luminous haze which dissolves the forms and attenuates the colours.

Well protected from the stresses of city life, marvellously free of care, agile and insatiably curious, perhaps already full of strange and incongruous ideas and projects, he discovered all the wonders that nature had to offer, from starry skies to the endless play of light and colours. It would be no exaggeration to say that he had a charmed boyhood. He thrived on nature, without and within, attuned to the strains of a secret harmony which proclaimed both a promise and a pact: "Io, Lionardo, one day I shall know all things and master all the arts which unlock the great secrets of the Universe!"

Opposite and next page

VERROCCHIO
The Baptism of Christ
(detail)
1452-1519. Oil on wood.
Florence, Uffizi.
With extensive contributions
by Leonardo.

The angel in the foreground
of this Baptism of Christ by Verrocchio
is the earliest painting we can attribute
to Leonardo. The profile with
the raised head recalls the influence
of his Florentine master, but the play
of light and shade bathing this angle
will be a characteristic feature
of Leonardo's masterpieces.

Life for him was an endless source of wonder, and everywhere he turned he could find cause for joy: in the singing of the birds, in climbing up a rocky slope, in the discovery of a fresh-water spring, or the mouth of a deep cavern into which he would venture with a mixture of fascination and terror. Then there was his extraordinary capacity for solitude, and an inner strength of the kind that has characterized all of the great mystics of both East and West. This strength had its origins in a deep-felt and constant desire to be in a state of total communion with nature. This basic need, which was instinctive in his youth, became more and more ingrained and conscious as he grew to manhood, but was never systematic.

One wonders if this happy-go-lucky, wayfaring child had any other tutors than nature itself. No doubt he was somewhat put off at first by the dark and lifeless tomes of his paper-pushing father; the boy must have seemed ill-suited to acquiring a taste for book-learning.

His favourite companion and playmate in his father's household was his young uncle Francesco. The latter must have taken a great liking to his brother's spirited, charming, unpredictable offspring, for he made him one of his heirs, along with Ser Piero's other, legitimate sons.

Although he lived in Anchiaro, a town three kilometres away from Vinci, it would not be far-fetched to presume that the parish priest of Santa Croce may have tried to teach Leonardo the rudiments of Latin at his father's behest. Yet surely to no avail, for the wild young boy still preferred to spend his time in the company of the local peasants, who were simpler and more down-to-earth in their ways. With them, he could at least hear colourful stories and legends, peppered with the proverbs and sayings which he later delighted in recording and quoting in his notebooks. Even when his genius and fame were well established and he was well advanced in years, their coarse and earthy wisdom added a special savour to his writings. Thus, we are confronted with a paradoxical situation: the man generally recognized as the paragon of humanist culture in Tuscany was in fact an autodidact, someone who always gave precedence to experience over scholarly authority.

Although refined and subtle in most things, he was nonetheless a plain and instinctive soul in his affinities, writing such recommendations as: "Avoid study which gives birth to

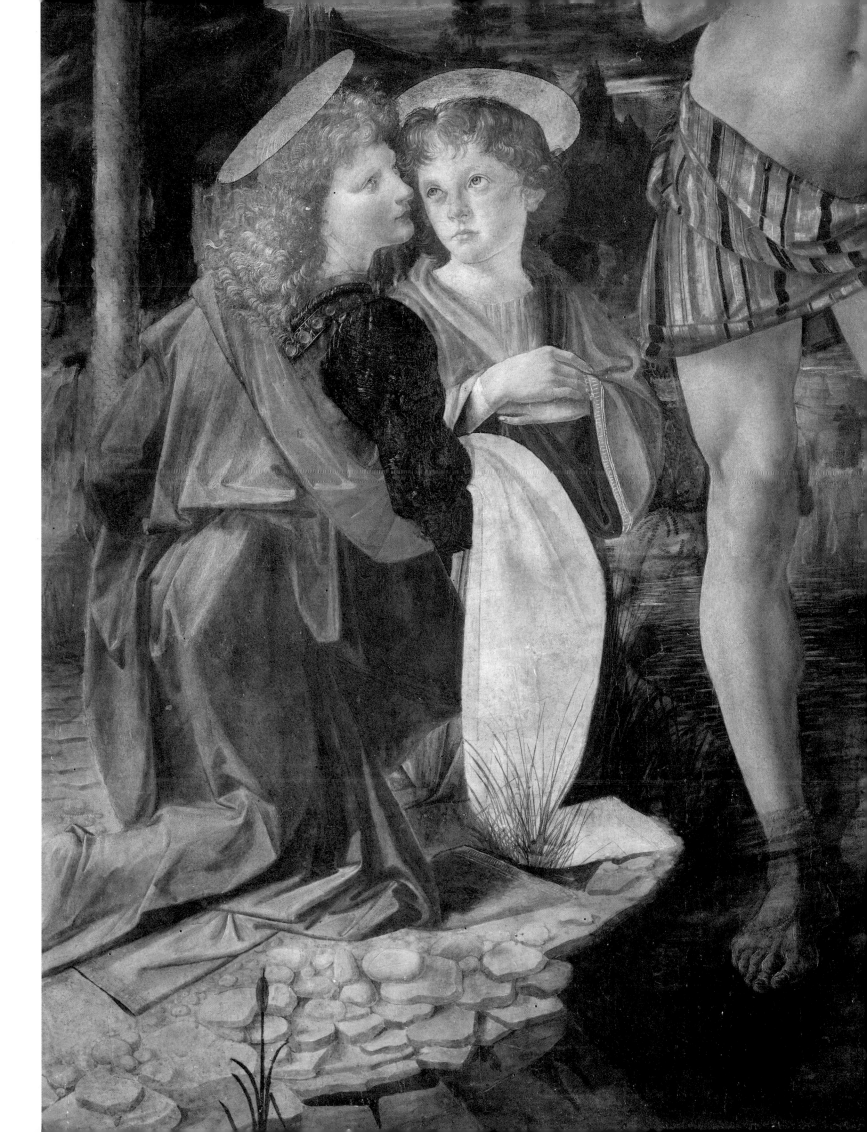

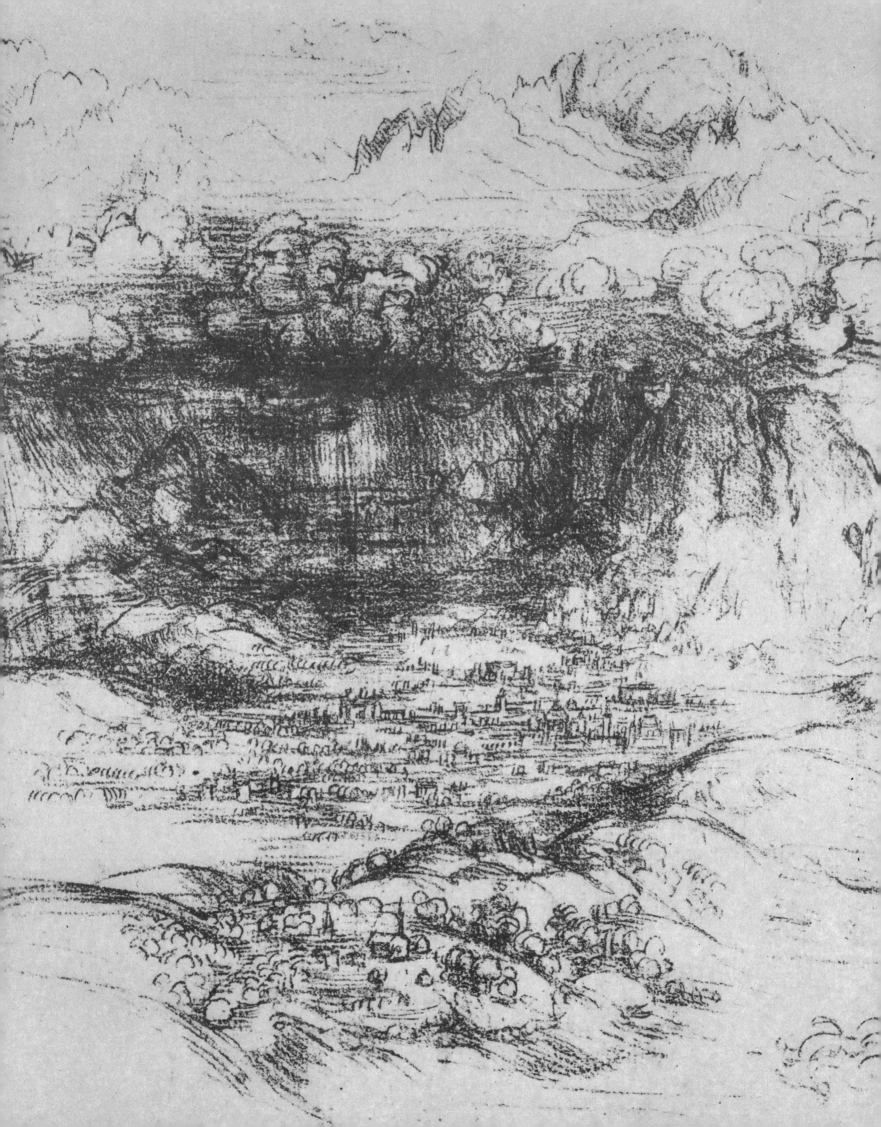

works that are fated to die, like their authors," and "Science is the captain, practice the foot-soldier."

To be sure, he also experienced a profound nostalgia and no little resentment, even if he cloaked it with pride and disdain, that his unconventional roots alienated him from the learned circles of his day: "I am fully aware of the fact that, because I am not a learned man, certain presumptuous people will see fit to reproach me for my alleged ignorance. The stupid fools!... They will say that my ignorance of letters (Greek and Latin) prevents me from adequately expressing my views on the subjects that I discuss. But the exposition of my subjects requires the support of experience rather than of authority. And because experience has been the master of those who write well, I will choose it as my master, and will appeal to it in every case. Many will consider me blameworthy on the grounds that the proofs advanced by myself contradict the authority of certain authors whom their judgement, unverified by experience, holds in great reverence, not thinking that my conclusions are the result of experience pure and simple, which is the true master...."

Leonardo was faithful to experience, and therefore to nature, to the cult of what is concrete rather than the abstract idea.

Be that as it may, this Achilles' heel profoundly irritated and preoccupied him. Thus, although well into his thirties, he undertook to study Latin, which he never quite succeeded in mastering. He also began to pore over the works of the great philosophers, and, according to Vasari, often strayed into all sorts of personal theories that no longer had much to do with the systems of the great thinkers of Antiquity – principally Plato and Aristotle – or their Renaissance avatars of the Neo-Platonic persuasion, such as Giovanni Bessarion, Giorgio Gemistus Plethon, and Marsilio Ficino. Although the latter were the leading intellectual lights of the day, they have since mostly fallen into oblivion.

He tried his hand at just about everything, but his rebellious and somewhat heretical streak caused him to twist everything in line with his own tastes and insights. He could not fit into any of the existing norms, and he knew it. As we have seen, even from his earliest childhood he was bent on cultivating this irreducible difference.

Throughout his life Leonardo endeavoured to create and make things, not in the name of abstract theories, but by basing himself on material reality. Obsessed with the

Storm over an Alpine Village
Red chalk, 290 x 150 mm. (11 x 6 in.).
Windsor Castle, the Royal Library
(fa. Scala).

This drawing may be related
to the composition of the Virgin and
Child with Saint Anne in the Louvre.

Leonardo the meteorologist?
This drawing depicts dense vapour
clouds at an altitude of about 2,000
metres being transformed partially
into precipitation, while, higher up, at
3,000 metres, the peak of Monte Rosa
stands under a clear sky. Leonardo
alluded to this phenomenon in a note:
"And I saw that the air below me was
very dark and the sun which struck
the mountains much more luminous
than in the lower plains"
(Ms Leic. fol. 4).

need to imitate and reproduce, he was the **homo faber par excellence**, a born maker in the image of his Maker, driven by the passion to understand, develop, and, if possible, improve on everything under the sun. He sketched everything he saw, from leaves and insects to the shapes of the rocks and hills of his native Tuscany. An explorer of the world around him on the one hand, and, on the other, a magician who transmuted the creatures and objects of the natural kingdom. Even as a child, he would collect all manner of things: dead fish, wilted flowers, bizarre insects, and so on. In his **Lives**, Vasari relates a now-famous anecdote in this connection. The incident must have taken place in 1469, the year in which the da Vinci household moved to Florence and his father established himself as notary for the Signoria, taking up lodgings in a house on the Piazza San Firenze. The boy was seventeen or eighteen years old.[3]

"One day, while in the country, the notary Piero da Vinci was visited by one of his farmers, who had made a **rondaccio** (a type of shield) from the wood of a fig-tree felled on his land, and asked him to have it painted in Florence. The notary readily agreed... and, without telling him anything about its origins, entrusted the object to Leonardo to paint. Noticing that the object was warped and poorly fashioned, Leonardo straightened it out in the fire and gave it to a turner, who transformed the coarse surface into a perfectly smooth and even one. Then the painter coated it with a ground of his own making and began to ponder what he could depict on the shield to frighten the enemy.

With this in mind, Leonardo set himself up in a room to which he alone had access, and proceeded to collect lizards of all sizes, snakes, butterflies, grasshoppers, bats and other weird animals; assembling these disparate elements, he created a fearsome monster that spewed poisonous fumes in all directions. Then he represented it emerging from a dark opening in a rock, belching poison from its gaping jaws, smoke from its nostrils, and fire from its eyes, a truly horrible monster. He was so engrossed in his work that he did not even notice the stench of the decomposing animals that fouled the air in the room.

Finally the work was done, but neither the peasant, nor his father had asked about it; so Leonardo invited his father to fetch the shield when he wanted.

Piero arrived one morning and knocked on the door to the room. Leonardo appeared and asked him to wait

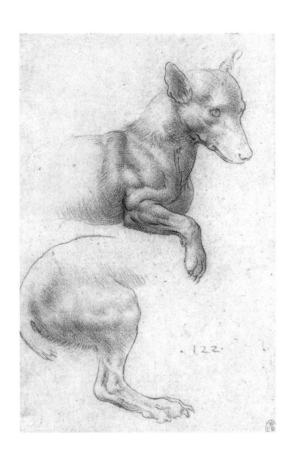

Study of a Dog
Windsor Castle, the Royal Library.

Opposite

Ox and Donkey
Windsor Castle, the Royal Library.

3. VASARI, Giorgio, **The Life of the Florentine Painter and Sculptor Leonardo da Vinci**, in **The Lives**, see bibliography.

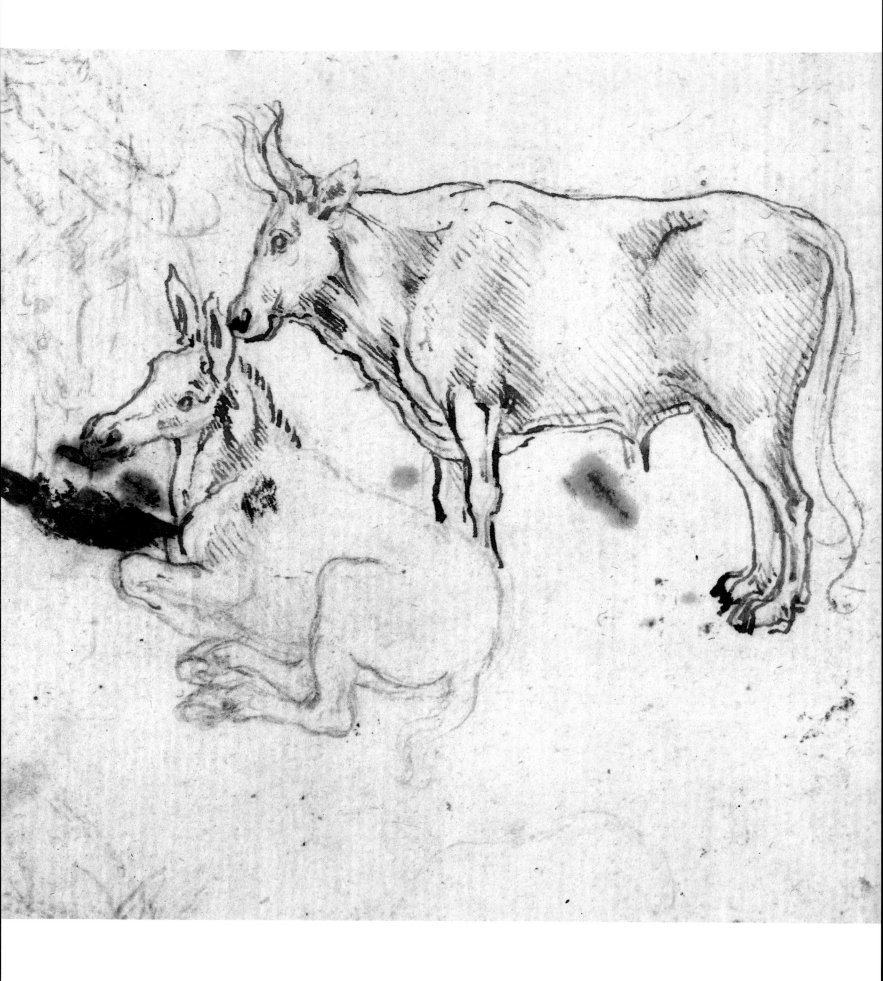

Study for the Virgin with a Cat
London, British Museum (fa. Scala).

Opposite

**Study of Cat Movements
and Positions**
Windsor Castle, the Royal Library.

while he installed the shield in good lighting on his easel, and closed the shutters to darken the room. Then he bade his father enter. Ser Piero was taken aback when he saw it, not realizing that he was looking at the shield, and much less a painting. He drew back, but Leonardo prevented him, saying: "It is doing its job; take it; that is what a work of art is for." This comment greatly impressed Ser Piero who appreciated his son's subtle reasoning.

Not mentioning a word of this, he went to a merchant and purchased another shield depicting a heart transfixed with an arrow and gave it to the peasant, who was grateful to him for the rest of his life. Then he secretly sold his son's work for a hundred ducats to Florentine traders, who shortly afterwards sold it for three hundred ducats to the Duke of Milan."

Convinced that there was a market for his son's talent, Ser Piero decided to place him as an apprentice in the workshop of the famous Florentine master Andrea del Verrocchio. Was this the purely mercantile reaction of a petty official? Probably not, for art had nothing to do with his decision. In those days, a painter was considered on the same footing as a manual labourer, and so a career in the arts for a notary's son was more of a step down the social ladder. As it was, the relationship between father and the son seems not to have been particularly affectionate. Leonardo never mentioned his father in his writings until the day in 1503 when he learned of his death and noted: "On 9th July, at seven o'clock, death of Ser Piero da Vinci, notary at the Podestate Palace, my father; he was eighty years old; he left behind two male children and two daughters."

This is rather succinct for an eulogy. Incidentally, Leonardo was mistaken about his father's age: he was in fact three years younger. When Ser Piero's estate was settled in 1506, at his stepmother's request, Leonardo was not among the heirs proving that he was never legitimized and that his father had made no provision for him in his will.

Although his mother had never taken care of him, Leonardo had her brought to Milan when he lived there, and, when she died, made sumptuous funeral arrangements, dutifully recording the expenses in his notebook.

Note: With few exceptions, the texts and inscriptions in Leonardo's hand were intentionally written in an inverted script (from right to left). The works shown here are reproduced as in the originals.

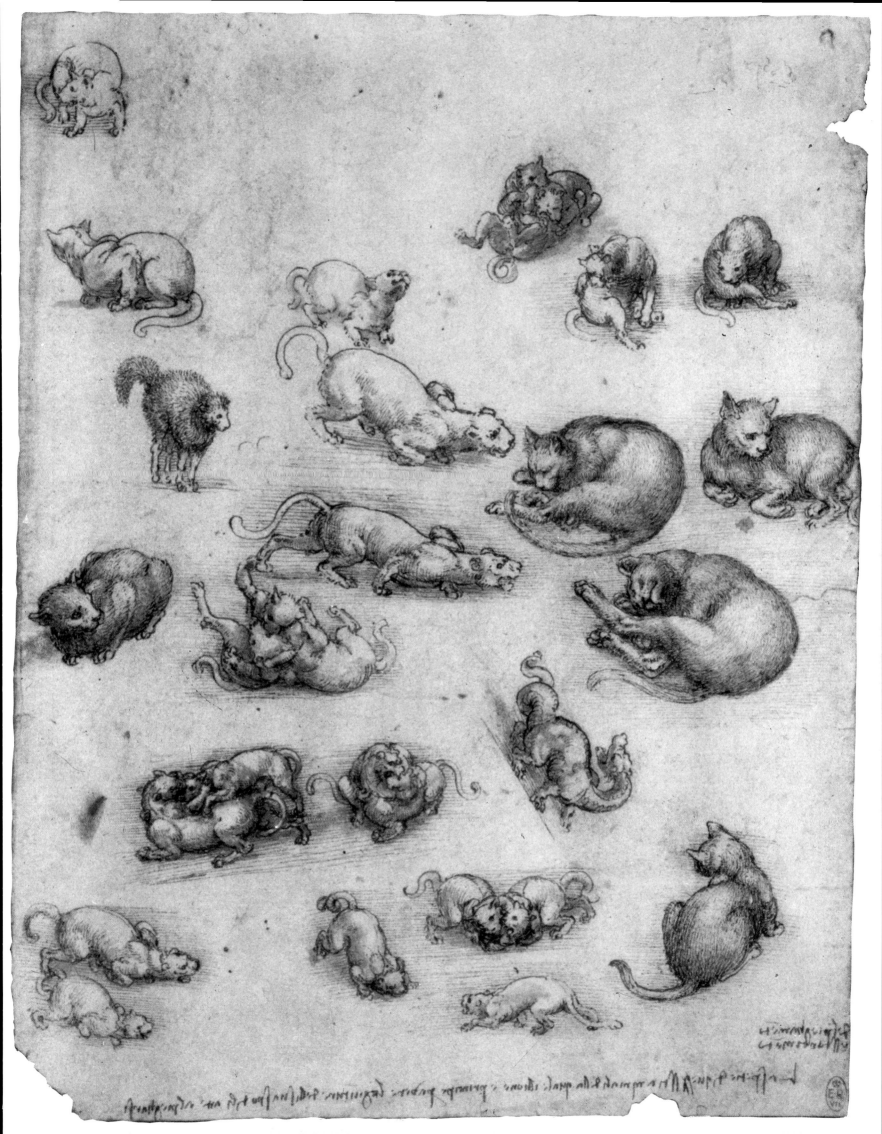

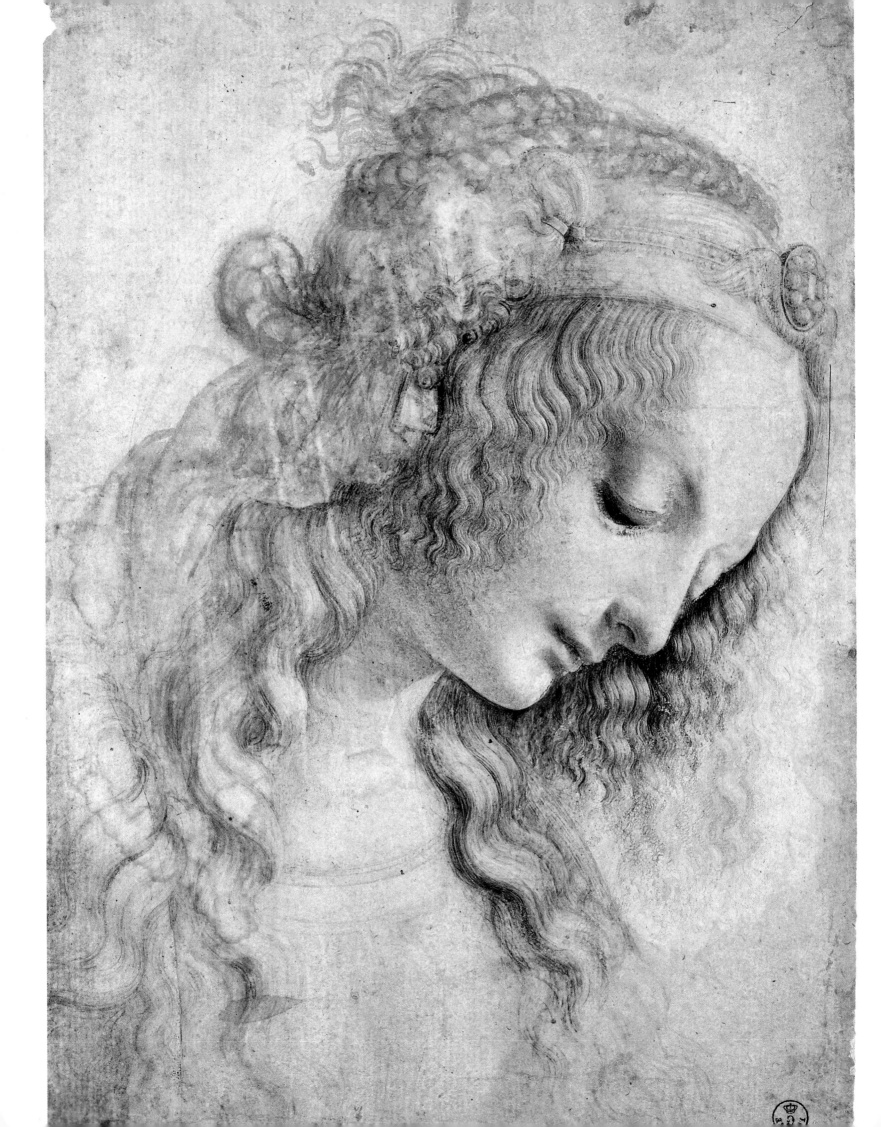

2

The Saltarelli Affair

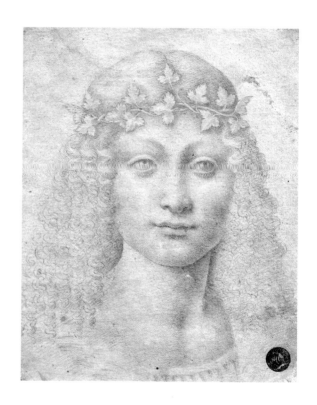

Giovanni Baco
Venice, Accademia.

Opposite

Head of a Woman
Florence, Uffizi, Dept. of Prints and Drawings.

Leonardo thus became a member of Verrocchio's studio, which already included such promising young talents as Sandro Filipepi, better known as Botticelli, then aged twenty-three, Pietro Vanucci, or Perugino, twenty years old, Lorenzo di Credi, fourteen, Domenico Ghirlandaio, twenty-one, and Francesco Botticini, twenty-four.

The operation of an artist's studio in those days was quite different from what it can be today. An apprenticeship was a long and fastidious affair. For at least a year, before the student ever touched a brush to pigment, he had to learn and perform the indispensable menial tasks of the painter's art, the most common of which were grinding pigments and washing the various implements. According to guild regulations dating from medieval times, an apprenticeship could last up to six or seven years.

Like his fellow-students, Leonardo progressed from these simple tasks to more complicated ones, such as transferring preparatory drawings from cartoons to the final surfaces. Students could also be entrusted with the execution of drapery and other minor pictorial elements. Only after having proven his skill in such tasks did the apprentice become a full-fledged assistant, capable of executing a complete picture from his master's sketches and instructions.

It is important to remember what the status of an artist was in those days. In the eyes of his princely or ecclesiastical patrons – his only possible clientele – he was a skilled worker filling a commission. For centuries, these commissions were implemented through notarized contracts

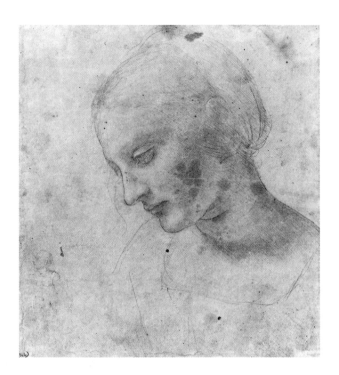

Head of a Woman
Silverpoint on light-green paper.
180 x 165 mm. (7 x 6 ¹/₂ in.).
Paris, Musée du Louvre.

Study for the Madonna Nursing
the Child.

Opposite

**Madonna Litta
or Madonna Nursing the Child**
1490. Oil. 42 x 33 cm.
(16 ¹/₂ x 13 in.).
Saint Petersburg, Hermitage Museum.

After much controversy, this picture is
today generally attributed to
Leonardo, although it may have been
finished by Boltraffio, his best-known
student. The style displays the
Lombard influence under which
Leonardo worked during his first
sojourn in Milan; this style is
characterized by a very stark modelling
of the figures, quite different from the
sfumato of his later works. Originally
painted on a wood panel, then
transferred to canvas in the nineteenth
century, this painting has
unfortunately suffered some damage.

with detailed stipulations. There was no art market as such and
so no independent creation.

Leonardo had not been in Verrocchio's studio for
very long when the latter was commissioned to paint a
Baptism of Christ (today in the Uffizi) for the church of San Salvi
in Florence. According to Vasari's account, although his young
pupil lacked practical experience and had ground but few
pigments, Verrocchio had already taken the measure of his
talent and entrusted him with painting the figure of an angel in
this picture: "And, despite his great youth, his angel proved to
be better than the figures of Andrea del Verrocchio. Because of
this, humiliated at having been bettered by a mere child, the
master swore that he would never touch a brush again."

Yet another tenacious legend! For where could
Leonardo have learned to paint so well at his age? In the town
of Vinci? And with which painter? On the other hand, if, as
some experts believe, the painting in question dates from
1472, then Leonardo had already completed two years of his
apprenticeship, and, prodigy that he was, may well have been
able to equal his master. In any case, Verrocchio, who preferred
sculpture and working with metal, must have been delighted
to have a student who could take over his easel painting. As for
this first documented effort, recent scholarship tends to
attribute to the future master not just the famous angel, but
also the landscape on the left.

In choosing Verrocchio's studio for his son's artistic
training, Ser Piero da Vinci had not set his sights low. This
studio, famous for maintaining the co-operative spirit of the
medieval crafts tradition, was rivalled in Florence only by the
workshop run by the Pollaiuolo brothers, Pietro and Antonio.

In 1472, Leonardo's name appeared on the roster
of the Company of St. Luke, as the painters' guild was called.
Listed as "**Leonardo di Ser Piero da Vinci dipintore**," he had
just turned twenty and, after paying the guild fees, was
entitled to open his own workshop. In those days, guilds were
very powerful institutions, organized along the lines of a union,
or like the corporate associations governing the medical and
legal professions. They issued very strict guidelines regulating
apprenticeships and established professional codes of ethics.

His enrolment in the guild gave him the status of an
independent master, but, probably because he lacked the funds
to strike out on his own, Leonardo stayed on another four years
in Verrocchio's studio, where he took on increasing responsibility.
One of his duties was to help design the processions organized

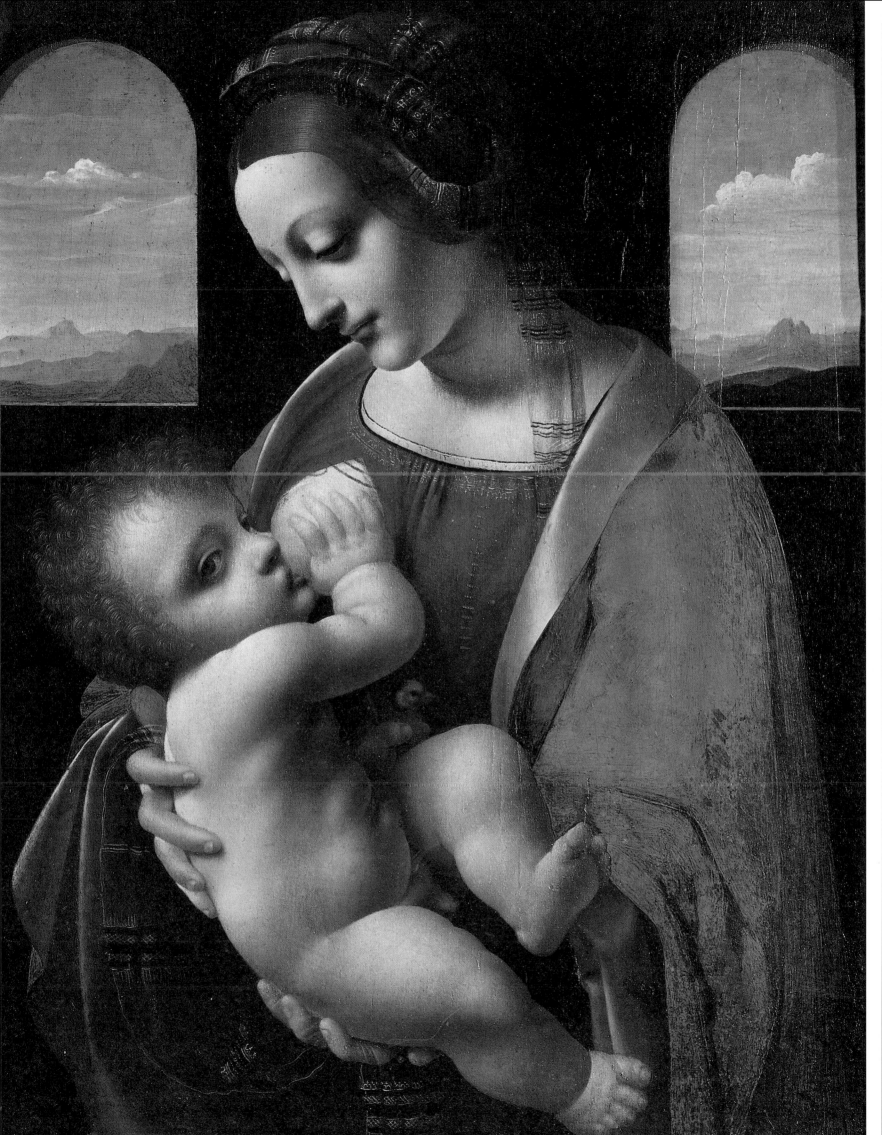

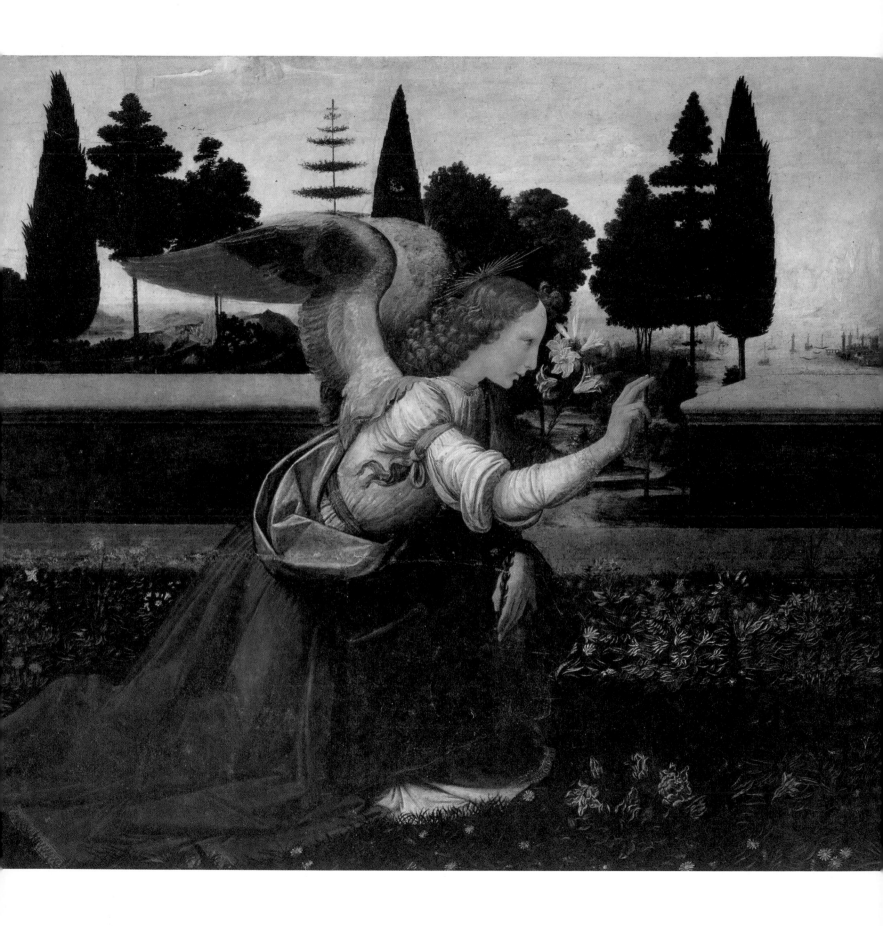

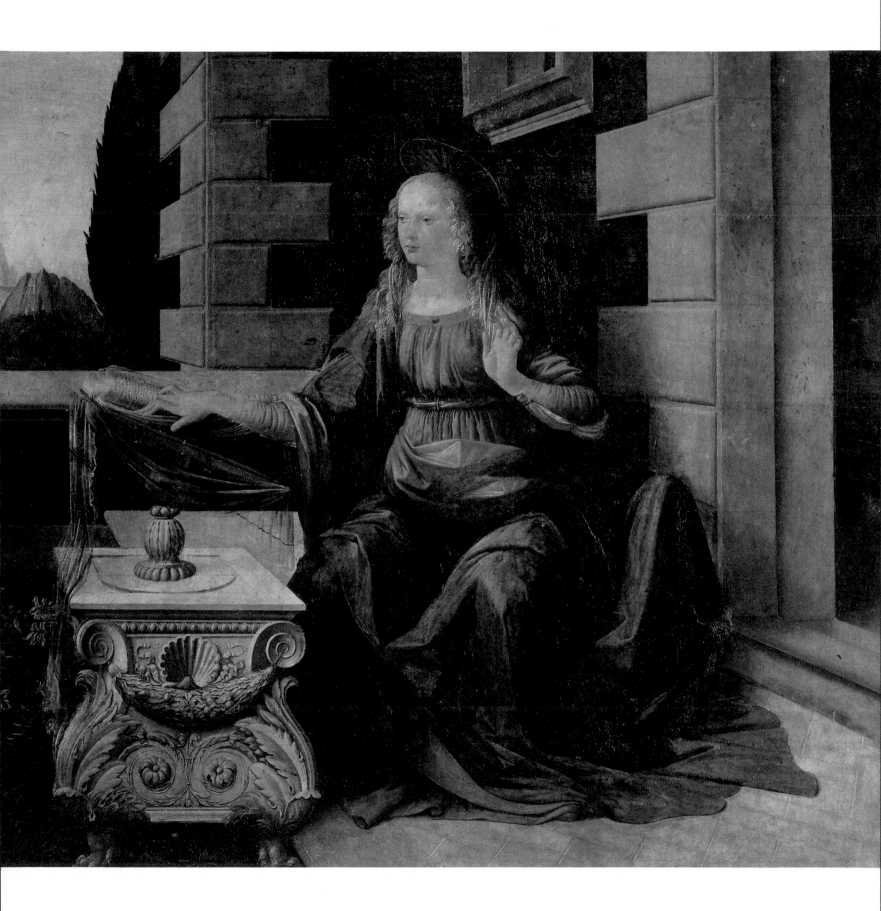

Overleaf

The Annunciation
1472-1475. Oil on wood.
98 x 217 cm. (2 ¹/₂ x 7 ft.).
Florence, Uffizi.

The first work of the twenty-year old
master, this Annunciation is not yet
what one would call Leonardesque.
The composition follows a centuries
old model with the angel on the left,
the Virgin on the right, and a lectern
in between; the whole depicted in
an architectural setting that opens out
onto a landscape. The kneeling angel
is magnificently youthful with his high
forehead, stylized wings, rich clothing,
and lily. The Virgin, surprised while
reading, raises her hand in a gesture
of astonishment, and displays
a fine-featured face which some have
described as cold. Her pose, with
knees evenly spread and covered with
broad and supple drapery, gives her
a strong monumental character.
The product of a collaborative effort in
Verrocchio's studio, this picture is
nonetheless a masterful achievement
and proof of Leonardo's innate
pictorial talent. Everything in this work
is of a high poetic and stylistic quality:
the handling of the figures and
their attributes, the spatial
construction, and the distant trees
and watercourse, which attest to the
artist's enduring love of nature.
Many changes were to come in
his painting, for da Vinci was a tireless
innovator, but this picture would
suffice to rank him among the
greatest.

Opposite

Study of Hands
Silverpoint with white highlights on
cream-coloured paper.
215 x 145 mm. (8 ¹/₂ x 5 ³/₄ in.).
Windsor Castle, the Royal Library.

Preparatory study for the Mona Lisa
(Paris, Musée du Louvre)
or for the Portrait of Ginevra Benci
(Washington D.C., National Gallery).

in honour of Florentine worthies or visiting dignitaries: he
probably worked on the decoration of the processions of
Lorenzo de' Medici in 1469 and of Giuliano de' Medici in 1475,
and very likely also on the festivities for the visit of the Duke of
Milan, Galeazzo Maria Sforza, and his brothers in 1471.

One of his first dated drawings (5 August 1473)
shows that he was left-handed and that he already wrote in his
inverted script (he was equally skilled with his right hand and
would sometimes write from left to right). What can we learn
from this drawing depicting a castle in a mountainous land-
scape? For one thing, it demonstrates his enduring interest in
nature in all its forms and his consistently simple and assured
line. Then there is that marvellous sense of mystery which so
often pervades his work, even if the subject is just a landscape
composition, as here. Finally, and strange though it may seem,
the more closely one looks at this drawing, the more one can
discover shapes which, although ostensibly depicting natural
details, suggest forms of a totally fantastic and imaginary order.
In this respect Leonardo shared the visionary gifts of his great
Northern contemporaries, Dürer and Altdorfer.

In 1476, Verrocchio executed one of his most
beautiful and fascinating works, the sculpture of **David**
(Barghello, Florence). The triumphant youth is well-built, as one
would say today, and harmoniously proportioned, posing with
his left hand resting on his hips while in his right hand he holds
the sword with which he has just beheaded the giant Goliath
lying at his feet, a grisly trophy. The figure symbolizes the
victory of intelligence over brute force. Framed by abundant
curls, the face is surprisingly calm and dignified, although
tinged with irony. The gaze is distant, almost sad, while the
finely-shaped mouth betrays a hint of bitterness.

Many authors, and some important ones (Stendhal,
for example), have claimed that this statue is a likeness of
Leonardo himself. This is not at all improbable. Of all of the
students in his workshop, Leonardo was probably the most
handsome and physically graceful. Descriptions of him mention
that he was of very athletic build, thin, with blue eyes and thick
blond hair. At a time when it was fashionable to dress in long,
dark clothes, Leonardo is described as a paragon of elegance,
tastefully clothed in short garments, almost always sporting the
beautiful rosy-orange colour that graces the houses of
Lombardy and Tuscany.

The year 1476 was a difficult one for Leonardo. On
two occasions – on 8 April and 7 June – he and three of his

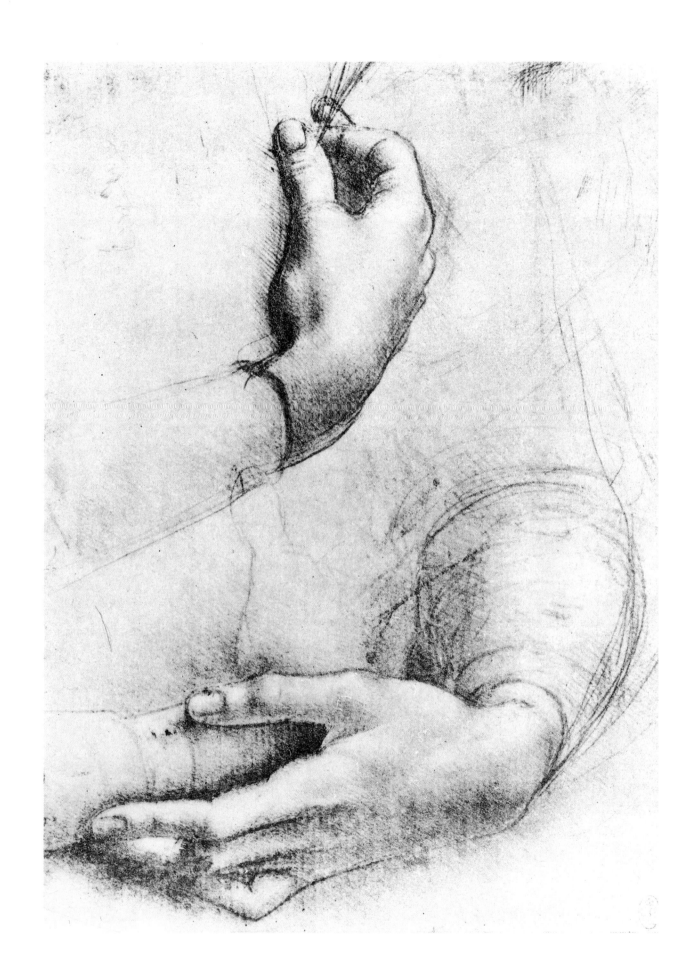

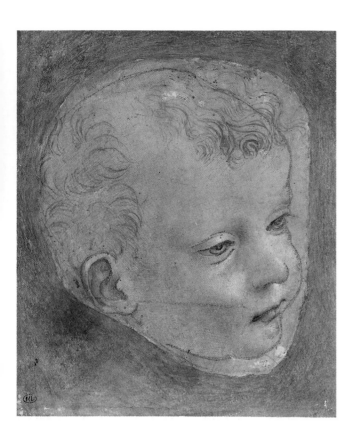

Head of a Child
Paris, Musée du Louvre.

colleagues were denounced for having sodomized a certain Jacopo Saltarelli, aged seventeen, who modelled in Verrocchio's studio, but was also a known prostitute. The denunciation was made in an anonymous note deposited in a special letterbox outside the Palazzo Vecchio which, like the notorious **bocche di leone** (lion's mouths), was intended especially for conveying information to the police.

No proof was forthcoming and, because of the lack of any evidence or testimony substantiating the accusation, the case came twice before the courts within the space of two months. Naturally, it caused a scandal in Florence. In despair, Leonardo wrote a letter to Bernardo di Simone Cortigiano, an influential figure in the Florentine guilds, declaring, among other things: "As I have already told you, I have no friends!" Yet thanks to the intervention of Verrocchio and the families of the other defendants, Leonardo was acquitted on probation. It was a close call: several years later, under the intolerant rule of Savonarola, who thought that homosexuals should be burned at the stake, the same crime in Florence would be punishable by death without any possibility of appeal.

The question in Leonardo's case remains open: was he or was he not a homosexual? Judging from the evidence of his own work, in which many figures, both male and female, seem so androgynous, one might be tempted to answer in the affirmative. But the Saltarelli incident proves nothing one way or the other. Yet another question is why did the gifted young Leonardo suddenly become so melancholic; why, at the dawn of his fame, did he withdraw so deeply into his shell that no information on his affective life has come down to us? Calumny is easily perpetrated when all that one needs to do is to slip a note into a letterbox! Seldom has so well-documented a historical figure so jealously guarded the secrets of his intimate life, causing one author to ask: "Did Leonardo have a sex at all?"[1]

We can follow him closely throughout most of his career, but we know absolutely nothing about his love life. What is certain is that he never married and that he had no children. And we know nothing of any mistress. As for the comely androgynous figures that he was so fond of painting, one can infer what one likes.

The female nudes that he painted, like the figure of Leda in **Leda and the Swan,** are totally carnal creatures, with

1. Guy Rosolato, in **Léonard et la psychanalyse,** 1964.

full, sensual thighs, and alluringly detailed pubic regions that invite the spectator to a contemplation of the charms that seduced Jupiter out of his Olympian reserve. Yet at the same time, their faces always have something that is not wholly natural. They seem to be alien to humankind. Leonardo undoubtedly loved the female body – how else could he have made it so lifelike? But he was also a consummate dreamer. He projected the female form into a never-neverland beyond the facts of physiology, beyond the vortex of sexuality.

How else can we explain that this peerless artist and absolute master of anatomical drawing came to depict a female vulva in one of his drawings in the way that he did? There is nothing prudish whatsoever about this drawing – why? The simple reason is that Leonardo consistently refused to accept sexuality as a flesh-and-blood fact of everday life. He was not drawn to it, and, some have claimed, he was positively repelled by it.

The male sexual organ fared no better in his esteem. The advocates of his deep-seated homosexuality will be able to point out that in one particular drawing Leonardo took great pains to depict the anal sphincter isolated from the rectal cavity. But what they overlook is that this drawing deals – somewhat imperfectly – with the intimate parts of the female anatomy. Why should we today give any credence to psychoanalytic fantasies and to shopworn Freudian scholastics?

Leonardo's bizarre vision of sex and his lifelong aversion to sexual facts appear all the more odd and idiosyncratic when we consider that he lived during a period characterized by untrammelled sexuality and unbridled licentiousness, with members of the clergy openly living with their mistresses and illegitimate children.

Some authors believe that the Saltarelli Affair, which suddenly focused intense public attention on the proud, yet sexually modest, young man and subjected him to shameful police scrutiny – to say nothing of the threat of incarceration – brought on a sort of phobic reaction, an inhibition, from which he never recovered. But these are just so many idle conjectures: attempts to reduce the psychology of an exceptional being to the lowest common denominator and neutralize his discomfiting singularity.

Yet at the same time, those who would make of Leonardo a disciple of the homophilic persuasion, can advance some quite pointed arguments. They can say that, while this "penchant" does not systematically determine genius, it might

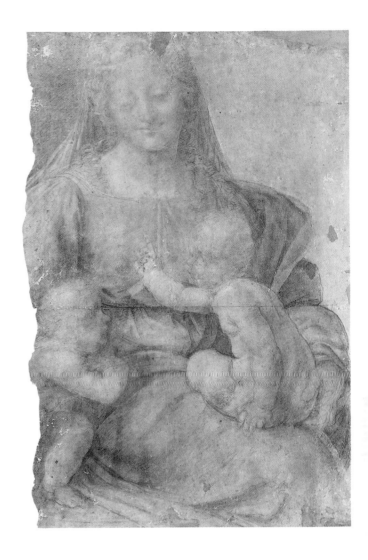

**Drawing of the Virgin
and Child with Saint John**
Bayonne, Musée Bonnat.

account for not a few of his personality traits: his acute sensitivity, his taste for luxury – he was especially fond of precious fabrics – his instability and dispersed activity, and his great loneliness. Although he was a familiar of the great courts of his day, he preferred the company of mediocre figures: his student Francesco Melzi, whose talent was limited – unlike his devotion to his master – and a certain Gian Giacomo Copotti da Oreno, nicknamed Salaï, or "devil," a mischievous wretch whose story will be told later.

The best thing would be to refrain from any conclusion; the enigma of Leonardo the man will no doubt remain forever sealed. And the advocates of one view will never convert those of the opposite view. The question is moot: what matters are the works that he left us and his extraordinary insights.

Although we have scant information about Leonardo's early career as an artist, what we do know seems true to form. Solitary, tending to daydream, little inclined to submit to the discipline of any long-term project, but easily sidetracked by the appeal of a new idea. He saw too much, heard too much, understood too much. He was compelled to go from one topic to another, from one quest to another, never finishing anything before taking up the next thing. This was the story of his life. Between the unfinished works and the lost works, those attributed to him and those rejected outright, what remains of a career that spans forty years?

There are only ten paintings – but what paintings! – and another ten about which there is some doubt. All because this man of countless possibilities so often quit his easel to roam the countryside, to indulge in his thoughts, always fleeing the mundane and the vulgar, constantly drawn from one thing to another, like a Don Juan hopping from conquest to conquest. To be sure, he was enthusiastic, and fervently so, whenever he took up a new project; but before long his initial excitement and interest would invariably wane.

The pursuit of a successful worldly career and attachment to honours and influence were therefore out of the question. Did he view public life and its inevitable political intrigues with scorn? The evidence suggests that he did. He seems to have been acutely aware of the vanity of human ambition, of the meanness of social promiscuity, and of the brevity of human life. He clearly said as much in notations such as: "I thought I was learning to live but I was learning to die," and "Keep the end well in mind, think first of the last."

Study of Infants
Venice, Accademia.

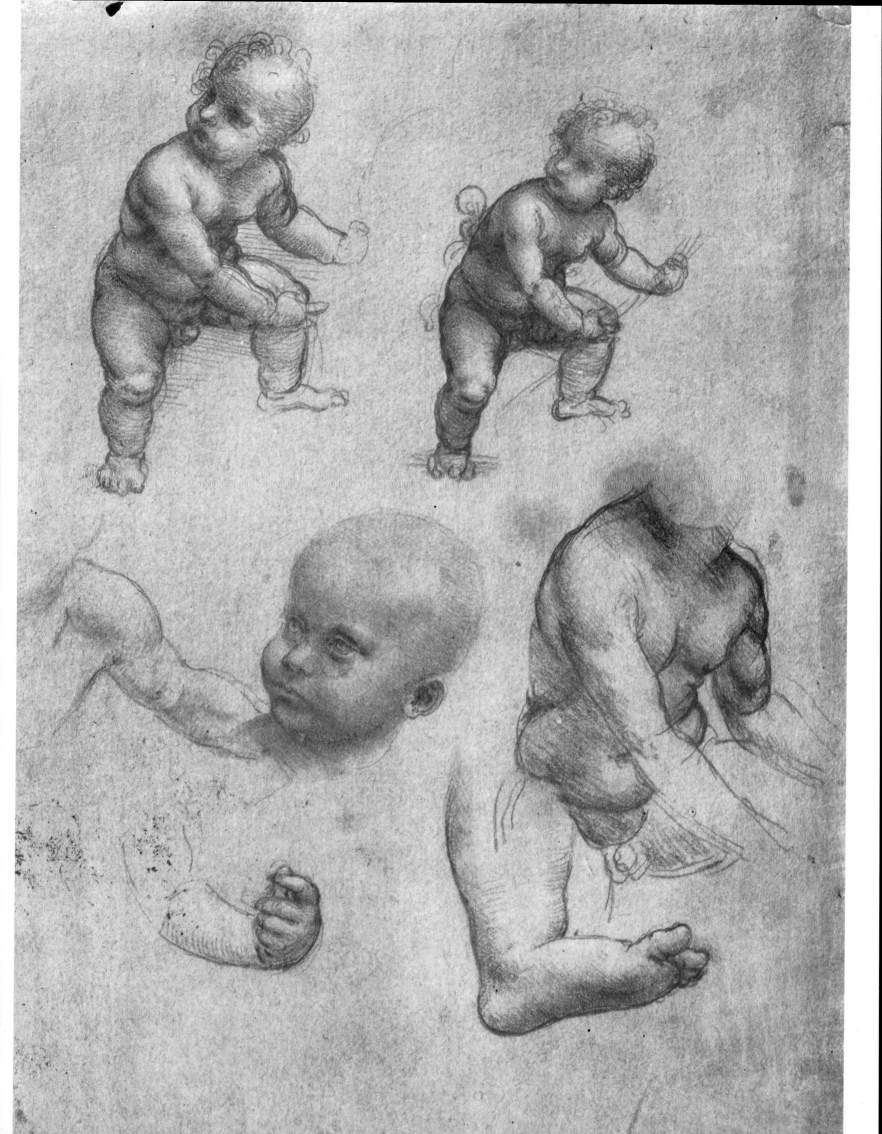

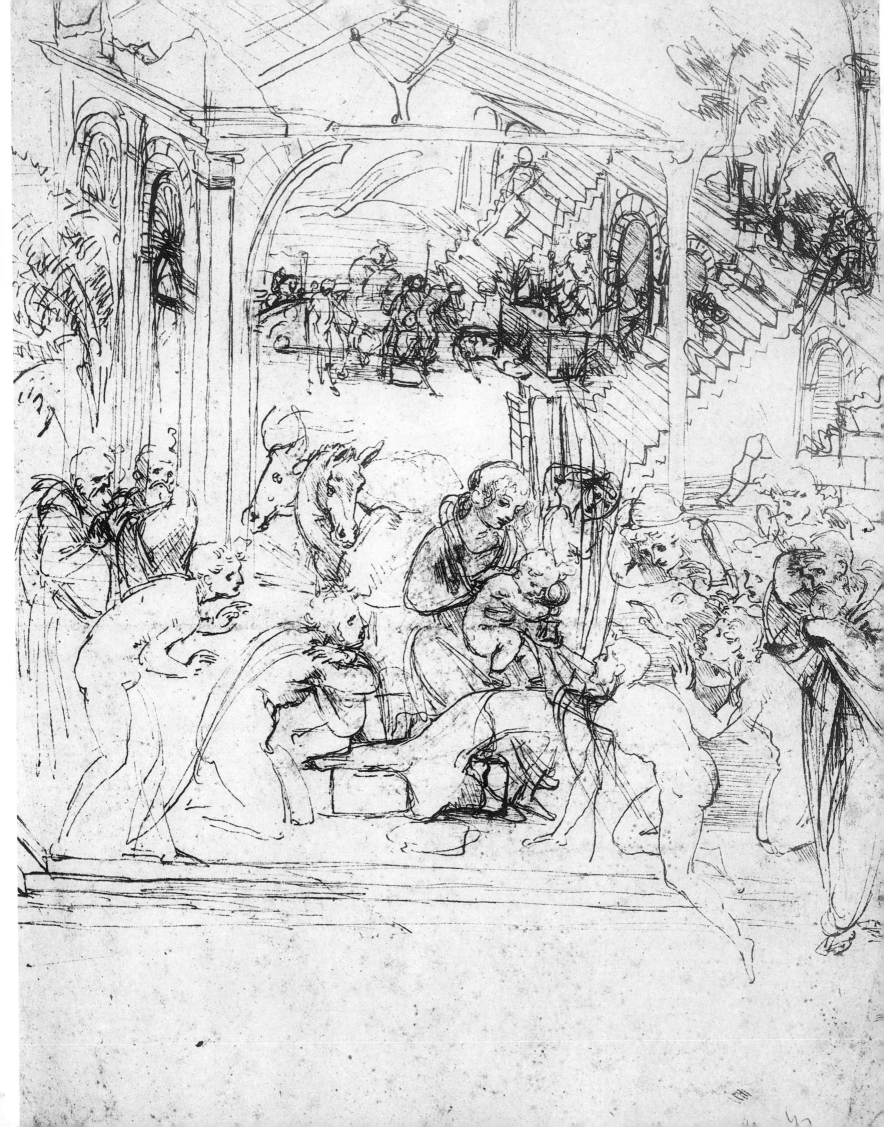

But because of his love of nature, the arts and invention, he was in constant search of enlightened patrons able to give him the means to progress with his intellectual work – and he disappointed more than one. Much has been written of his fundamental instability. But was it really instability? His was a quick mind and he wanted to accomplish too many things, never giving much thought to his social position. No wonder he was chronically poor, and even when he occasionally fared better, he inevitably ran into material problems, because he stubbornly refused to accept the economic facts of life.

He no doubt strove to cultivate his singularity; but very often he came across as a rebellious, atypical person, who made no concessions to appearances, although he did not try to pass this off as the paradoxical expression of genius. Urbane, pleasant and amiable, with a spiritual kinship for the under-privileged, he was not one to hazard a scandal by subjecting his companions to empty harangues. He was totally averse to outbursts and emotional excesses of any kind. Leonardo was different, unpredictable, unwilling to follow any fixed rules.

While he was still employed in Verrocchio's studio, he could often be seen at the livestock market; but not to buy animals for his own pleasure. Although his purse was anything but full, he would often pay high prices for small caged creatures, especially birds. Once the transaction was complete he would simply open the cages and let the unfortunate creatures loose. The birds would fly away, or the cats and dogs run free, while Leonardo would laugh with joy, and the people gaze at him in bewilderment.

He was to repeat this performance often: in Florence, Milan and Rome. And each time he would encounter the quizzical looks of the onlookers, and sometimes insults: "Is he mad?" And the young man with the long blonde hair and the rose-coloured tunic – and later, the old man, somewhat bowed, with white hair covering the fur collar of his mantle – would silently walk away. In his notebook he wrote: "No one has the right to imprison another being, whether man or animal, without due process. God gave to each the gift of freedom, and none can take it away."

Although attuned to the great thinkers of the Renaissance, Leonardo did not believe in the absolute pre-eminence of Man over Nature. We know how much he cared for nature: for him it was a marvellously innocent and pagan reality, the mother of all creation.

Preliminary sketch for the Adoration of the Magi
Pen and ink on paper.
284 x 214 mm. (11 x 8 in.).
Paris, Musée du Louvre,
Department of Drawings (fa. Scala).

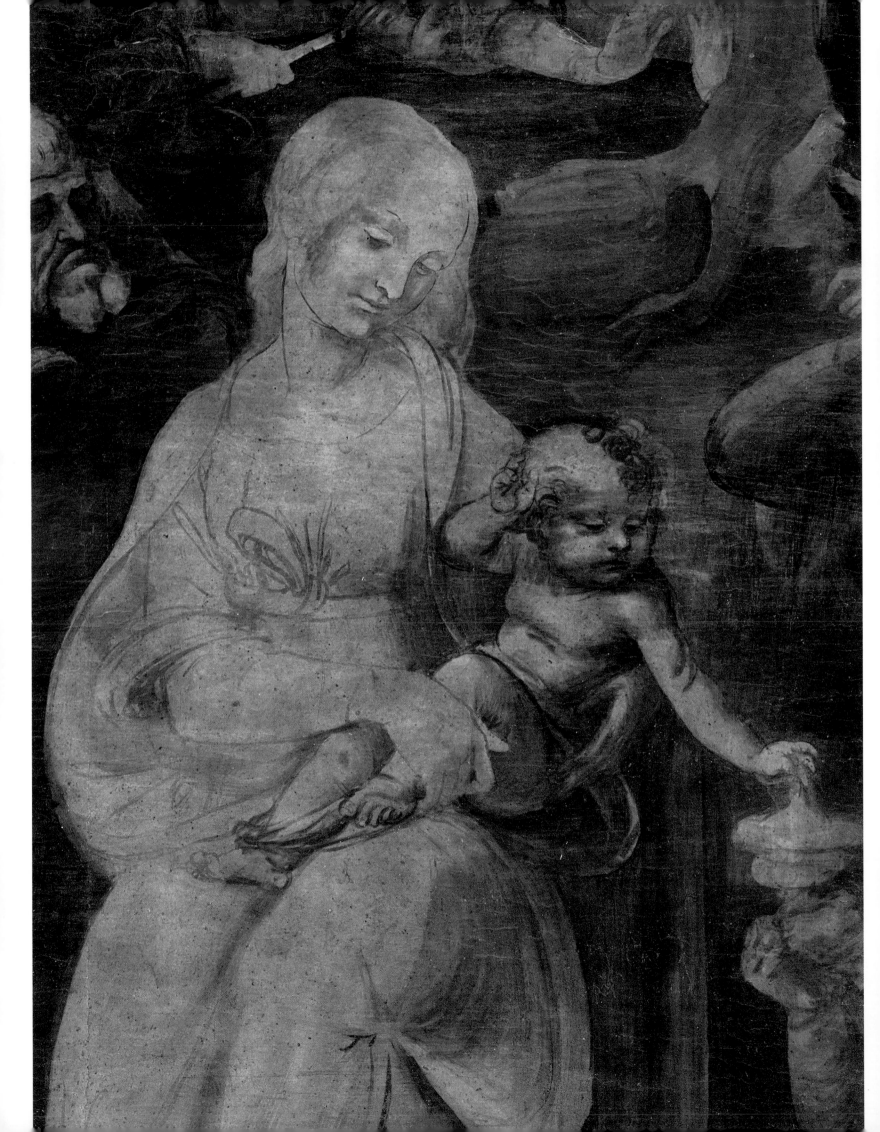

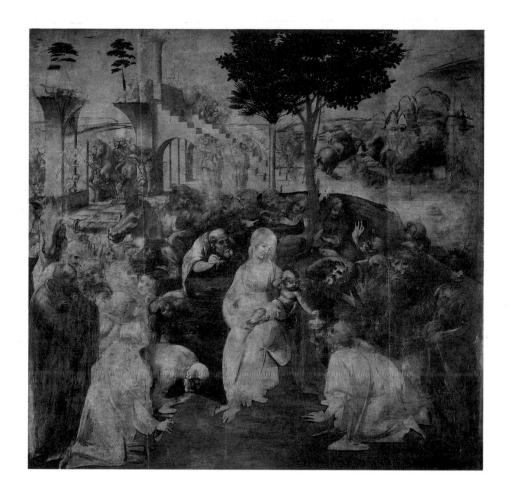

Above and opposite (detail)

The Adoration of the Magi
1481-1482. Yellow ochre and brown ink
on panel. 246 x 243 cm. (8 x 8 ft.).
Florence, Uffizi.

This Adoration of the Magi is perhaps
one of Leonardo's strangest and most
fertile compositions. By combining
figures of pleading old men and
armed horsemen, he transformed
a banal biblical subject into a scene
from human history. At the same time,
he took the technique of non finito
to its extreme. The figures
and architectural elements boldly
delineated and filled out in earth
colours on the five boards that make
up this panel anticipate the type
of sketchwork that will characterize
modern art. This picture is remarkable
for its extreme concentration
and power. Leonardo's contemporaries
erroneously assumed that it was
unfinished.

The Adoration of the Magi

(detail)

1481-1482. Yellow-ochre and brown ink on panel. 246 x 243 cm. (8 x 8 ft.). Florence, Uffizi.

Leonardo's composition includes typical Quattrocento motifs: the palm tree (Verrocchio and Gozzoli), the orange tree (Piero della Francesca), and the staircase (Filippo Lippi and Botticelli). But here they take on a new significance: only by turning away from his animal side (rearing horses) can man elevate himself to another plane of life.

He inclined sometimes toward the Aristotelian point of view, and at other times, but more rarely, toward the Platonic, but not at all toward the biblical conception of Man as the master of all other creatures on the face of the Earth. He believed in God, and often invoked Him: "O Lord, you offer all good things for sale, but for the price of our effort." His God, in any case, was not the deity of the Judeo-Christian tradition. His God was bound by a love of nature and the contemplation of infinite Creation. He never considered himself a privileged agent of some jealous, all-powerful Creator who cared only for mankind and its insane ambition to exercise dominion – by scriptural fiat – over everything that lived and breathed.

If the painter of the **Mona Lisa** seems so close to us in spirit, it is not because he adhered to Judeo-Christian archetypes, which he consistently transfigured, but rather because he was an attentive and keen student of the Western tradition, which was essentially based on the legacies of Athens and Rome. In this respect, he was fully in step with many of his contemporaries who lived in rapt contemplation of the achievements of Antiquity.

The court of Lorenzo de' Medici – dubbed "Il Magnifico" (1449-1492) – was dominated by the life of the intellect. This was the period when Gemistus Plethon strove to resurrect the spirit of Athens, while Marsilio Ficino, Pico della Mirandola and other eminent scholars were convinced that a new humanistic culture would pervade the Western world. Constantinople had just fallen into Turkish hands (1453): a new Athens had to be created! Lorenzo de' Medici, a poet himself and well-versed in philosophy, founded the first academy of Fine Arts.

In 1477, in the wake of the Saltarelli Affair, Leonardo decided to leave Verrocchio's studio. Perhaps he only wanted his independence; for he remained faithful to his master's teaching. Alone, without money or the support of an influential patron, he was reduced to living at subsistence level. He accepted his fate, yet not entirely without ill-feeling, otherwise why would he have written, "I regret not so much being, as being in want." He was, however, able to bear and overcome this adversity, for his quest drew him toward the fount of all human experience. And, besides, he still had some contacts and some solid recommendations. He quickly discovered which doors they would open.

In the following year, after a close contest, Leonardo was awarded the commission for an altarpiece in the

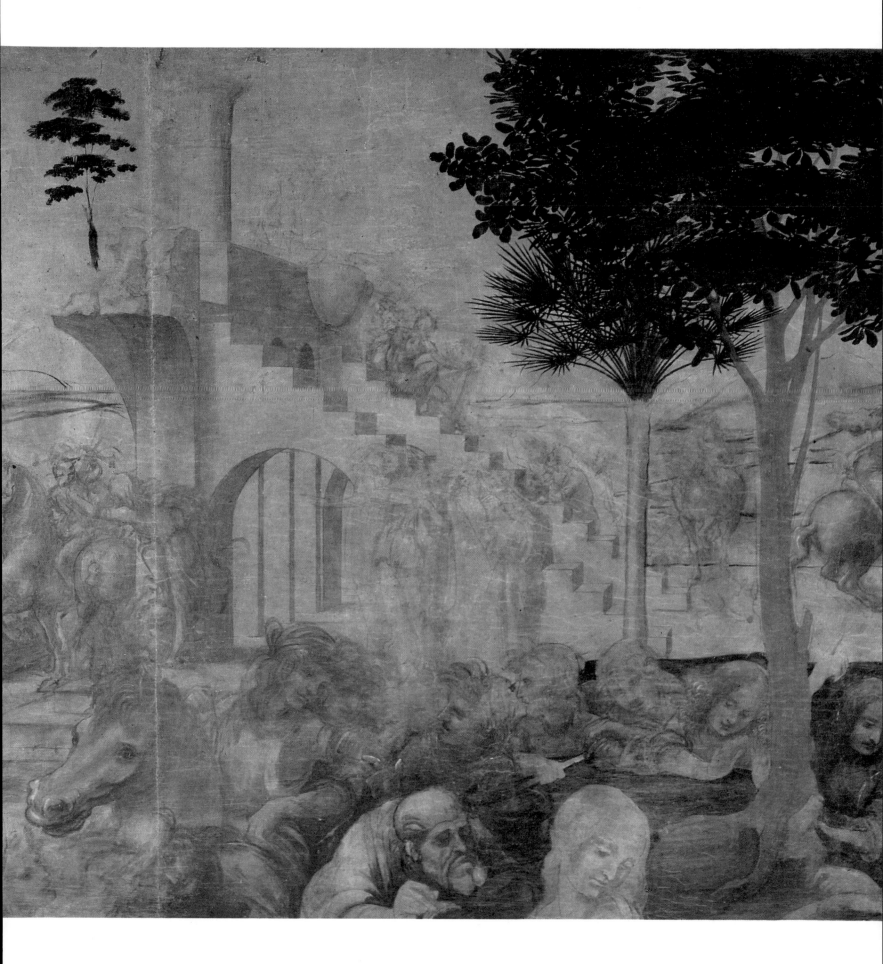

San Bernardo Chapel in the Palazzo Vecchio. Two depictions of the Virgin, the **Benois Madonna** and the **Madonna with Flowers in a Vase**, were probably painted at this time.

Vasari wrote about the second picture: "Leonardo painted a Madonna, a very fine picture that belonged to Pope Clement VII; he depicted, among other things, a vase with water and flowers, so true to life with drops of condensed water on the sides, and so perfectly rendered that it seemed more real than the actual thing."

The background landscape, which can be glimpsed through the dark, but elegantly-shaped windows, is already typical da Vinci with its mountains bathed in shimmering light, under a pale sky that is full of suggestive forms for those who give rein to their imagination.

According to Vasari, he "then had the idea of painting in oils a head of Medusa wreathed with intertwined snakes, a most strange and singular invention. But the project required a great deal of time, and, like most of his works, remained unfinished.

Despite his unreliability, and because his enormous talent was recognized by all, Leonardo was granted another commission in March 1481; but it too was destined to remain unfinished. The monastery of San Donato in Scopeto, not far from Florence, requested an **Adoration of the Magi**. The commission was made official by a contract duly established by Ser Piero da Vinci, stipulating that the painter was to finish the work within a period two years. In return, he would receive one third of an inheritance that had been donated to the friars.

Shortly after the signature of the contract, the monastery gave Leonardo an advance to cover the cost of his pigments. By July, he had requested a further 28 florins. In addition, between July and September, the monastery provided him with wood for heating, flour and wine. Yet Leonardo dragged his feet; once again, he was not satisfied with the commission. He hesitated, made sketches, and, when the monks began making reproaches, promised to speed up the work. But still no altarpiece was forthcoming.

In 1482, when Leonardo turned thirty, he met his first patron: Lorenzo de' Medici, who engaged him, not as a painter but as a sculptor and decorator, to landscape the Medici garden in the Piazza San Marco. In return, he received room and board. Leonardo did not remain long in the service of the Medici. Lorenzo de' Medici was above all an enlightened patron of the literary arts, and while he appreciated the visual

Architectural study with figures for The Adoration of the Magi
Silverpoint, pen and brown ink, and white highlights on paper.
163 x 290 mm. (6 x 11 in.).
Florence, Uffizi,
Dept. of Prints and Drawings.

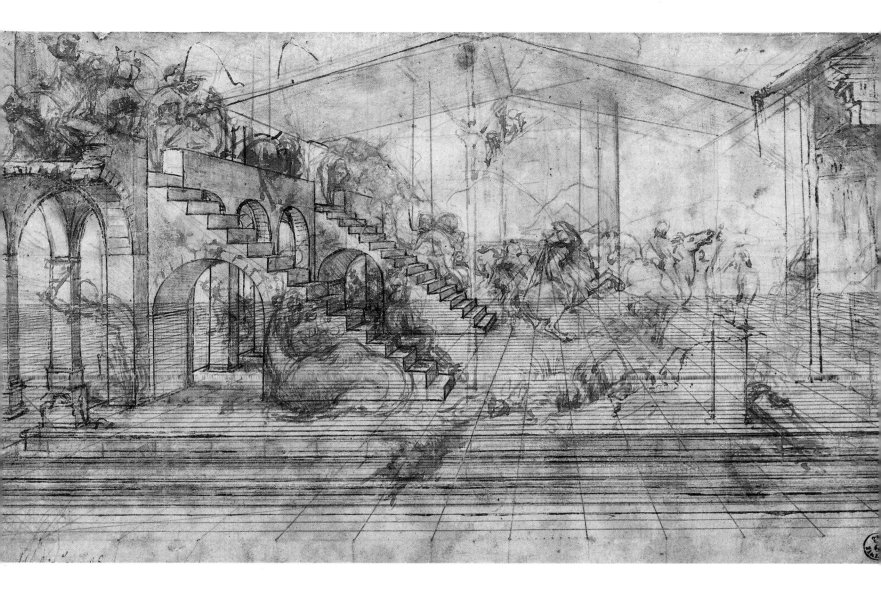

arts as a dilettante, they were never the main focus of his interest.

During this time, Leonardo also studied science and mathematics, although he frequented a court that subscribed to Pico della Mirandola's maxim: "**Mathematicae non sunt verae scientiae**" (Mathematics are not a true science). His taste for the concrete led him in other directions; we know that, at this time, he was an avid student of the works of Roberto Valturio, a theoretician of the military arts and architecture; of Pliny the Elder; of the agronomist Pierre de Crescent; and of the cosmographer Sacrobosco (author of **The Sphere**), to mention only those that he himself has cited. And, because his character was now formed, because he was accumulating vast stores of knowledge that would soon be applied to the most various and daring projects, it is more than likely that he also took a

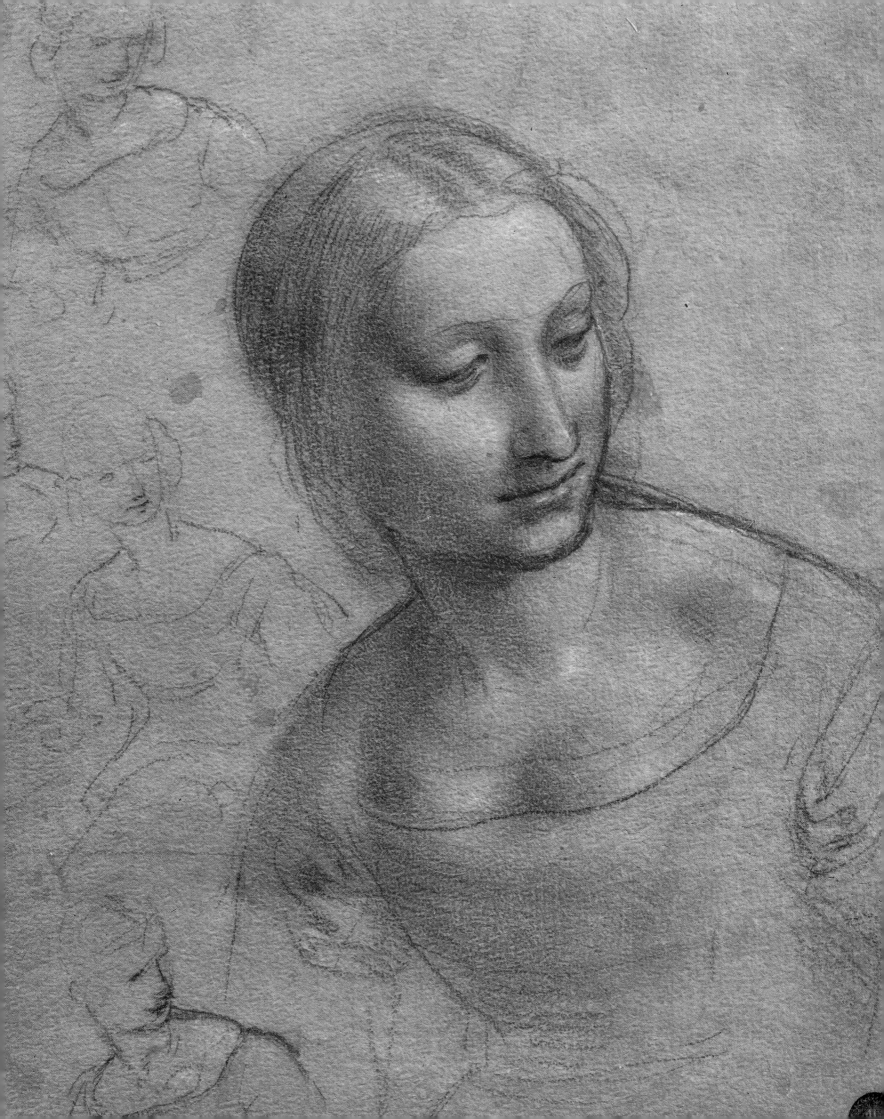

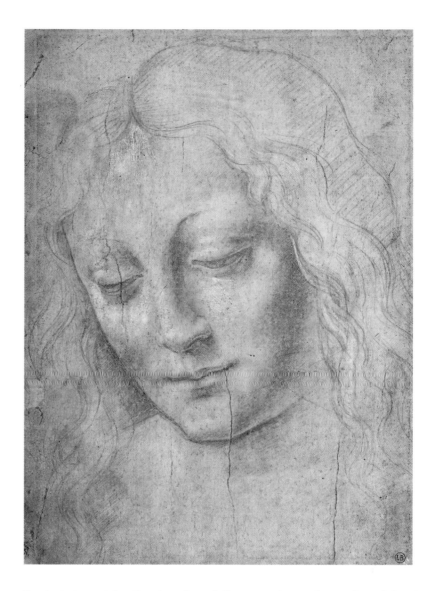

Head of a Woman
Drawing, Bayonne, Musée Bonnat.

Opposite

Head of a Young Woman
Venice, Accademia.

lively interest in the books of the great masters of architecture and warfare, such as Conrad Keyser (1366 - ca. 1405), author of **Bellifortis**, and Mariano Daniello di Jacopo, called Taccola (1381 - ca. 1458), who wrote **The Art of War.** What distinguished Leonardo from all his predecessors in these fields was the exceptional quality of his drawings; it was during this period that he executed his first technical drawings, inaugurating a field of endeavour that contributed as much, if not more than painting to his fame in his own lifetime.

He left Florence without ever completing the promised **Adoration of the Magi.** Nevertheless, according to André Chastel, the incomplete painting is a completely new way of treating the subject. Previously, the theme of the Nativity had always been linked with the angelic revelation to the shepherds and its joyful reception. But Leonardo transformed it into a scene from human history. He depicted a

crowd of surprised and bewildered onlookers. The celestial messengers are depicted surrounding the Holy Family, but they are benign supernatural presences, while all around them swirls a crowd of mortals filled with their faith, doubts, passions and sacrifices, the whole steeped in a singular, golden light. This pure masterpiece, unfinished though it may be, would surely not have the same impact if it had been painted with colours.

One wonders what inspired or compelled his departure from Florence at this time. Perhaps the commissions on which he depended (such as the altarpiece for the San Donato Monastery) did not offer enough of a challenge, and hindered rather than helped him in his quest for freedom. Or perhaps he felt that he would never find his true place in the City of Flowers, which he deemed too academic, too vainly "philosophical" for his taste, and so not open enough to the vast engineering projects that filled his fertile imagination. Or perhaps it was an active – and understandable – desire to see new places and experience life at other courts; or the conviction that he would be better able to express himself, fulfil his potential, and try out his ideas in another city; or the intuition that History was being played out in other, more daring and warlike cities than in the mercantile atmosphere of Florence; or the desire to start life anew, with a clean slate. All of these considerations, to varying degrees, must have a played a role in the final decision made by the thirty-year-old Leonardo.

In those times, the courts of Central and Northern Italy were great concentrations of both power and of culture and still offered the image of medieval city-states constantly engaged in warfare. The ruling figure – prince, duke, pope or cardinal – had the authority to award honours and appointments, and so attracted those in search of protection and favours. During the fifteenth century, the most influential, apart from the Medici court in Florence, was that of the Sforzas in Milan, followed closely in prestige and power by Rome and the Vatican, then the Este Family in Ferrara, and the Gonzagas in Mantua.

The ducal residence in Milan took up the entire centre of the city: it was a huge and mighty fortress, designed to withstand the heaviest assaults – whether from outside invaders or local insurgents – surrounded with moats spanned by sixty-three drawbridges, protected by between fifteen hundred and two thousand of the most highly perfected war machines, and a force of one thousand five hundred well-paid mercenaries.

The Virgin and Child with a Cat
Study for **The Virgin with a Cat**. Pen and ink on paper (with other drawings). 281 x 199 mm. (11 x 8 in.). London, British Museum, Dept. of Prints and Drawings (fa. Scala).

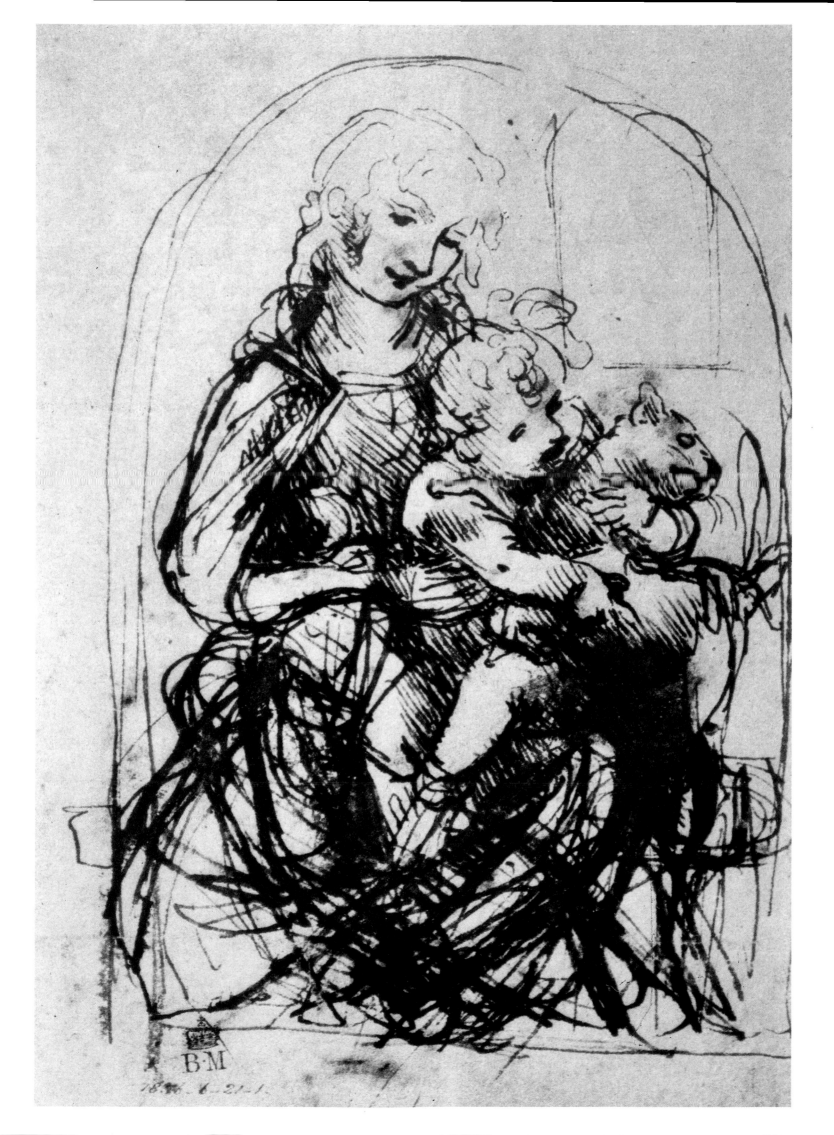

The Benois Madonna

1475-1478. Oil. 49.5 x 31.5 cm.
(19 1/2 x 12 3/8 in.).
Saint Petersburg, Hermitage Museum.

Painted between 1475 and 1478, the
Benois Madonna is one of Leonardo's
freshest and most original early works.
The ease of execution and the
application of colours "in layers, like
dew," are a wonder to behold still
today. Yet this picture has been much
criticized: Bernard Berenson, the
American art historian, was disturbed,
by the Virgin's receding hairline, full
cheeks, toothless mouth and bleary
eyes. The picture's name refers to Léon
Benois, its last owner before it entered
the collections of the Hermitage
Museum in 1914.

And so Leonardo, equipped with a letter of
recommendation in the hand of Lorenzo the Magnificent and a
superb gift of his own making for the duke – a silver lyre in the
shape of a horse's skull – turned his back on his bitter-sweet
youth in Florence and arrived in Milan in 1483.

Ludovico Sforza, also called "Il Moro" (the Moor),
had summoned him not as a painter, but as a sculptor and
bronze-caster, which proves that his fame in these fields was by
now fully and widely recognized. He was to execute an idea
suggested by Lorenzo de' Medici in 1478: a bronze monument
to commemorate Ludovico's father, Francesco Sforza – a project
that, needless to say, would never be completed.

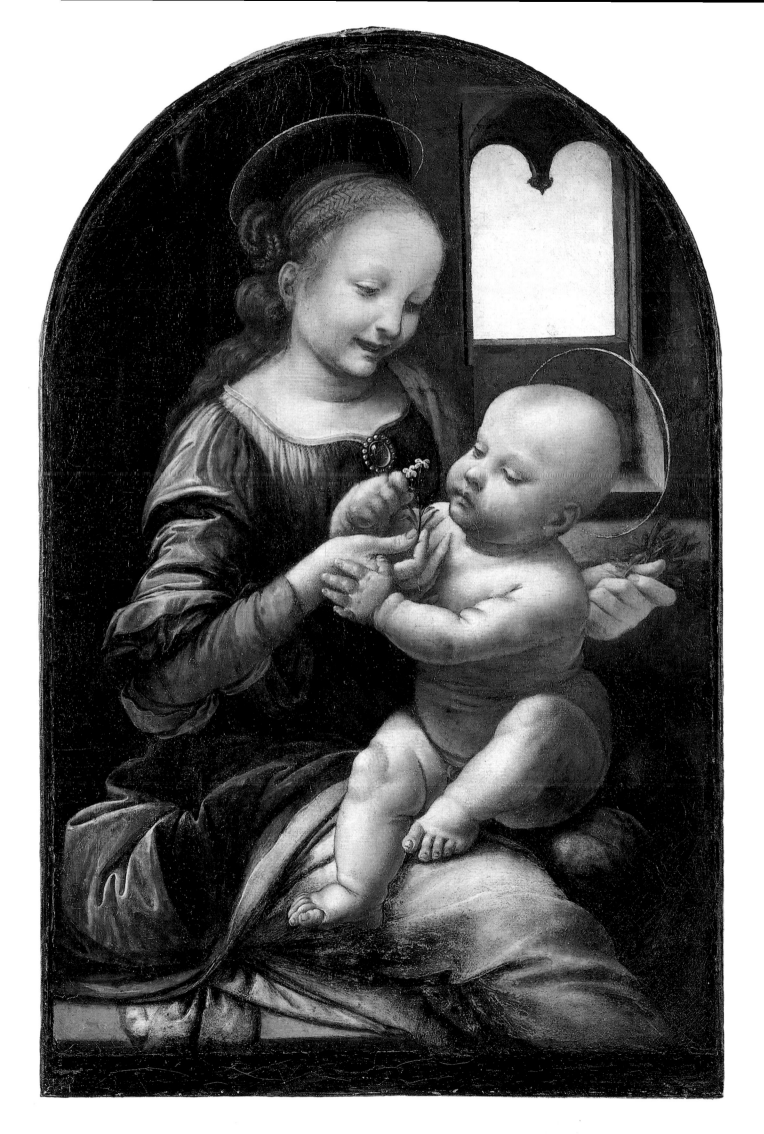

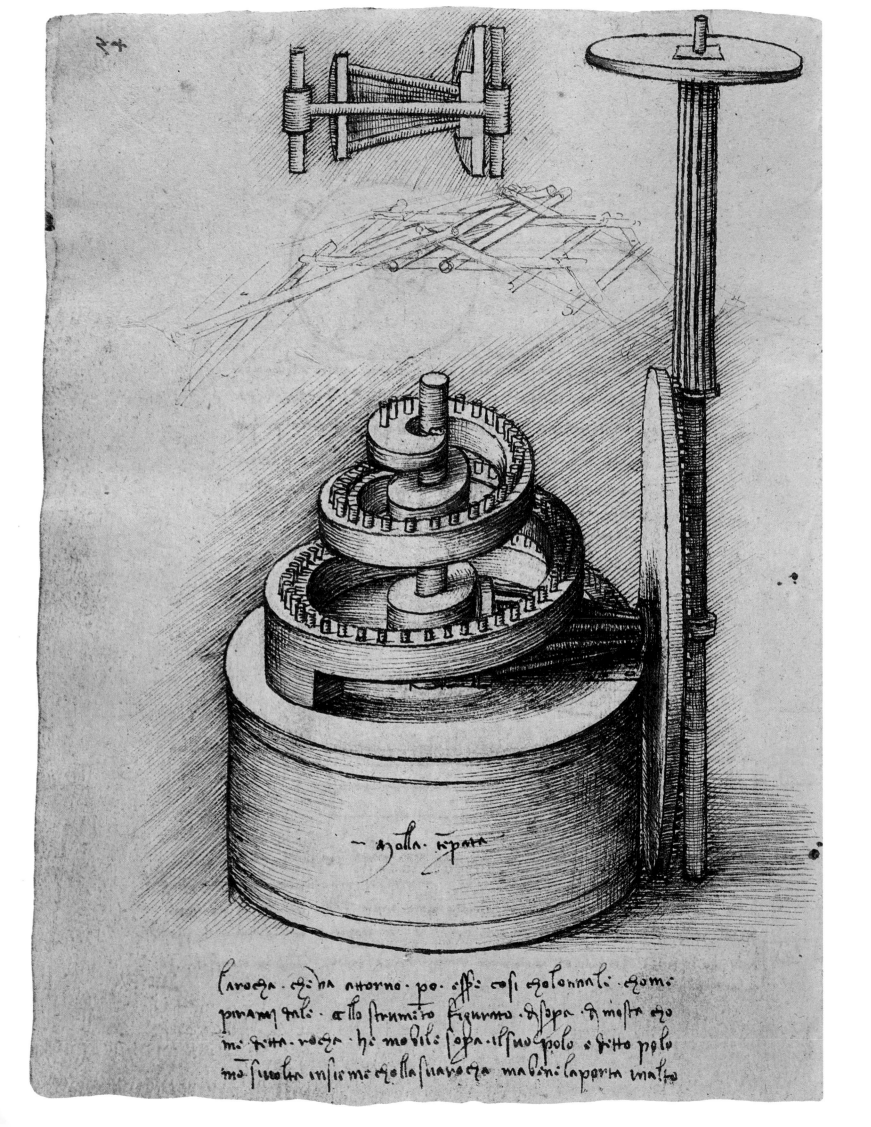

34

molla tepata

la rocha che va atorno po esse cosi cholonnale chome
piramidale allo strumeto figurato disopra dimosta cho
me detta rocha he mobile sopra ilsuo polo e ditto polo
mo sircula insieme cholla sua rocha ma bene la porta malto

3

From war machines to anatomy

With his arrival in Milan, a new period in Leonardo's life began. We may never know if the letter addressed to Ludovico Sforza was really in his own hand, or if he did in fact send it from Florence shortly before his departure. However, the evidence tends to substantiate these suppositions, for what then transpired confirmed Leonardo's desire to be recognized as an engineer.

This famous letter reads as follows:
"Most illustrious Lord,

Having until now sufficiently studied and considered the experiences made by all those who call themselves masters and inventors of war machines, and having found that their machines in no wise differ from those that are ordinarily used, I would make so bold, without meaning to offend anyone, as to address myself to your Excellency to teach him the secrets, and to offer to demonstrate, at his convenience, everything briefly described below:

1. I am able to build very light, robust bridges, that are easy to transport in order to pursue and, if need be, rout the enemy; and others, sturdier still, which are resistant to fire and attack, simple and easy to install and remove. And also the means to burn and destroy those of the enemy.

2. To capture a stronghold, I know how to drain water out of moats and build every sort of bridge, ram, scaling ladder, and other devices for this sort of undertaking.

3. Likewise, if a stronghold cannot be reduced by bombardment because of the height of its glacis or its

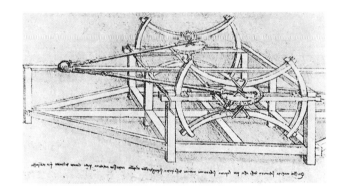

Catapult
Drawing. Codex Atlant. fol. 51 v-b.
Milan, Biblioteca Ambrosiana.

Opposite

Gears
Madrid, Biblioteca Nacional.

Gears played a major role in the machines invented by Leonardo. While he frequently resorted to types of gears that were already in use (with triangular teeth, pegs, etc.), he was the first to take such problems as friction and efficiency of transmission into consideration.

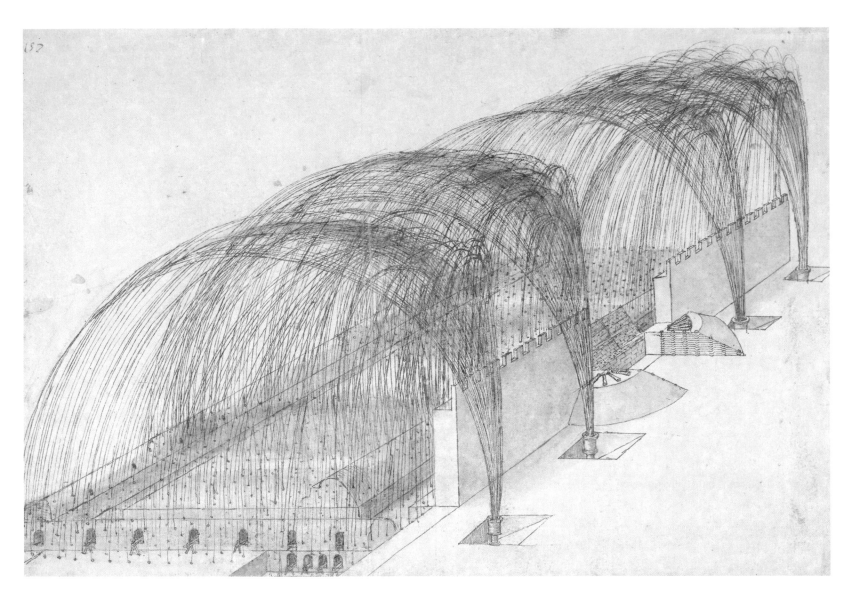

Bastio under mortar fire

Drawing. Windsor Castle, the Royal Library.

Covered assault vehicle (Tank)

Drawing. London, British Museum.

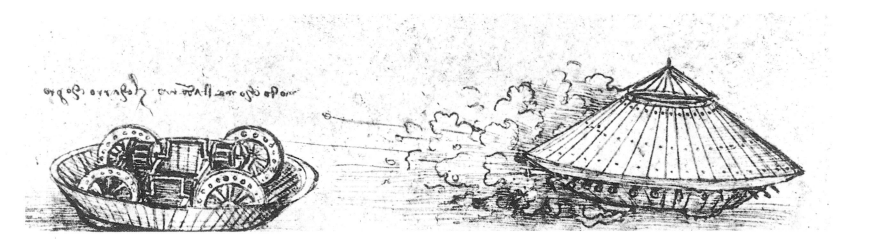

commanding position, I am able to destroy any citadel or other stronghold if its foundations are not built on rock.

4. I also have bombardment devices that are convenient and easy to transport, that hurl rocks as thickly as hailstones, creating great terror in the enemy with their smoke, as well as extensive damage and confusion.

5. And if perchance the engagement take place at sea, I have plans for constructing devices well suited for the attack or defence of vessels that are resistant to the fire of the biggest bombards, to powder and to smoke.

6. Likewise, I have the means to reach specific places through underground tunnels and passages, constructed without noise, even if they must be dug under moats or rivers.

7. Likewise, I will construct secure and unassailable covered wagons that will break enemy lines with their artillery, and there is no company of men at arms large enough to resist them; thus the infantry will be able to follow them unharmed and without encountering any obstacles.

8. Likewise, if necessary I will make bombards, mortars and cannon of very fine and useful shapes, completely different from the ones commonly used.

9. Where the use of cannon is impossible, I will construct catapults, ballistas, **trabocchi** and other machines of great effectiveness that are in general little used. In short, as necessity dictates, I will construct an infinite number of devices for attack and defence.

10. In times of peace, I believe myself capable of giving entire satisfaction to you, whether as an architect for the construction of public or private buildings, or for the channelling of water from one place to another.

Likewise, I can execute sculpture in marble, bronze or terracotta; and in painting no one can surpass me.

Furthermore, I will undertake the execution of the bronze horse that will bring immortal glory and eternal homage to the blessed memory of the Lord your father and to the illustrious house of Sforza.

And if any of the things mentioned above seem impossible or impractical, I shall demonstrate them in your park or any other place that may please your Excellency, to whom I commend myself with all due humility."

What this letter demonstrates most clearly is, not only Leonardo's amazingly rich spirit of invention, but also, and

Overleaf

Chariots armed with scythe-blades
Turin, Biblioteca Reale.

Below

Model of a tank
made after Leonardo da Vinci's plans.
Vinci, Museo Vinci.

An armoured, four-wheel vehicle to be driven by man- or animal-power thanks to a system of crankshafts and pivots. Holes at the base permitted the firing of cannon. A turret at the top permitted observation. It was only when the internal combustion engine was invented that such devices finally become feasible.

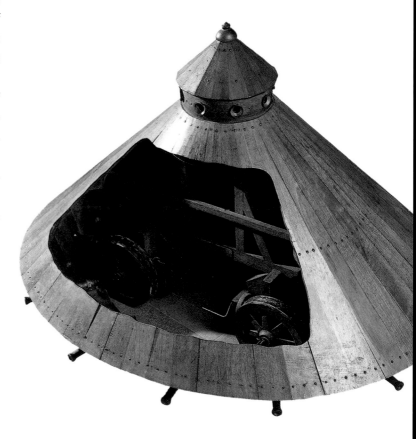

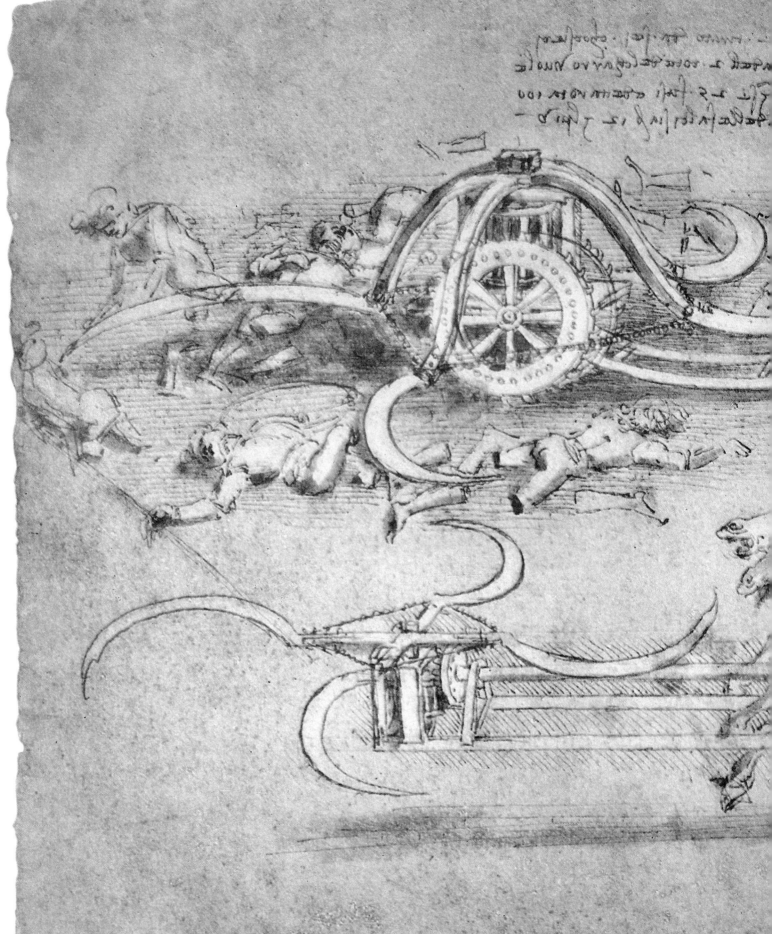

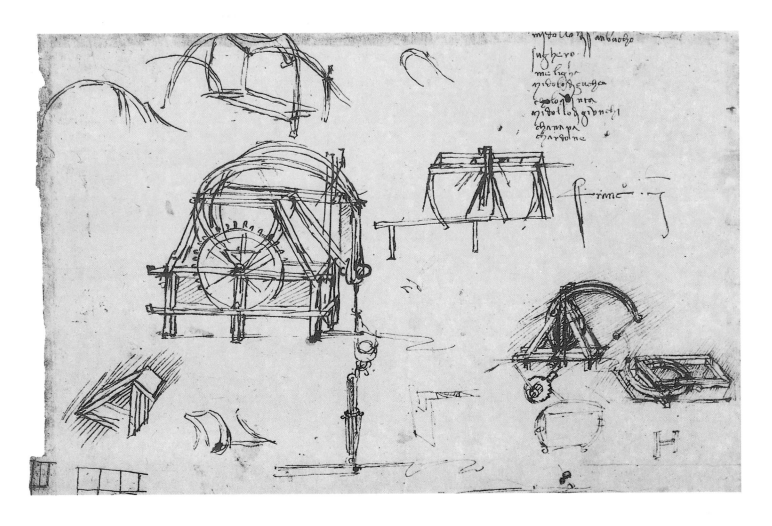

Perpetuum Mobile

Study for a perpetual motion device.
Milan, Biblioteca Ambrosiana.

Leonardo still thought that all motion
was transitory. "Any activated thing
cannot have a long effect; for, if the
causes are absent, so are the effects."
(Ms A. fol. 22). The idea that motion
could be perpetual in a vacuum never
occurred to him because he did not
believe in a vacuum. The elimination
of friction and resistance caused
by the ambient medium was one
of Galileo's major contributions
to the problem of perpetual motion.
Leonardo, however, did discover
two principles of Classical Mechanics:
the Principle of Inertia,
and the Principle of Reaction
(today called Newton's Principle).

perhaps especially, his command of the art of selling himself to
a new patron, who in this case was wealthy, powerful and
receptive to technical innovation and daring.

Within months of establishing himself in Milan, after
arriving there impoverished and somewhat embittered,
Leonardo experienced a sudden upward turn in his fortunes,
and lived a comfortable and carefree life in a ducal court that
prided itself upon its two hundred servants. He was free to
wander in the castle gardens and in the surrounding
countryside at his leisure. In return, he provided his patron with
an impressive number of detailed plans for war machines,
some directly inspired by his long letter of introduction, and
others improvised according to the fancy of his tireless pen.

Yet although undoubtedly relieved at not having to
submit to any financial inquisition to account for his income, as
he had to in Florence, he was rarely satisfied, and we may well
imagine that he soon regained his appetite for solitude and his
own research. The landscape around Milan did not inspire him
much; it was too featureless, devoid of the relief and rolling hills

that graced his native Tuscany. But he made do with it for a while and used its canals and marshlands as proving grounds for his engineering skills.

He roamed everywhere, through the outlying towns and villages, searching for interesting faces for his paintings. He would capture their features in quick sketches wherever he happened to be, in taverns or along the wayside. Should he be without pencil and paper, he would hurry back to his modest studio and draw them from memory with an unerring ability to perceive and capture their inner lives. As Vasari wrote, "He was so fond of seeing bizarre heads and faces, with beards or with dishevelled hair, that he would spend the whole day following someone who had caught his eye. His mind was so observant that, back in his workshop, he could draw them as if they stood in front of him."

As for his audacious inventions in the military arts, however far-fetched his elucubrations, they should not be treated with too facile an irony. In expounding on and boasting of his ideas and inventions in the field of armaments, Leonardo was not indulging in any personal folly. As the British art historian Sir Kenneth Clark has pointed out: "During the Renaissance in Italy, the art of warfare was the most important of all the arts, and it marshalled the services of the most skilled artists. Already around the beginning of the fourteenth century, Giotto made drawings of fortifications for Florence. Michelangelo drew updated ones during the siege of 1529. The casting of cannon, above all, required expertise and a knowledge of metals that was to be found only among the most experienced artisans."

Henceforth, Leonardo wanted to work and live primarily as an engineer. The rest was mere research, whether intellectual or artistic. If he sketched flowers, painted frescoes, or engaged in geological studies, it was the result of his enduring attachment to the teachings of Verrocchio.

Obsessed by the workings of gears, he designed a mechanical grill, a press, a sort of automatic cart "permitting the transportation of people," and a viol that already bore a strong similarity to the violin. Noting the ineffectiveness of existing tools, he also designed a drill, a lift, and a welding torch.

Nor was he especially averse to lazing around in his bed. Anxious and tormented by his imagination, he was only fully awake in the evening and at night.

In 1485, Leonardo also made his first sketches for the construction of a flying machine. For safety reasons,

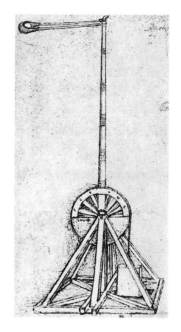

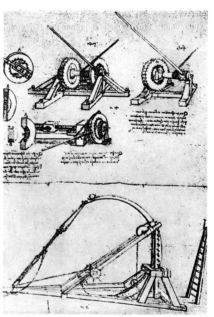

Above

Machine for projecting rocks
Drawing. Cod. Atlant. fol. 57 a-b.
Milan, Biblioteca Ambrosiana.

Below

Study for catapults
Drawing. Cod. Atlant. fol. 53 a-b.
Milan, Biblioteca Ambrosiana.

however, he recommended that the trials be conducted over a stretch of water. In that same year, he was fortunate enough to observe an eclipse of the sun, and devised a method for observing it without injuring the eyes.

He began to think about abandoning his artistic activity to devote himself exclusively to industrial projects. Wanting to revolutionize the production of textiles, he built a machine to mass-produce needles and drew plans for new types of looms. Once again, however, all of these efforts came to naught. But nothing abated his creative fervour; setbacks only spurred him on. He designed a rolling mill for metalwork, submitted his plans to Ludovico Sforza but received no reply. No matter, he went on studying mechanics and took a lively interest in ball-bearings, creating very elaborate designs that were about two hundred years ahead of the technology of his day.

His genius found outlets in plans for new cities and other projects of equally ambitious scope such as an underground sewer system and a ventilation system to clean the air in Milan.

Although there are no conclusive documents on this point, it is very probable that he also collaborated on construction projects in Milan – of which there were many. Yet, he does not seem to have exercised any decisive influence. Ludovico Sforza already had his own appointed architects and engineers to oversee major projects, notably Bramante and Bertola da Navate. If Leonardo was one of them, he must have played a secondary role.

From 1484 to 1486, Milan was struck by the plague, but our aspiring engineer was spared. As always, he subsisted on great utopic schemes and drew plans for modern, even "futuristic" cities, that would be both healthy and beautiful. And all the while he researched and tested fortifications and defence systems of all kinds.

It is easy to imagine him inundating his patron with his audacious projects. He designed and coordinated stage sets and machinery for the court entertainments. In 1489, he brought the full weight of his experience and inventiveness to bear on the preparations for the spring wedding of Gian Galeazzo Sforza, son of the Duke of Milan, and Isabella of Aragon, creating a series of mechanical devices that astounded his contemporaries. Sparing no efforts to ensure the success of the festivities, he put aside his painting, drawing and beloved inventions, and devoted himself wholeheartedly to the under-

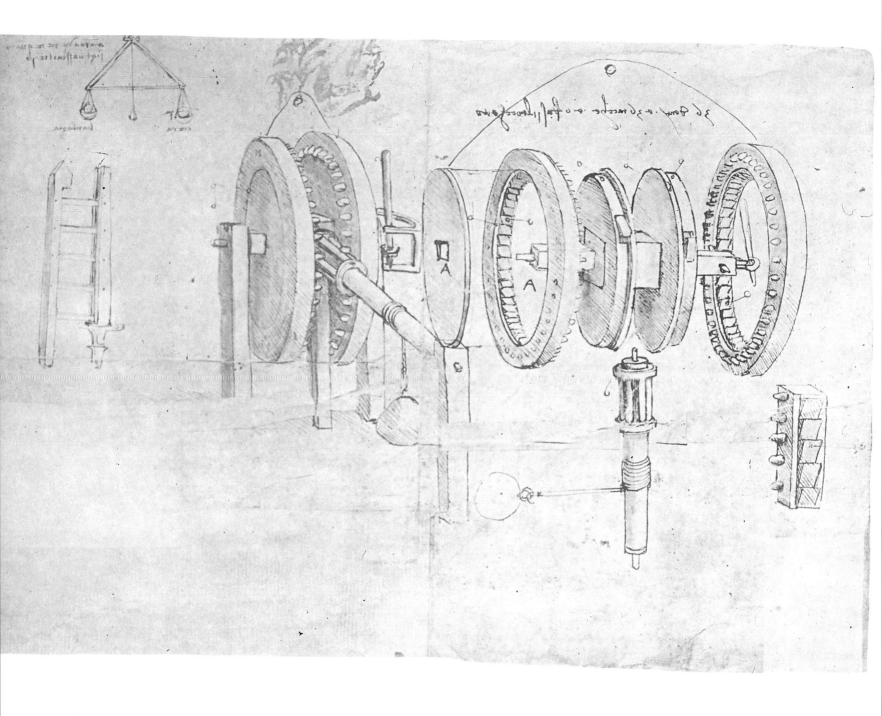

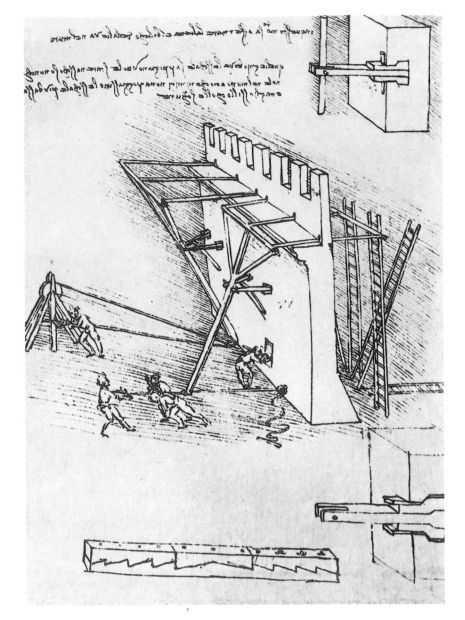

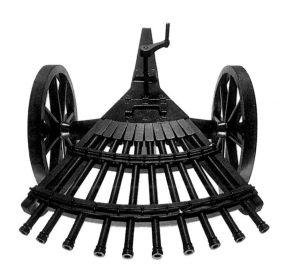

Fan-shaped multi-barrelled gun
Scale model made after Leonardo da Vinci's plans. Amboise, Clos-Lucé.

Da Vinci was the first to have the idea of a machine gun that could fire over a wide area – a deadly weapon against advancing troop formations.

Above, right

Fortifications
with devices to repel storm ladders.
Cod. Atlant. fol. 49 v-b.
Milan, Biblioteca Ambrosiana.

taking. He saw it as an unusual challenge: was there any human activity, even the most frivolous, that he could not master?

Leonardo was entrusted with organising and staging the nuptial ceremonies, and the ensuing extravaganza was the product of his imagination alone: the divine Empyrean realm was represented by a hemisphere crowned by the mobile circle of the Zodiac, while a machine he had invented caused the seven planets to sing and Apollo to appear. It was both a sublime allusion to the **Timaeus**, one of Plato's most famous dialogues, and the culmination of a long tradition going back to the engineers of the school of Alexandria. He probably found ideas in treatises from Antiquity or the works of Arabian authors and perfected them in the process. But no one could rival his genius and powers of imagination.

The most famous festivities entitled **Il Paradiso**, or Paradise, were held on 13 January 1490. Leonardo made full use of his art, techniques and mastery of mechanics. In the grand reception hall of the ducal palace, he built a mountain

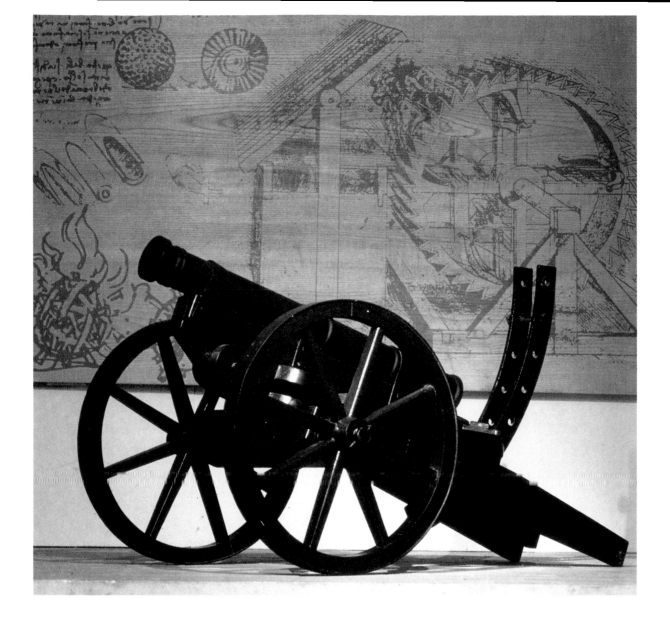

Model of a cannon
made after Leonardo da Vinci's plans.
Amboise, Clos-Lucé.

crowned by a sort of giant egg. Several automats allegorizing the human race sang the praises of the Sforza family while the egg rotated on its own axis and finally opened to reveal the seven planets and personifications of the twelve signs of the Zodiac, followed by figures of the Graces, the Virtues, Nymphs, Hermes, Jupiter and Apollo. Ludovico Sforza and his court remained for many a day under the spell of their genial magician.

This impressive success was his first consecration on such a grand scale. It lent official weight to a fact that none could doubt any more: Leonardo was equal to any task. A master of painting, architecture and marvellous mathematical formulas, he could animate great masses of metal or stone, where none could have imagined that motion was possible.

During this same period in Milan, Leonardo executed two paintings: the unfinished **Portrait of a Musician**, which is his only known male portrait and believed to depict Franchino Gaffurio, the choirmaster of Milan Cathedral; and the **Portrait of Cecilia Gallerani**, the seventeen-year-old mistress

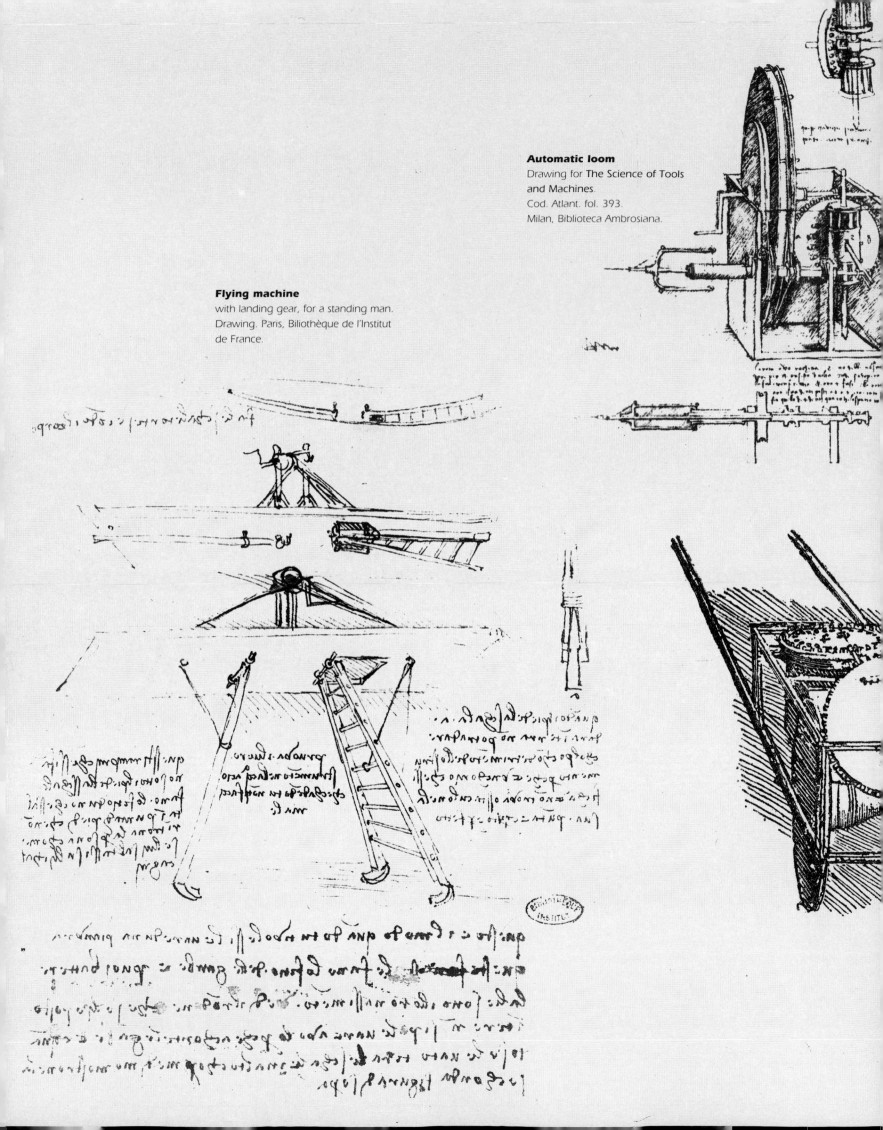

Automatic loom
Drawing for The Science of Tools
and Machines.
Cod. Atlant. fol. 393.
Milan, Biblioteca Ambrosiana.

Flying machine
with landing gear, for a standing man.
Drawing. Paris, Biliothèque de l'Institut
de France.

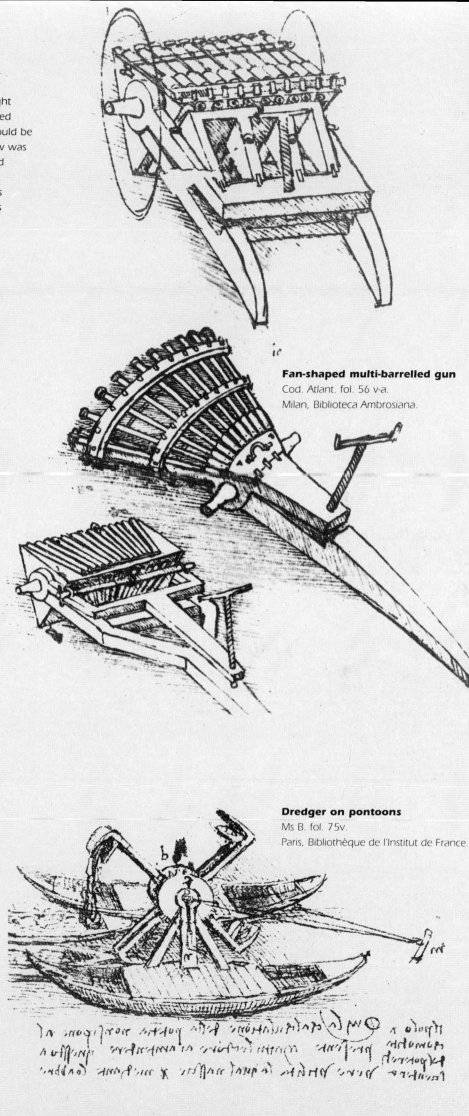

Multi-barrelled gun

Cod. Atlant. fol. 56 v-a.
Milan, Biblioteca Ambrosiana.

Da Vinci lined up thirty-three light
cannon barrels on a prism-shaped
drum, so that eleven cannon could be
fired simultaneously. As one row was
fired, another could be reloaded
and the third allowed to cool.
This weapon anticipates "Stalin's
organs," used to project missiles
during World War II.

Fan-shaped multi-barrelled gun

Cod. Atlant. fol. 56 v-a.
Milan, Biblioteca Ambrosiana.

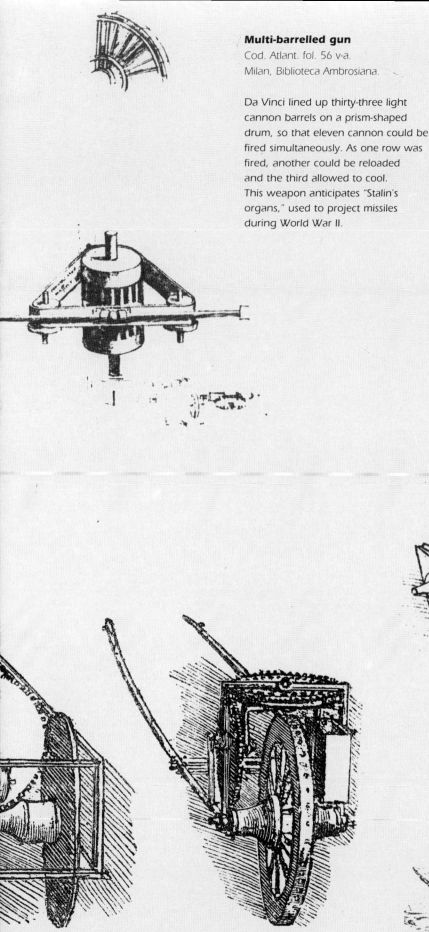

Dredger on pontoons

Ms B. fol. 75v.
Paris, Bibliothèque de l'Institut de France.

Metric gauge

Drawing. Cod. Atlant. fol. 394 v-a.
Milan, Biblioteca Ambrosiana.

The movement of the wheels turns
a horizontal notched platform
with holes in it; with each full turn,
a marble falls into the box, permitting
the distance covered to be measured.

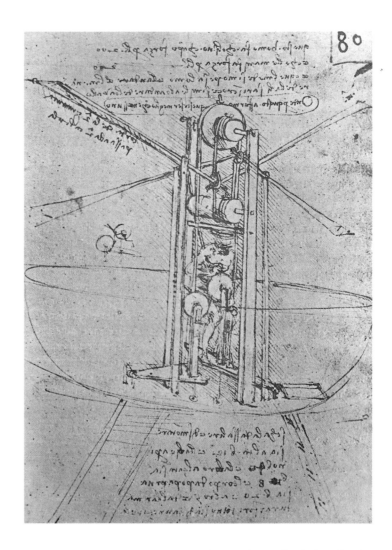

Study for a flying machine with four wings

for a man standing. Cod. B. fol. 80v. Paris, Bibliothèque de l'Institut de France.

The pilot had to activate the wings by pushing a shaft with his head, manoeuvring two cranks with his hands, and bearing down on a bipedal platform with his own weight: the result was a driving force of 200 kilos.

of Ludovico the Moor, a picture traditionally called the **Lady with an Ermine**.

Cecilia Gallerani was famous for her beauty, grace and wit, and dominated the court of Milan for ten years. The white ermine which she holds in her arms symbolises her legendary chastity. The smooth, even brushwork is harmoniously combined with Leonardo's precise drawing style to a degree rarely achieved in his other paintings.

Leonardo had an enduring interest in the human body leading him to study the functions of its organs in detail by devoting himself with characteristic zeal – and with the express permission of Ludovico Sforza – to the dissection of corpses, which did little to enhance his reputation as a normal citizen. Indeed, a man who could plunge his hands deep into the cold entrails of corpses could scarcely be anybody's idea of a "good Christian!" Rumour had it that he reeked of death, and that he kept in the rooms where he lived the human remains that he drew with such extraordinary precision. When evaluat-

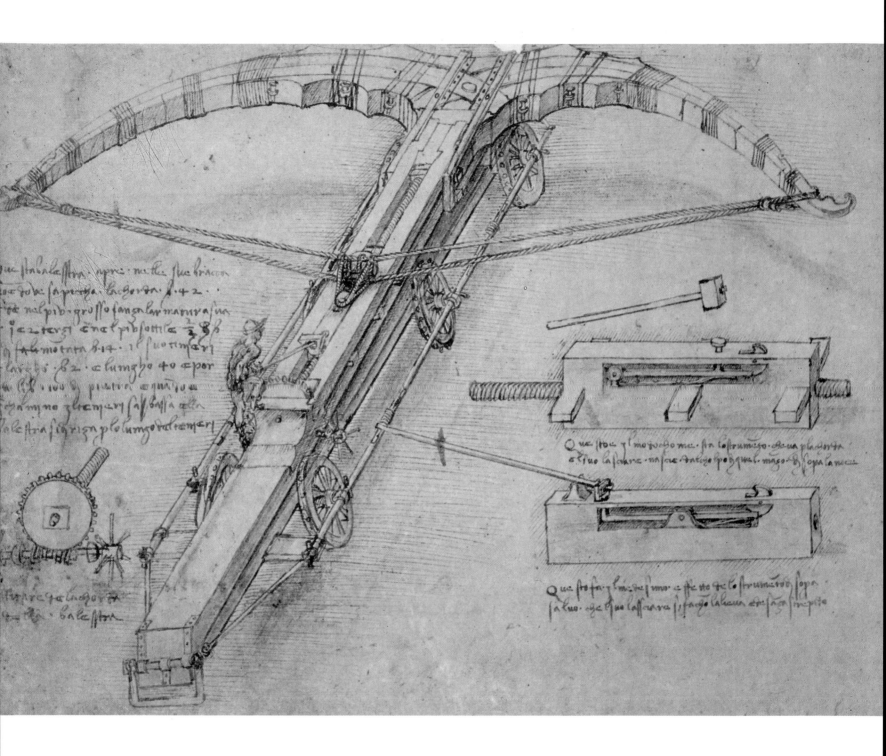

Giant ballista
on a chariot with tilted wheels.
Around 1499.
Cod. Atlant. fol. 53v. a-b.
Milan, Biblioteca Ambrosiana.

**Study for the Portrait
of a Musician**
Drawing. Paris, Bibliothèque Nationale.

Opposite

Portrait of a Musician
possibly Franchino Gaffurio
1490. Oil on wood. 43 x 31 cm.
Milan, Pinacoteca Ambrosiana.

The only known portrait of a man
painted by Leonardo. The sitter was
probably the Choirmaster of Milan
Cathedral, Franchino Gaffurio, a friend
of the painter's. He is depicted holding
a musical score. Only the face and hair
are finished; the rest has been left in
the state of an advanced sketch.
With its brisk handling
and psychological penetration, this is
one of Leonardo's most unusual
portraits.

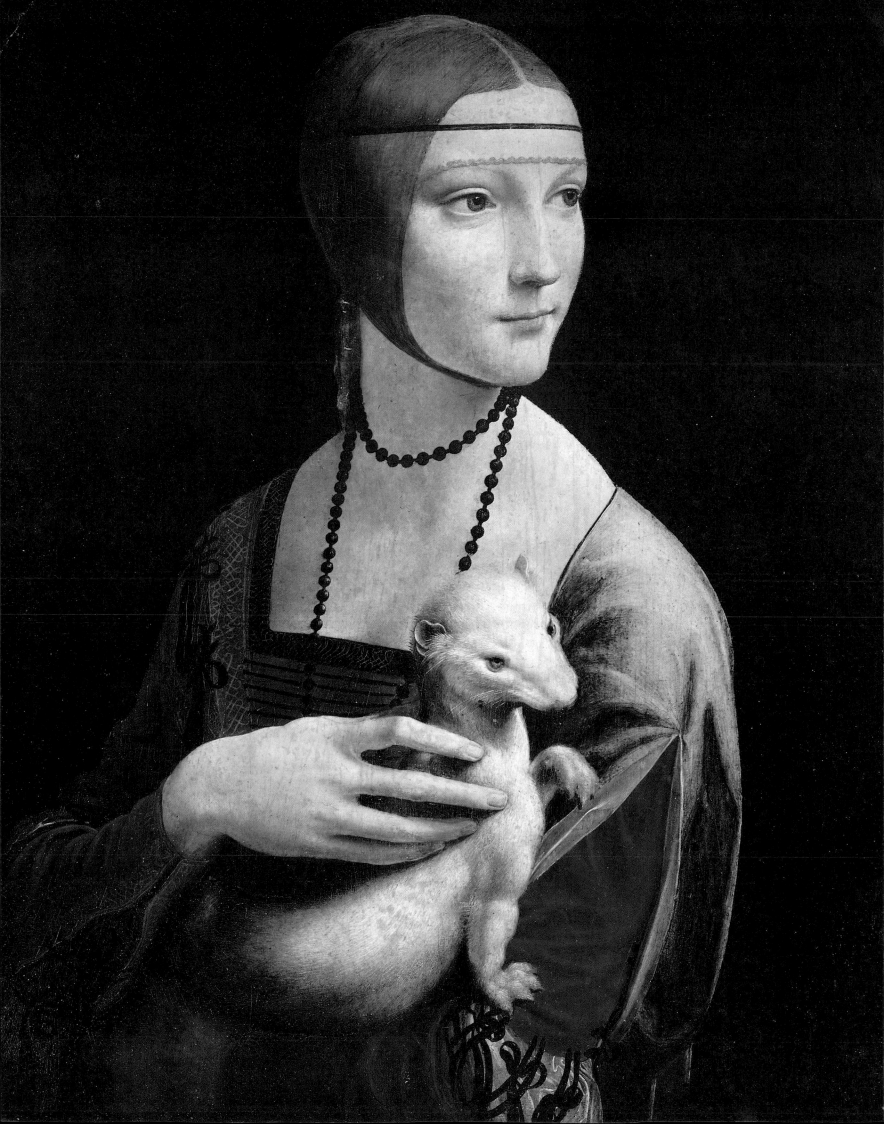

ing the results of his scientific activity, he calculated with some pride that he had dissected thirty corpses to discover the secrets of the human organism.

Unfortunately the corpses decomposed fairly rapidly in the Italian climate, and so dissections had to be performed within three to four days. This necessitated swift, methodical work, with few interruptions. Alone in a dank cellar, Leonardo would spend long nights bent over the dismembered bodies. Yet he was not so utterly inured to this occupation that he could ignore the chilling sound of flesh and bone being cut and sawed, or remain completely oblivious to the stench of putrefaction.

Anatomists had long recognized the need for a schematic representation of the human body, but had generally used very approximate and conventional drawings. Leonardo was the first to represent the internal structures of the human body with such precision and realism; in fact, the perfection of his drawings was not to be equalled for centuries afterwards. The transverse sections that he obtained by sawing and cutting were a complete innovation in his day, anticipating the techniques of modern science. Many of his anatomical drawings – including those he did of the skull around 1489 – are executed in silverpoint, and are among his finest works. In addition to their artistic perfection, his drawings of the human skeleton constituted an important advance on the knowledge of the day.

Leonardo was also the first to draw correct representations of the curves of the spine, and to show the tilt of the sacrum as it distributes the weight of the torso to the lower limbs, the arches of the ribcage, and the exact position of the pelvis, which was confirmed many years later. Further anticipating later anatomical discoveries, he determined the shape of the sphenoid and frontal bones of the cranium, and explored various cavities, such as the maxillary cavity, which was discovered in 1651 by Highmore (who gave it his name). He even described the functions of the heart and the circulation of blood in the arteries.

He was a trained physician and worked almost in secret years before Andreas Vesalius (1514-1564) and even longer before the Englishman William Harvey (1578-1657). In his own time, his anatomical work was considered not only audacious but also – and especially – heretical. Although he was never subjected to the Inquisition, he was accused of perpetrating all manner of devilry. It was rumoured that he was

Opposite and next page (detail)

Lady with an Ermine
(or weasel)
1483-1490. Oil on wood.
53.4 x 39.3 cm. (21 x15 1/2 in.).
Cracow, Czartoryski Museum.

One of the most fascinating portraits by Leonardo, it depicts the virginal Cecilia Gallerani. For a decade, she dominated the Court of Ludovico Moro in Milan with her beauty, wit and virtue. The ermine she holds – a traditional symbol of chastity – was slightly enlarged to balance the composition.

The hand of the *Lady with an Ermine*, both firm and elegant, is definitely in Leonardo's style. It does not have the fullness and grace that one usually finds in young women's hands painted during this period, but demonstrates instead the results of his anatomical exploration of muscle and bone structures.

an alchemist and necromancer delving in ungodly knowledge to bring cadavers back to life.

Anxious to avoid coming to the attention of the courts and the Inquisition, he never tried to publish his findings and intuitions – though they often proved to be correct. Not knowing where else to go to give free rein to his genius, he contrived an original way to tarry in the labyrinthine world of his imagination: he spread the word that he was no longer in Milan, that important responsibilities were keeping him away from Italy, somewhere in the Orient. This was probably the context in which he dreamed up his great journey to Cairo and the Taurus, and his encounter with a "giant," which he described in his letters to his friend Benedetto Lei.

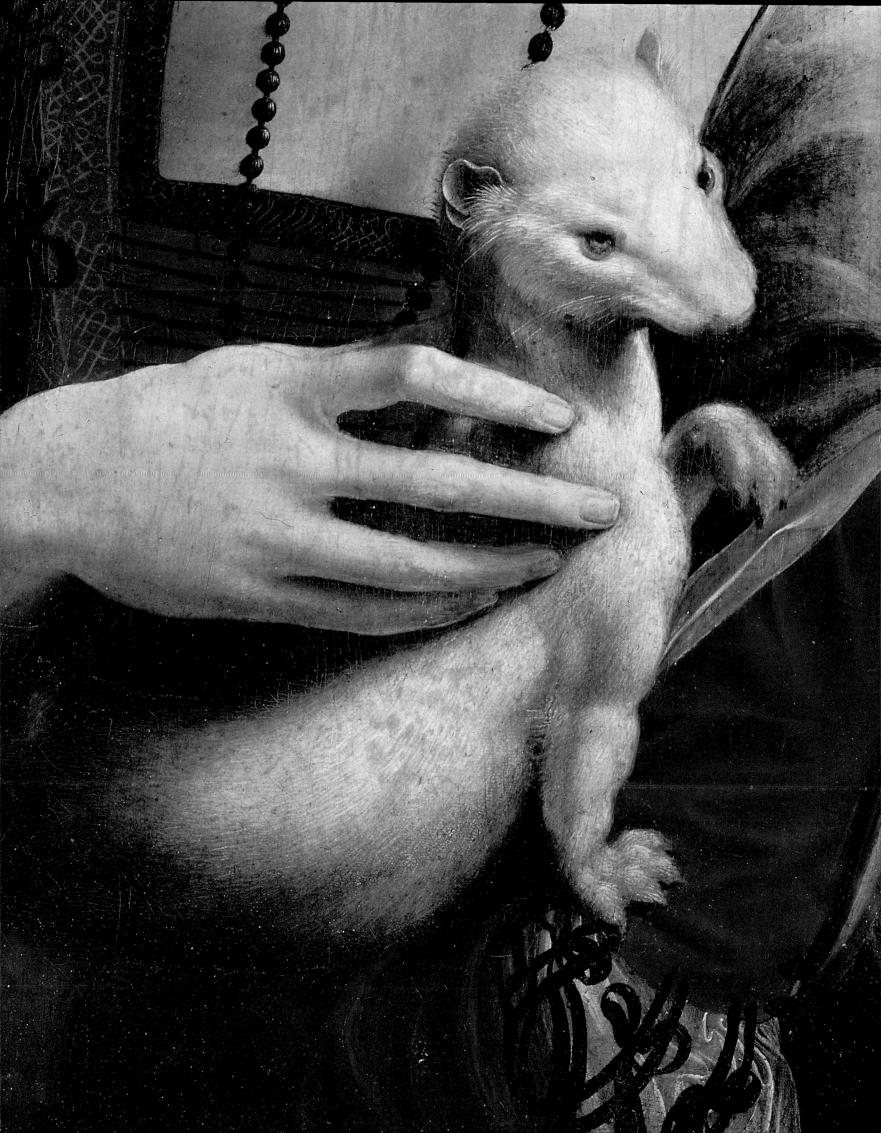

Section of the arm muscles, in relaxed and contracted states
Pen and ink.
287 x 198 mm. (11 x 8 in.).
Anatomical Studies,
fol. 145v. Windsor Castle,
the Royal Library.

Leonardo brought all his skills
to the study and reproduction
of the muscles, especially
the superficial musculature, which
he realized was important in
determining the external forms
of the body and expressing emotion.
From the physiological standpoint,
he understood the general laws
governing muscular mechanics,
and the relationships between
articulations and bones.

**Effect of the back muscles
on the spine, neck and ribs**
Pen and ink, black chalk, wash.
289 x 105 mm. (11 ³/8 x 4 in.).
Anatomical Studies, fol. 149v.
Windsor Castle, the Royal Library.

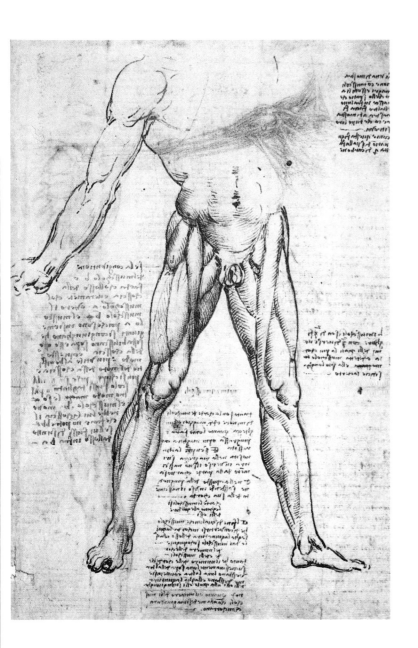

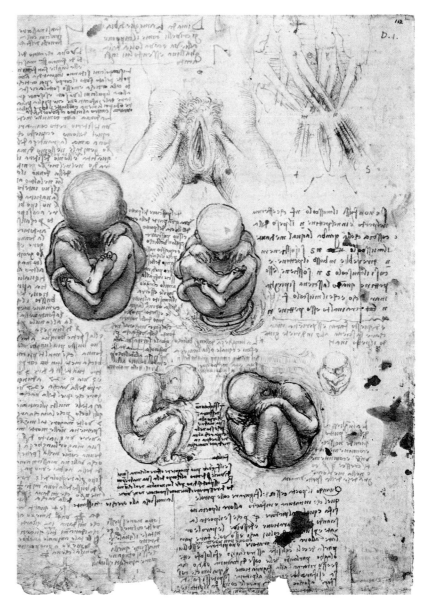

Thigh Muscles
Pen and ink, black chalk, wash.
289 x 207 mm. (11 3/8 x 8 1/3 in.).
Anatomical Studies, fol. 148v.
Windsor Castle, the Royal Library.

By 1515, at a time when the dissection of human bodies was still forbidden by papal decree, Leonardo is said to have dissected around thirty human bodies, both male and female, and of all ages. The purpose of his work was not just the study of anatomy (structure), but also of the physiology (movement) and morphology (external form). Anatomical dissection became an accepted practice only a century later, in Descartes' time.

Above, right
**Abdominal muscles of
a pregnant woman**
Left
Female reproductive organs
Below
**Human foetus in intra-uterine
position**
Anatomical Studies, vol III, fol. 7v.
Windsor Castle, the Royal Library.

Leonardo was also very interested in embryology. According to him, maternal and paternal characteristics were transmitted in equal measure. The pregnant mother's soul governed the body of the foetus, and her impressions had an influence on it. The conditions of conception also played a key role in the development of the child's personality.

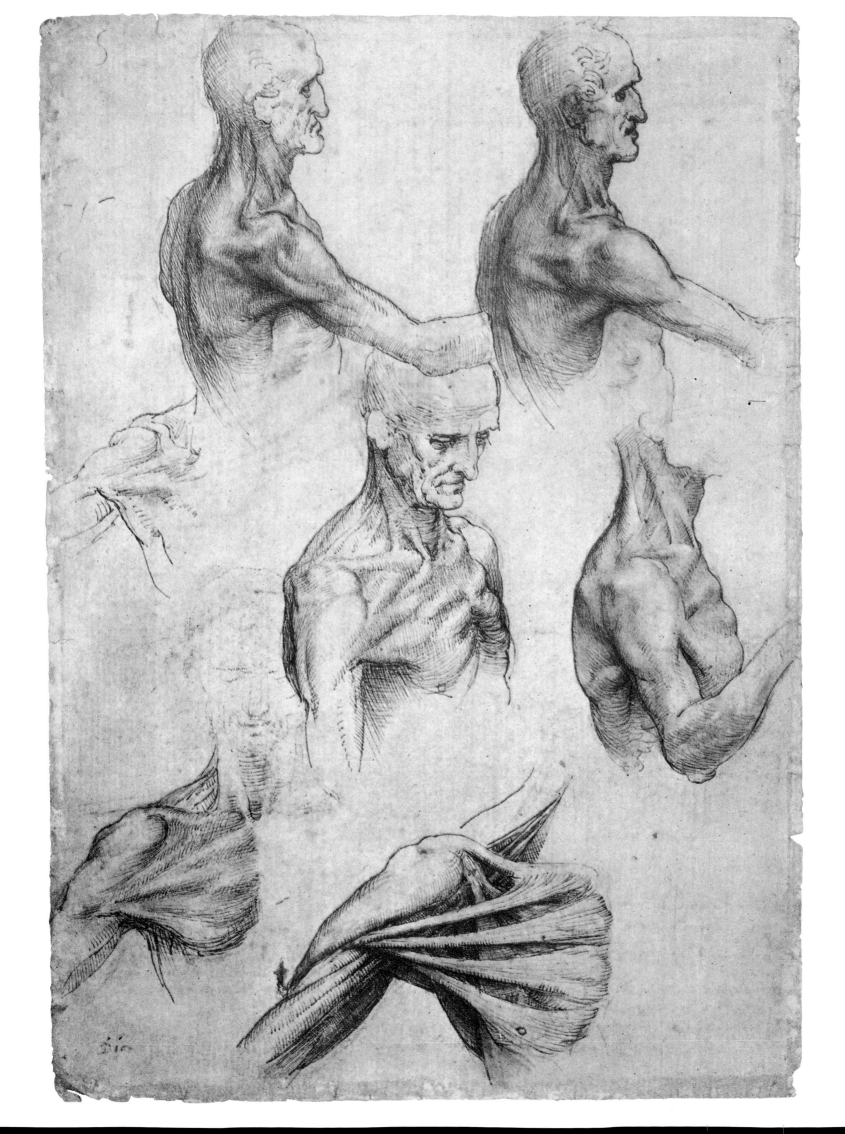

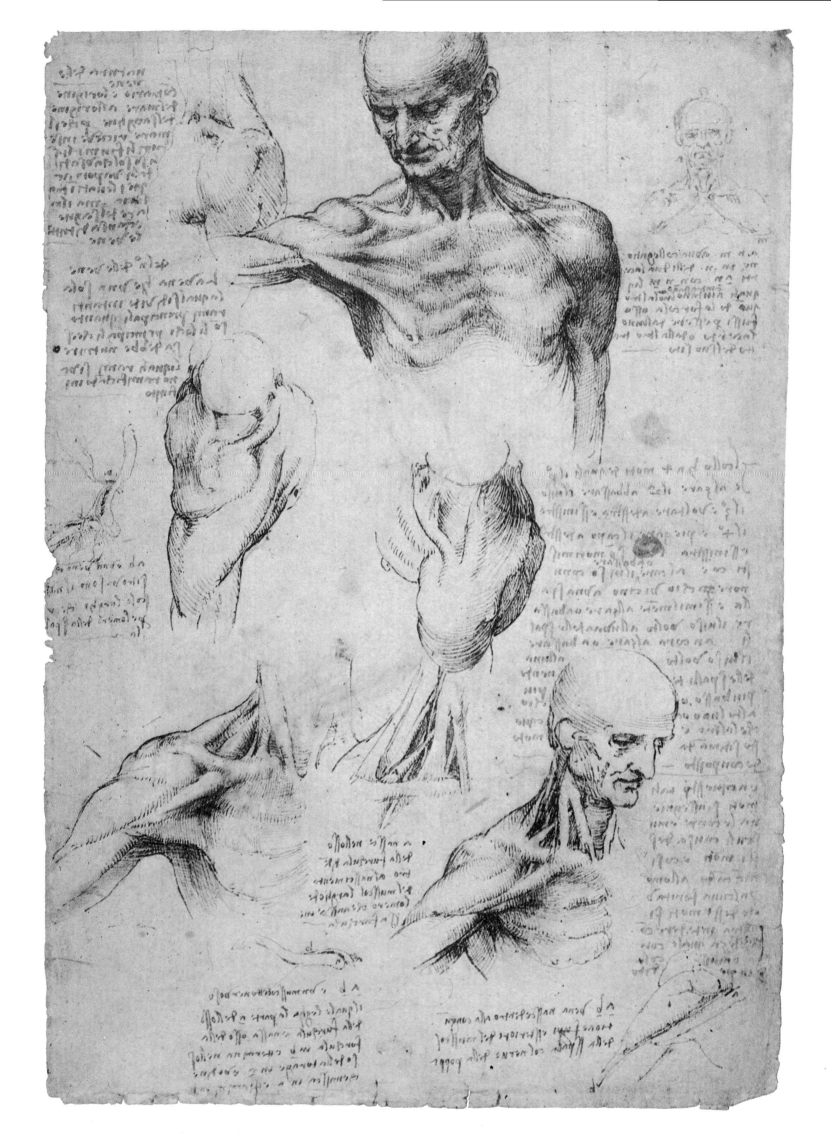

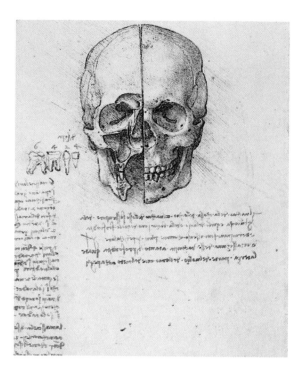 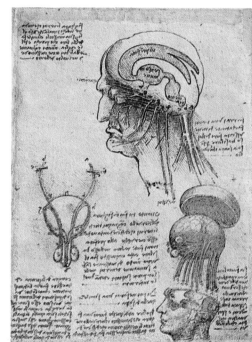 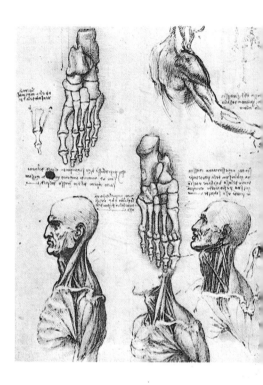

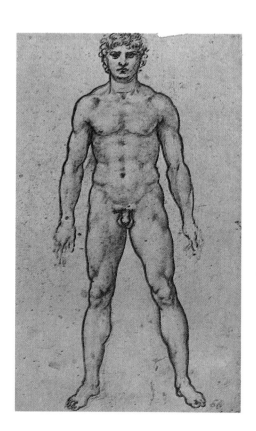

Overleaf

**Muscles of the neck
and shoulders**
Pen and ink, black chalk, wash.
292 x 98 mm. (11 $^{1}/_{2}$ x 3 $^{7}/_{8}$ in.).
Anatomical Studies, fol. 137v.
Windsor Castle, the Royal Library.

**Muscles of the rib-cage and
shoulders in a living man**
Pen and ink, black chalk, wash.
298 x 198 mm. (11 $^{3}/_{4}$ x 7 $^{3}/_{4}$ in.).
Anatomical Studies, fol. 136v.
Windsor Castle, the Royal Library.

Opposite

Standing man, frontal view
Pen and ink, red chalk.
237 x 146 mm. (9 $^{1}/_{3}$ x 5 $^{3}/_{4}$ in.).
Anatomical Studies, fol. 86v.
Windsor Castle, the Royal Library.

Above, right to left

**Section of the skull
and drawing of teeth**
Pen and ink, and black chalk.
190 x 137 mm. (7 $^{3}/_{4}$ x 5 $^{3}/_{8}$ in.).
Anatomical Studies, fol. 42v.
Windsor Castle, the Royal Library.

**Brain, cranium
and uro-genital system**
Pen and ink. 192 x 135 mm.
(7 $^{3}/_{4}$ x 5 $^{3}/_{8}$ in.).
Weimar, Schloßmuseum.

**Bones of the feet, muscles
and tendons of the neck
and shoulders**
Pen and ink, black chalk, wash.
Anatomical Studies, fol. 134v.
Windsor Castle, the Royal Library.

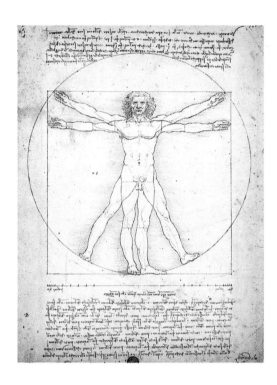

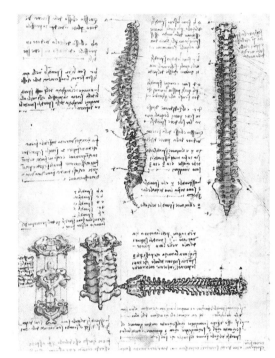

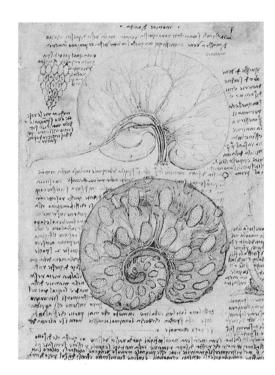

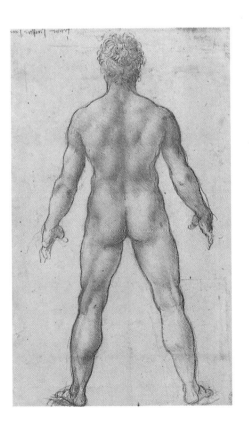

Above, left to right

Study of proportions

from Vitruvius's **De Architectura**.
Pen and ink. 34.3 x 24.5 cm.
(13 $^1/_2$ x 9 $^5/_8$ in.).
Venice, Accademia.

Lateral and frontal views of the spine; dorsal vertebrae

Pen and ink, black chalk, wash.
286 x 200 mm. (11 $^1/_4$ x 7 $^7/_8$ in.).
Anatomical Studies, fol. 139v.
Windsor Castle, the Royal Library.

Leonardo drew the first correct
depictions of the curves of the spine,
the tilt of the sacrum, and the arches
of the ribs. He was also the first to
draw the exact position of the pelvis,
which was confirmed only much later.

Gastro-epiploic vein and coronary artery of the stomach

304 x 213 mm. (12 x 8 $^3/_8$ in.).
Anatomical Studies, sheets B, fol. 22v.
Windsor Castle, the Royal Library.

Opposite

Standing man, back view

Around 1503-1507. Drawing,
red chalk. 270 x 160 mm.
(10 $^5/_8$ x 6 $^1/_4$ in.).
Anatomical Studies, fol. 84v.
Windsor Castle, Royal Library.

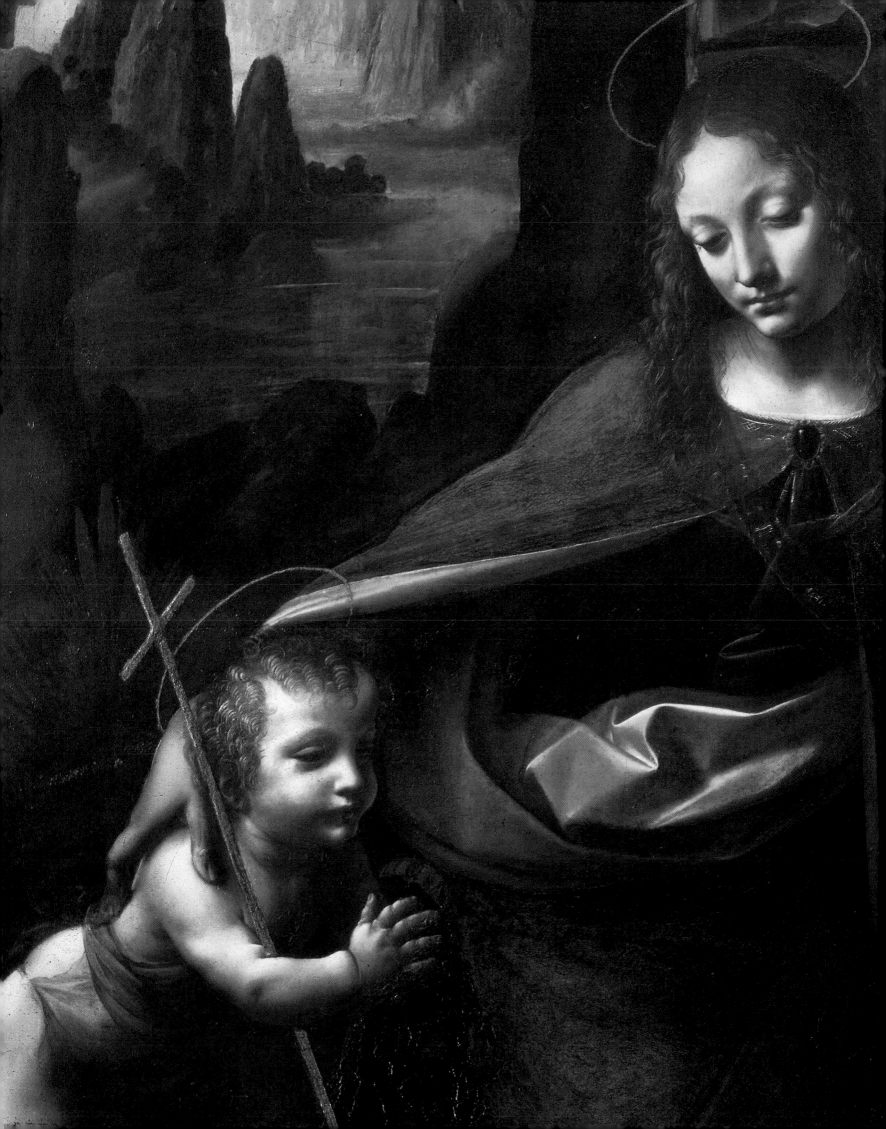

4

An imaginary Orient

Around 1484, Leonardo disappeared from public life in Milan for several years, leaving behind a first version of the **Virgin of the Rocks** (now in the Louvre), which he reworked upon his return. The second version (now in the National Gallery in London) was painted some twenty years later.

In each of these pictures we see a group of four figures, the Virgin, the Christ Child, the infant St. John the Baptist and an angel, in sitting or kneeling positions in a landscape of bizarre rock formations that give the impression of a fantastic, dreamlike architecture. This setting evokes the caves through which monsters from hell arrive on earth, a popular pictorial and scenographic theme, and Plato's metaphysical cavern that confines in its shadow.

Both paintings feature analogous compositions and poses, but differ markedly in their pictorial handling. In the Paris version, the four figures are slighter in form, but rich in detail, and bathed in a watery light that attenuates the shadows. But in the London panel, the group of sacred figures is more monumental, the bodies more substantial, and the shadows starker. The drapery is also treated differently in each picture. Leonardo thus avoided repeating himself, yet both works are imbued with the same powerful religious feeling.

As for the matter of his disappearance, no one can say exactly where he was. His own writings have lent support to the theory that he made a "Journey to the East" during this interlude. But what really happened? It is not entirely

Opposite and overleaf

The Virgin of the Rocks
(detail)
1503-1506. Oil on wood.
189.5 x 120 cm. (6 x 4 ft.).
London, National Gallery.

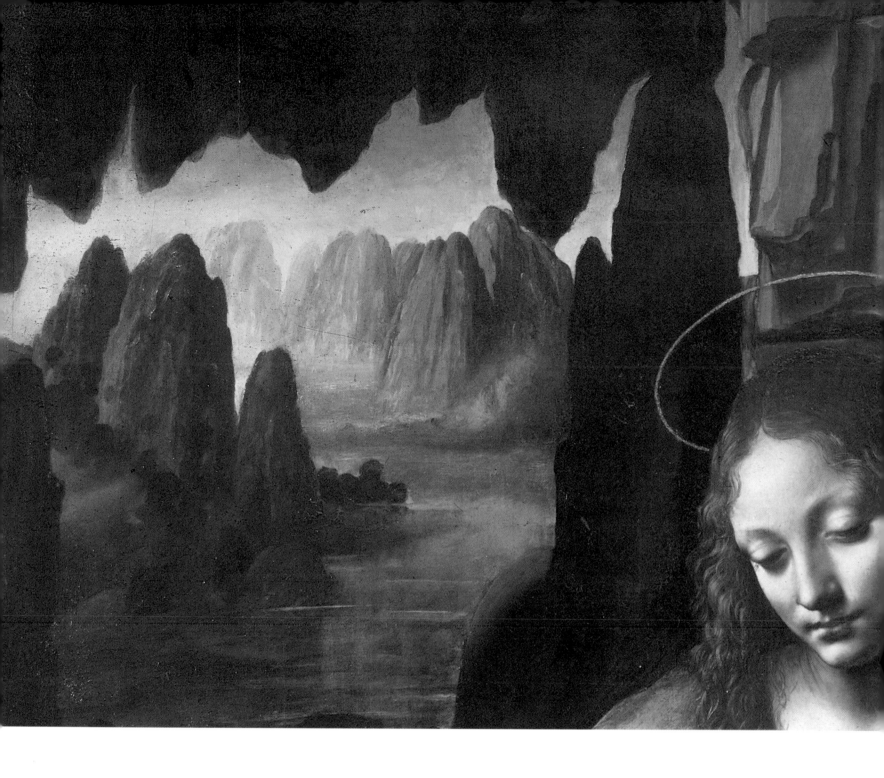

impossible that, as he himself claimed, he was sent by the **devatdar** (governor) of Cairo, Kaït-Baï, on a scientific mission under the auspices of the Sultan of Egypt. And yet Leonardo abhorred long journeys and risky adventures. Moreover, there are records in the form of contracts for many works commissioned in Milan during the same period, and this documentary evidence alone would suffice to discredit the theory of so surprising a voyage.

Perhaps Leonardo was still in the autumn mists of Milan, shivering under his pink cloak under the northern skies, and travelling to the remote reaches of Europe and Asia only in

the flights of his imagination. He nevertheless wrote accounts of his travels in the mysterious East, in often convincing detail. But perhaps he belonged to that line of humanists who, through books, travel more often in their imagination than in real life.

It is worthwhile giving Leonardo a hearing and letting him describe this fantastic journey in his own words; then we can see just how persuasive his knowledge and literary skills could be.

The stage is set somewhere in Asia in 1485, where Leonardo is engaged on a long mission for Kaït-Baï, the

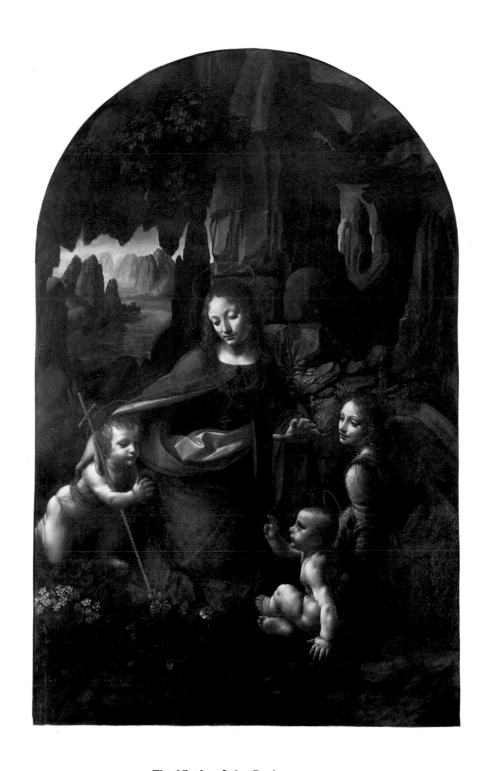

The Virgin of the Rocks
1503-1506. Oil on wood.
189.5 x 120 cm. (6 x 4 ft.).
London, National Gallery.

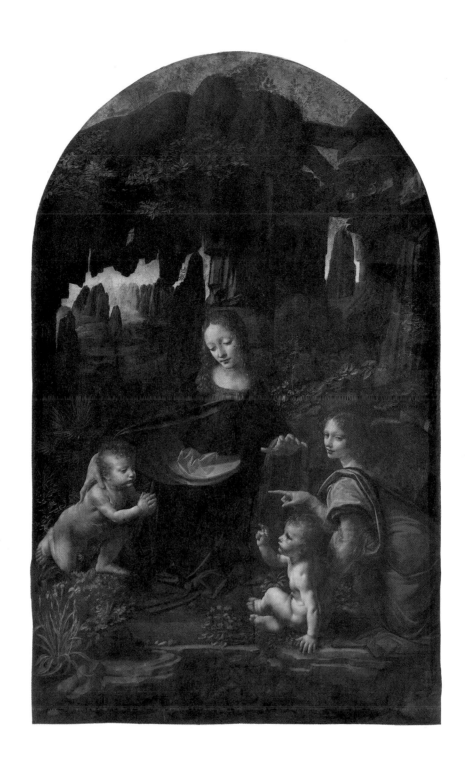

**The Virgin of the Rocks
(The Virgin and Child with
St. John the Baptist and an Angel)**
1483-1486. Oil. 199 x 122 cm.
(6 ¹/₂ x 4 ft.). Paris, Musée du Louvre.

mysterious governor of Cairo. After a long sea voyage on unseaworthy vessels, punctuated by awesome tempests, he finally reached the shores of Asia Minor, where the new Ottoman power was being created on the ruins of the Byzantine Empire.

He gave his position as "somewhere in Asia," and went on to write:

"Description of the Taurus and the River Euphrates. To the **Devatdar** of Syria and Egypt, lieutenant of the sacred Sultan of Babylon.

Finding myself in that region of Armenia to carry out with love and zeal the mission which you have assigned me, and to begin by those parts which seem the best-suited to your purposes, I came to the city of Claindra, which adjoins our borders. This city is located on the coast, in the part of the Taurus that is separated from the Euphrates, and faces the great Taurus mountain to the west. These peaks are so high that they seem to touch the sky, for there is no other place on Earth so lofty as their summits, which the sun always strikes first at daybreak, four hours before rising. The extreme whiteness of the rock makes it blaze with matchless brilliance, and for the Armenians in this country it is like the light of the full moon when all else is wrapped in darkness. Its great altitude rises above the highest clouds, up to a distance of four miles as the crow flies.... Why does the mountain [Taurus], whose peak glows splendidly during half or a third of the night, give the impression of a comet after sundown to those in the east? Why does the shape of this comet seem to vary, being at times round, at others long, and sometimes split into two or three parts, or all in one piece, alternately disappearing and becoming visible again?

O **Devatdar**, I should not be accused of idleness, as those around you insinuate; but the unbounded affection which inspired you to grant me the favour of your benevolence obliges me to research very carefully and to study diligently the origins of a phenomenon at once so great and so astounding; and this is why I needed so much time....

Some say the Taurus forms the crest of the Caucasus; and wanting to elucidate this, I spoke with those who live on the shores of the Caspian Sea. They told me that although their mountains have the same name, these are higher, and they assured me that this is the real mount Caucasus, for in the Scythian language, Caucasus means "splendid altitude." Indeed, no higher mountain is known to

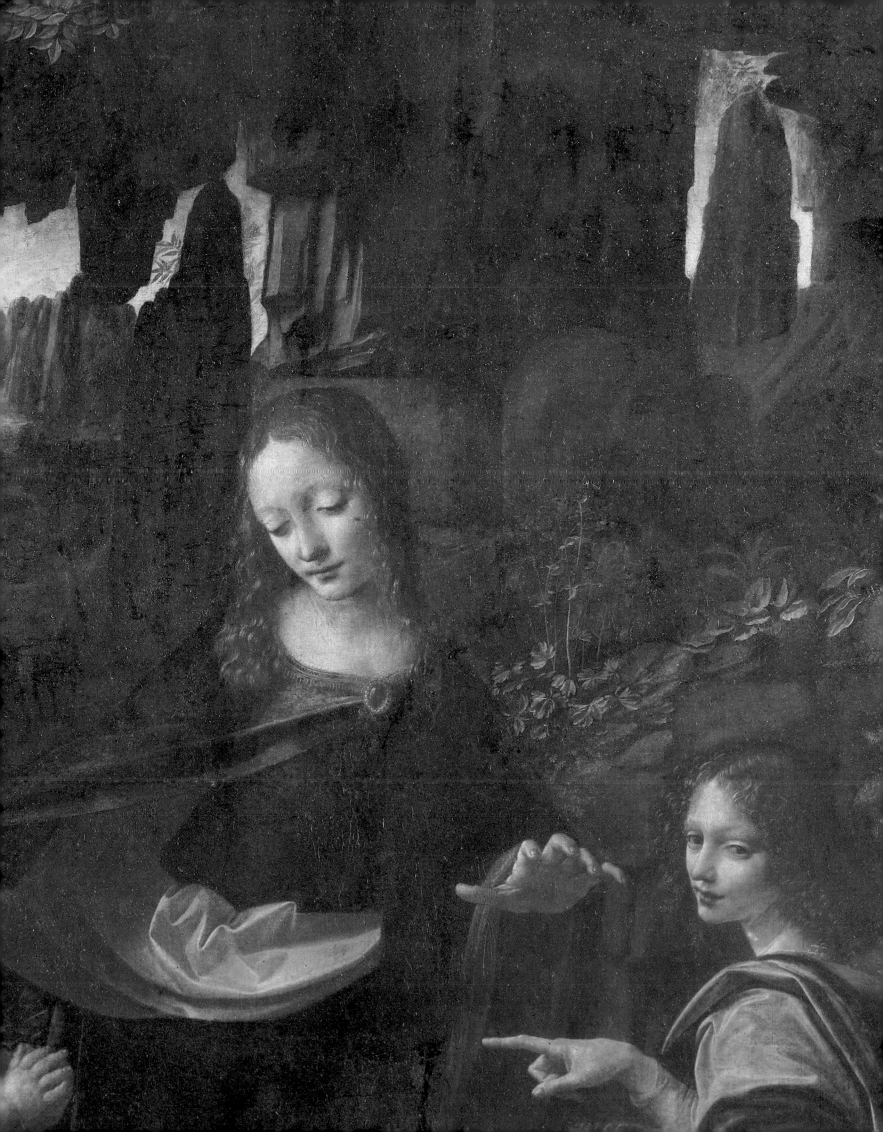

Caves have a long history in painting; in the Middle Ages, they symbolized the dark opening through which the forces of Evil were unleashed into the world. The Virgin and Child were sometimes depicted at the mouth of a cave – the better to block the way – as in Botticelli's well-known Nativity. Leonardo da Vinci took up this iconography in the two nearly identical versions of the Virgin of the Rocks that he painted, all the while giving it a new twist. This is no longer the cavern of the Dark Ages, but the Platonic cave of The Republic, in which Man is trapped by the shadow-play of his own ignorance, which can be dispelled only by turning towards the light. The juxtaposition of this theme with that of the Virgin and Child demonstrated that Platonic philosophy and Christian theology were reconciled, and that their union would bring Truth into being for all. Leonardo also innovated in the formal realm: where painters before him modelled their caves on the stage-sets that were built for religious feasts and the theatre, he drew his inspiration from a childhood memory in Tuscany. One day, while exploring the countryside, he came upon a cave so dark and mysterious that he did not dare to venture inside. He was also influenced by Mantegna's bizarre rock formations and by his own fantasies of the Oriental landscape, so unusual is the light in the distance in both pictures. At the same time, this watery or smoky luminosity, the so-called sfumato which is so frequently found in his paintings, could be interpreted to mean that the Veil of Truth is most readily lifted at dusk, when the bright light of day begins to fade.

Opposite and overleaf

The Virgin of the Rocks (The Virgin and Child with St. John the Baptist and an Angel)
(detail)
Paris, Musée du Louvre.

exist either in the East or the West; proof of this is the fact that the inhabitants of the lands to the west see the rays of the sun partly illuminating the summit during the fourth quarter of the longest night; and the same applies for the lands to the east."

Did Leonardo really make this journey? He may well have read these descriptions in books and transposed them, justifying the long interruption in his artistic and scientific work with stories of an extended, but not necessarily real, journey. But the wealth of detail is impressive. Here is his description of the "Structure and Dimensions of Mount Taurus."

"When I saw it, the shadow of the summit of the Taurus was so long that, in mid-June, when the sun is on the meridian, it reached the border of Sarmatia, a twelve-day journey away; and in mid-December, it stretches all the way to the arctic mountains, a journey of one month to the north. Clouds and snow perpetually cover the slope in the path of the wind, which is split in two by the rocks its strikes; once past them it joins again, driving the clouds in all directions, leaving them behind only in those places that it strikes: and since it is always being struck by lightning because of the large number of clouds, the rock is full of crevices and ruins.

The foot of this mountain is home to very opulent populations; it is full of rivers, fertile and rich in goods of all kinds, especially in the parts facing south; if one climbs three miles, one encounters forests of giant pine, spruce, elm and other trees; beyond, stretching for another three miles, are prairies and vast pastures; and all the rest, up to the summit of the Taurus is nothing but perpetual snow in every season up to an altitude of fourteen miles...."

And what do such detailed descriptions remind us of? Of the landscapes that compose the background of his paintings, those imaginary mountainscapes awash in the **sfumato** of his unbridled imagination. Did he travel to such far-away places in order to find his pictorial inspiration, or were his descriptions of the Taurus and other lands just another novel product of his febrile creativity?

Having so often depicted these remarkable landscapes, he may have wanted to make others believe that the strange mountains rising in the distance of his paintings or sketched on whatever paper was at hand were not just the fruit of his imagination, but that he had actually seen them in lands far away from the palazzi of his Milanese hosts.

Leonardo needed mystery. And he liked to protect his privacy by disappearing, by being elsewhere. He may have made a short trip or just taken up lodgings in some modest Lombardian inn, where he could renew the intricate workings of his soul, and prepare himself to further astonish those who had guessed that he was not just an artist and an engineer, but also a prophet who could interpret signs from the heavens.

Does this mean that everything he wrote of this Asian adventure was pure fiction? It is true that Leonardo was invited by the sultan to build a bridge in Constantinople; a sketch of his project has been preserved. Did he answer the sultan's summons and really explore the Taurus? The question remains unanswered. There is so much that is enigmatic about Leonardo da Vinci's life that one more puzzle should hardly surprise us.

There is one document that reinforces the conviction that this entire journey was a figment of his imagination. After his precise and realistic descriptions of the Taurus, he embarked on a bizarre and fairly incoherent tale which veers from vision to nightmare. In it, he appears in the first person and is devoured by a monster: "I do not know what to say or do; I have the impression of swimming, plunging head down, in the enormous mouth, and that, deformed beyond recognition by death, I am swallowed into its giant belly."

What is most interesting in this story are not the details of the giant that swallowed him: its longevity was such that it was alive during the days of the Persian king Artaxerxes, against whom it fought on the side of the Egyptian; its appetite was so great that it ate the biggest whales and ships whole, and so on. What fascinates us are the precise details of how, like Gulliver among the Lilliputians, the beast went about ridding itself of its numerous, but minuscule adversaries.

Let us read the last passage of this unexpected fable, for it gives an accurate measure of Leonardo's poetic genius and of his bewildering ability to imagine the impossible:

"The violence of the impact left him prostrate on the ground, as if thunderstruck; the crowd, thinking that he was finished, began to mill around his great beard; like ants running furiously to and fro in the scrub cut down by the axe of the sturdy peasant, the people pressed against its enormous limbs and scored them with wounds....

'Then, coming to his senses and seeing that he was almost covered by the crowd of people, and suddenly feeling the sharp pain caused by their stings, the giant let out a mighty

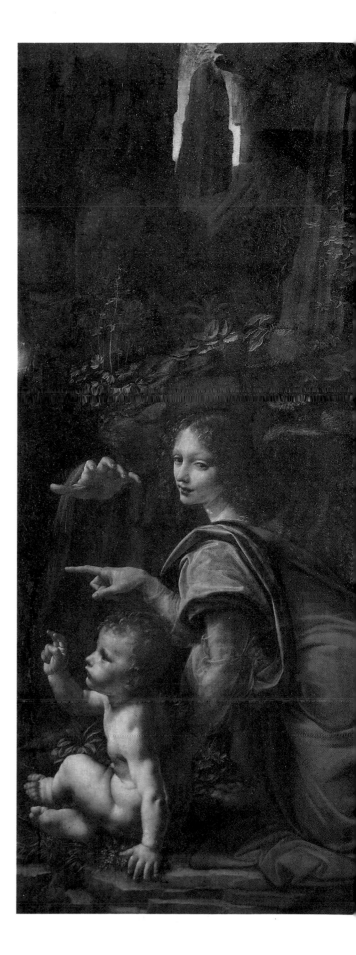

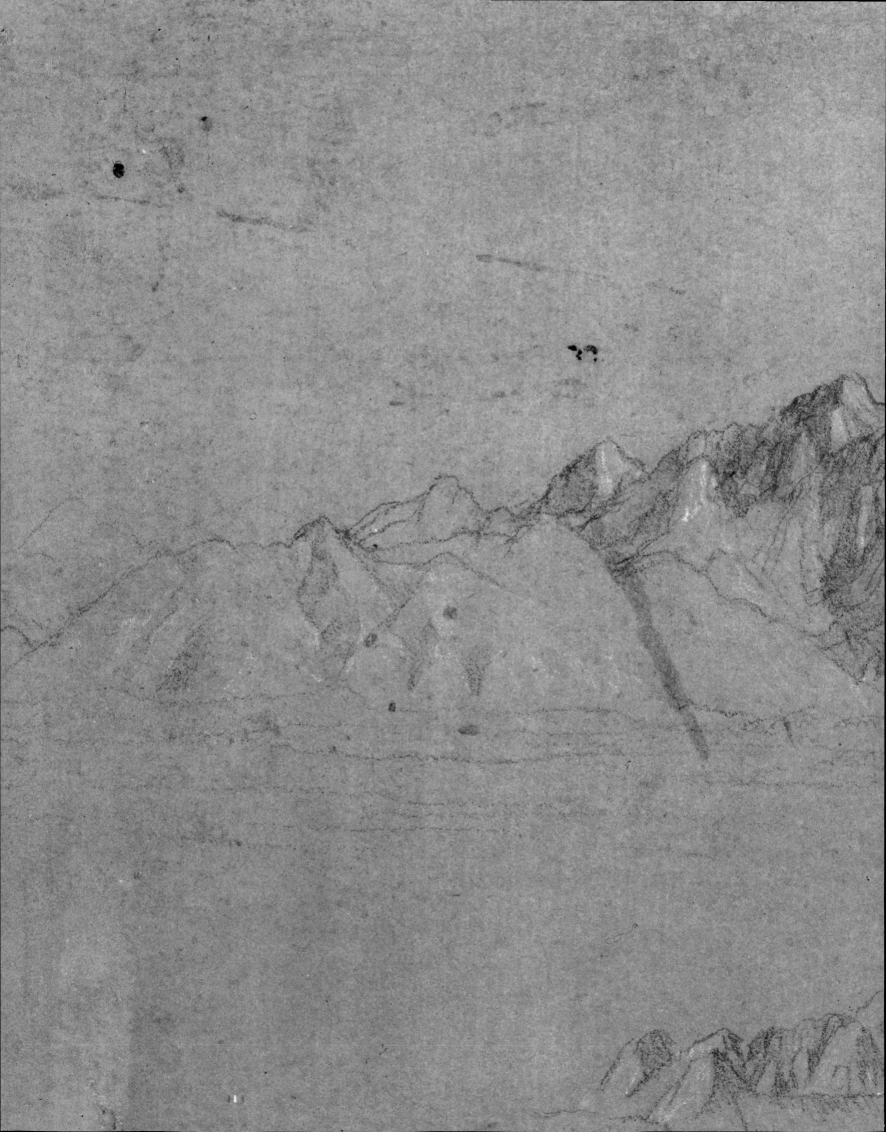

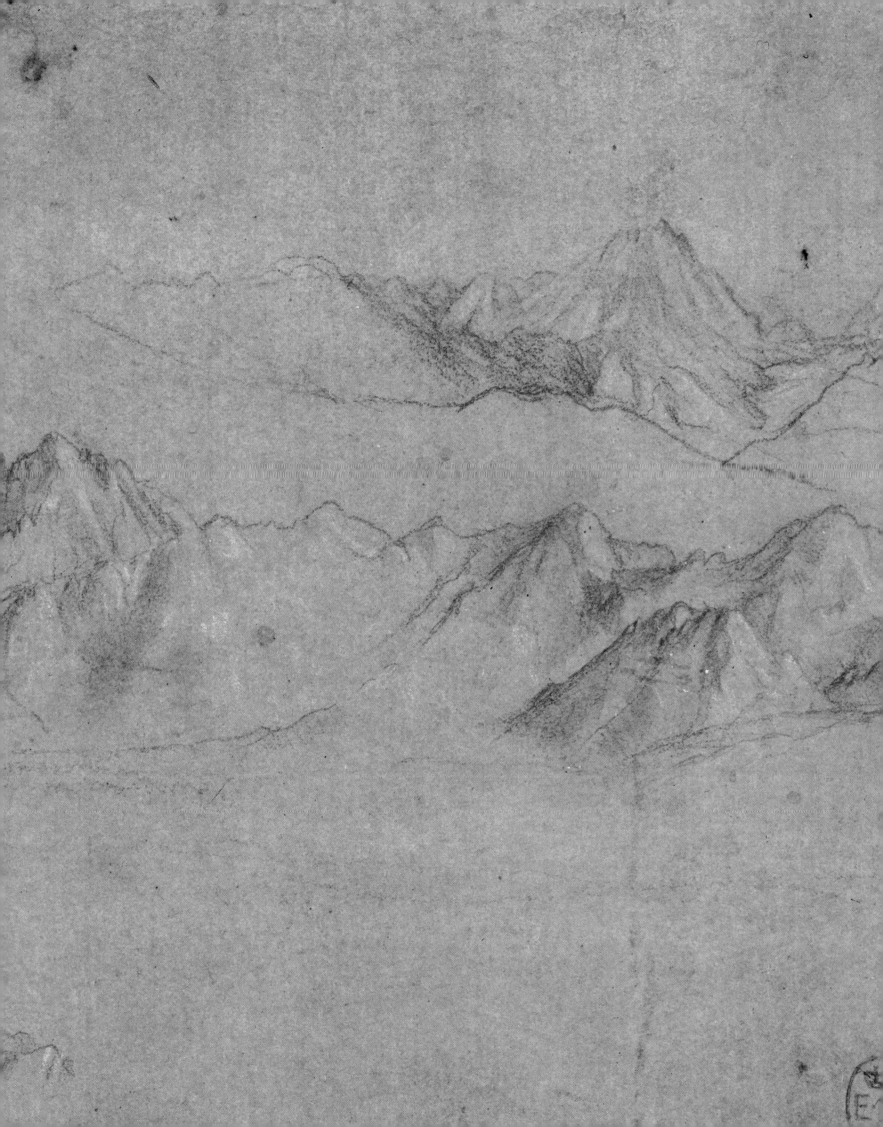

roar which sounded like a frightful peal of thunder; pushing his hands against the ground, he lifted his awful face, and, raising one hand to his head, felt the masses of men clinging to his hair like insects. Still holding fast to his hair and attempting to hide, these men were like sailors in a storm climbing up the rigging to furl the sails and loosen the violent hold of the wind; he shook his head and sent people flying through the air like hailstones in a storm, and many were killed by those who crashed down on them. Then the Giant stood up and, furiously stamping his feet, crushed these tiny beings that were men...."

Leonardo the traveller and visionary is a far cry from the genteel image that is often given of him. He is no longer the painter of the placid **Mona Lisa**, but the inventor of machine guns, tanks and gas bombs. He has become the creator of a fantasy world. Beyond the typically Florentine harmony of his compositions and the mollifying smiles of his figures, we find the anxious dreamer always ready to create a monstrous and terrifying world. It is as if, all of a sudden, he wanted to cast a hellish incandescence on his masterpieces of light, deliberately shredding the beatified image of the good painter and old sage whom legend had assigned to die peacefully in Blois, in the arms of the King of France. For Leonardo, who often lived surrounded by the stuff of night-mares, darkness was the hidden ingredient that quickened his otherwise serene compositions of life.

The intrinsic reality of the man, mysterious and formidable, does not reside in a mere sequence of events, which, in any case, is full of irritating gaps. He is never where one would expect him to be, and the motto that Descartes was to adopt a century later could easily have been his: **Larvatus prodeo** (I go forward in a mask).

Before his "departure," Leonardo had already begun working on the equestrian monument of Francesco Sforza, a grandiose project that was to occupy him for an entire decade. In the preface to his treatise **De divina proportione** (1497), Luca Pacioli, a mathematician invited to Milan by Ludovico Sforza, mentions that the bronze horse would measure twelve **braccia** (over 7 metres) from the horseshoe to the top of the head, and weigh some seventy kilos. Although the project was feasible, and even though Leonardo made many scale models, Ludovico would eventually have to abandon his dream of immortalizing the memory of his father.

For the times were anything but calm; nowhere did

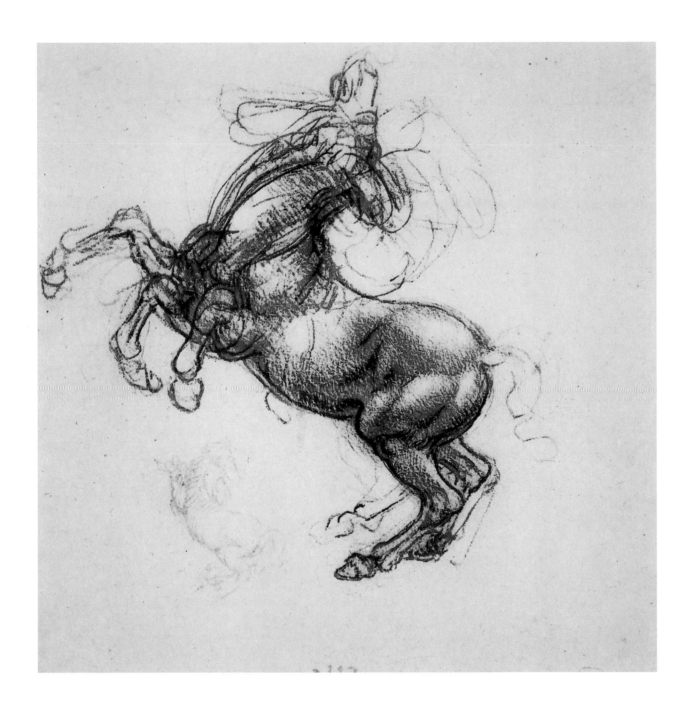

Opposite

Sketches for the equestrian statue of Francesco Sforza
Windsor Castle, the Royal Library (fa. Scala)

Leonardo da Vinci worked on this monument from 1483 to 1498, with long interruptions.

The preliminary sketch, depicting a rearing horse, broke completely with the classical type of equestrian statue. Luca Pacioli, who saw the monument as a modello, noted that it was "an admirable and wonderful equestrian statue." Its actual height, measured from the mane to the ground, would have been twelve braccia, or 7.64 meters.

Above

Rearing Horse
Red chalk. 153 x 142 mm.
(7 1/8 x 5 5/8 in,). Windsor Castle, the Royal Library (fa. Scala).

This drawing is thought to be related to the Adoration of the Magi or to the Battle of Anghiari.

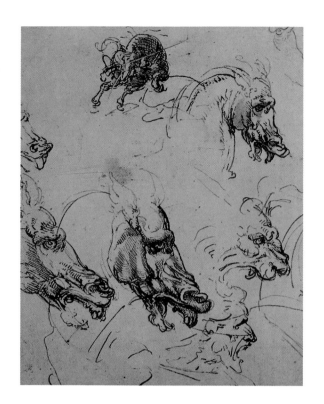

peace prevail. Between the Germanic Empire, the Italian principalities and the ambitions of the French king, war was just a matter of time. In 1494, Charles VIII crossed the Alps with a formidable army and thirty-six bronze cannon. Leonardo and Bramante were summoned to increase the fortifications. The invading troops approached steadily, as Charles VIII disregarded the long-standing treaties between the Duchy of Lombardy and the French Crown. The preparations for battle filled the streets of Milan with disorder and noise. No one felt secure. The military engagements, which took ever greater tolls, obliged "Il Moro" to put all his men under arms, and the seven tons of bronze that were to have been used to cast Leonardo's statue were requisitioned for the artillery. It was in this sorry way that one of his most cherished projects come to an end.

The giant terracotta model that Leonardo had already made by 1494 met with an even sadder fate. In 1493, Il **Cavallo** ("The Horse") was displayed in the Corte Vecchia, the main courtyard of the ducal palace, on the occasion of the wedding of Bianca Sforza, Ludovico's daughter, and the Emperor Maximilian I. This work, or rather its "prototype," soon made the sculptor famous throughout Italy, and as far as France and the German Empire. It was generally agreed that Leonardo had created "the most gigantic, stupendous, and glorious work ever made by the hands of man." Unfortunately, after the capture of Milan in 1500 by Louis XII, Charles VIII's successor, and not long after Leonardo finished working on his **Last Supper**, the terracotta model was destroyed by Basque crossbowmen, who used it for target practice. Louis XII took possession of the finished mould along with the other spoils, and its fate is unknown.

Leonardo found himself terribly alone. He left the modest studio where he had lived with the Predis brothers, also painters, and went to live in Ludovico the Moor's Castel Vecchio. Then, one day, strolling in the countryside, he chanced upon a handsome child dressed in rags busy sitting on a rock sketching the goats he was tending with a piece of charcoal. Leonardo was greatly moved... he thought he was seeing an angel. The young shepherd's father, a poor man, made no difficulty about letting the artist take his ragamuffin son off his hands.

Leonardo adopted the boy, whom he nicknamed Salaï (short for Salaïno, or little devil), and cared for him like a father. But Salaï lived up to his name and constantly played

tricks on his benefactor. This mattered little to Leonardo; his life was transformed and he could finally express the affection he felt. His new role as foster father gave him a kind of stability and a semblance of happiness, even if Salaï repeatedly stole from him and his patrons (not even sparing the Sforzas), and cost him a great deal of money. His fury spent, Leonardo would always forgive him and shower him with gifts. There is no evidence that pedophilia had anything to do with this relationship. It filled the affective void in the life of the lonely artist. Salaï was not a good remedy for his inner alienation, but he must have made it more bearable at times.

For the new year 1497, Beatrice d'Este, pregnant with the child of the Duke of Milan, decided to hold appropriate festivities. She danced a great deal and drank even more, then fell ill, and eventually died in labour. Six months later, wanting to celebrate the birth of his mistress's child, Ludovico ordered Leonardo to paint a monumental fresco of trees with intertwined branches in the banqueting hall of the ducal palace.

This highly symbolic work, painted shortly after the **Last Supper**, represents a grove of trees with branches and foliage inextricably interlaced and held together by knotted ropes. The powerful trunks reach down to the base of the walls and are prolonged by roots that have penetrated layers of rock. The trees rise to the ceiling and explode into a vast leafy canopy, while the "patient knots" of Art and Science connect this natural material and bend it to their purposes.

In 1499, Ludovico, who lost his ducal crown in September 1498, died after bequeathing to Leonardo a vineyard and a well-situated plot of land measuring twelve rods. With evident satisfaction, the artist noted: "I find myself now in the possession of two hundred and sixty-eight ducats, this 1st of April 1499." It must have come as a welcome relief. He felt more at peace, and ready for new undertakings and visionary projects. Having found a measure of financial security for the first time in many years, he no longer shut himself up in his lodgings, but went for long walks in the countryside again.

A new era was also dawning in Italy. Leonardo felt re-invigorated: he knew that his gifts had remained intact and he was convinced – now more than ever – of being able to express them. In the following summer, feeling perfectly fit, he climbed Monte Rosa. Several months later, he installed a bathroom for Isabella of Aragon in the Corte Vecchia.

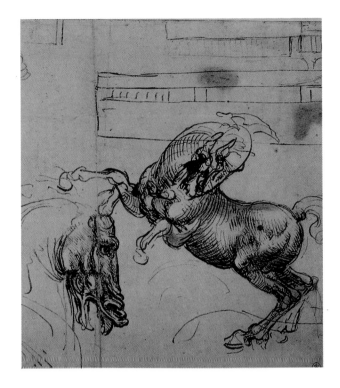

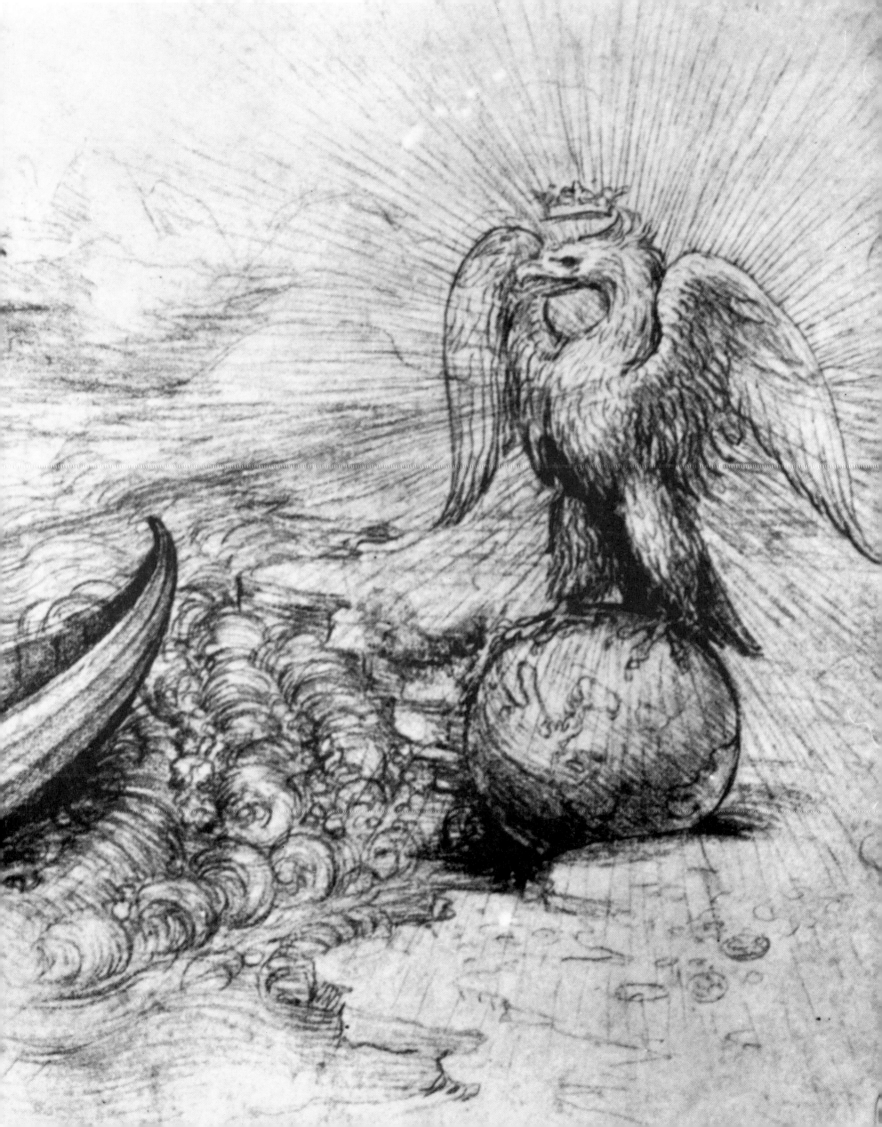

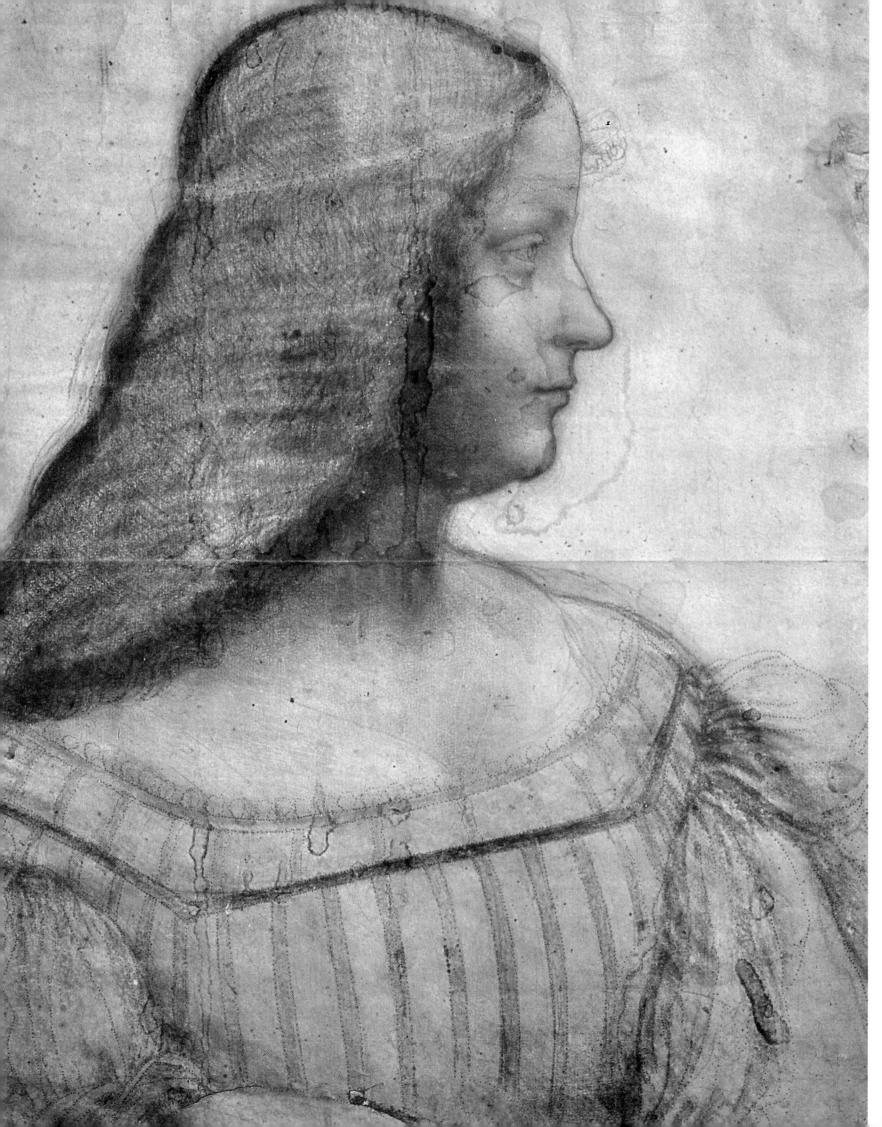

French troops under Louis XII's command still occupied Milan, but Leonardo no longer considered the foreigners as intruders; after all, the French officers were themselves steeped in humanist culture and full of admiration for the genius of the Lombards and Tuscans. Under the circumstances, Leonardo had no qualms about offering his services as engineer to Louis de Luxembourg, Count of Ligny, an adventurous mercenary whose ambition it was to capture Rome and Naples.

Nevertheless, the fate of **Il Cavallo** haunted him, as revealed by an anecdote related by an author known as Anonimo Magliabecchiano, who alludes to an altercation that must have taken place in Florence in 1503.

"One day, Leonardo, strolling in the company of Giovanni di Gavina de Santa Trinità, walked past the benches of the Spini Palace, where a group of gentlemen were discussing a passage from Dante. They called to da Vinci and begged him to explain it to them. At that precise moment, Michelangelo also happened to pass, and Leonardo told them: 'Michelangelo will explain it to you.' Michelangelo answered angrily, thinking that Leonardo was making fun of him: 'Explain it yourself, you who made a design for a horse to be cast in bronze and, unable to cast it, abandoned it, to your shame.' Leonardo remained silent and blushed. To embarrass him even more, Michelangelo called after him: 'And those Milanese idiots believed you!'"

Allegory of the Boat, Wolf and Eagle
170 x 280 mm. (6 5/8 x 11 in.).
London, Royal Academy of Arts.

This drawing seems to have been worked out for the wedding festivities of Giuliano de' Medici and Philiberte de Savoie.

Portrait of Isabella d'Este
1499. Pierre noire with touches of red chalk in the hair and skin, and pastel yellow highlights on the dress. 63 x 46 cm. (24 7/8 x 18 1/8 in.). Paris, Musée du Louvre, Department of Drawings.

Intertwined Trees

(detail)
Tempera on wall.
Milan, Castello Sforzesco
(Sala delle Asse).

In 1497, to celebrate the birth
of his child by Beatrice d'Este
(who died in labour), Ludovico Moro
commissioned Leonardo to paint
a symbol of Life.
This symbolic representation, a grove
of trees with intertwined foliage, was
executed in the following year in
the banqueting hall of the ducal
palace in Milan. This large-scale mural
depicts a canopy of interlaced
branches held together by knotted
ropes. At the base of the crenellated
wall, the trunks are prolonged by deep
and powerful roots that have broken
through the layers of rock. Gothic
in taste, but classical in its masterful
compositional rhythm, this wall-
painting stands completely on its own
in Leonardo's work.

· LVDOVICVS · MEDIOL · DVX ·
· MEDIOL · DVCATVS · TITVLVM · IVSQVE ·
· QVOD · MORTVO · DVCE · PHILIPPO · AVO
· IN · GENTE · SFORTIANA · OBITENERE ·
· NON · POTVERAT · AB · DIVO · MAX · RO ·
· REGE · IMPERATOREQVE ·
· MAGNIS · CVMVLATVS ·
· HONORIBVS · ACCEPIT ·

· AN · SAL · LXXXXV ·
· SVPRA · MCCCC

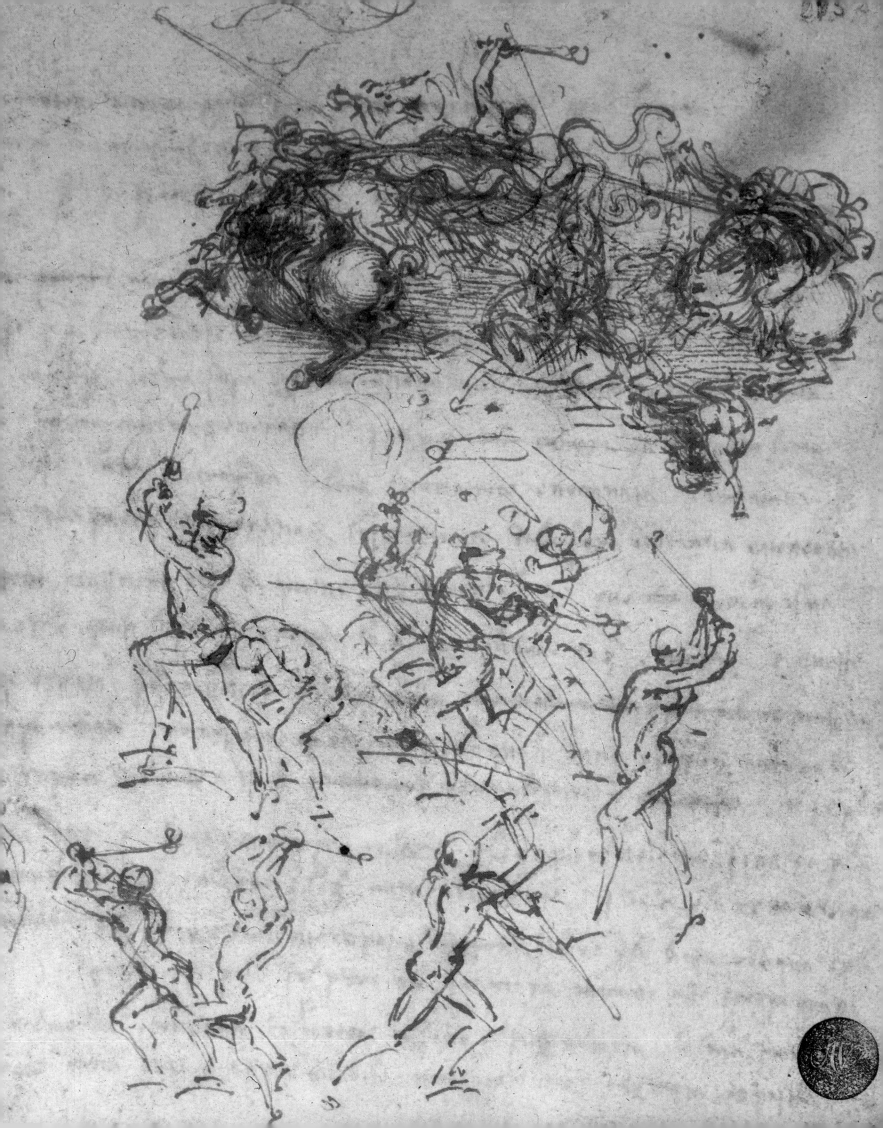

5

The Anghiari fiasco

In 1499, after Ludovico the Moor had been delivered to the French, Leonardo da Vinci finally decided to leave Milan. His planned to return to Florence, but took a fairly circuitous route. In March, he was working as a military engineer for Venice. The Venetians feared a Turkish attack and hoped against hope to find the "modern Archimedes" who would save their splendid city.

Leonardo set to work. He studied the lay-out of the city and the outlying areas. He made a systematic study of the course of the Frioul River and recommended raising the level of the Isonzo River with sluice gates in order to be able to flood the entire countryside around Venice.

At the same time, to improve the effectiveness of the defences of the city from the lagoon, he invented a sort of submarine and diving suit; but, once again, for one reason or another – lack of funds, lack of credibility, or just plain lack of perseverance – his plans never got off the drawing board.

His ideas, however, or at least those that were not overly innovative, found favour with his Venetian patrons. Consequently, he was able to establish himself in the City of the Doges and, presumably, to work there in peace.

But he missed Florence, and by Easter 1500, he was back in the City of Flowers, accompanied by Salaï, whose physical beauty and elegance made a strong impression on everyone.

Much had changed in Florence during his eighteen-year absence. The Medici family had been exiled from the city. The invasion of Italy by the French king, Charles VIII,

Skirmish between infantry and cavalry
Sketch for the Battle of Anghiari.
1504-1505. Pen and ink.
165 x 153 mm. (6 1/2 x 6 in.).
Venice, Accademia.

Head of a Warrior
Study for the **Battle of Anghiari**.
Around 1504-1506. Red pencil on
cream-coloured paper.
22.7 x 18.6 cm. (9 x 7 ³/8 in.).
Budapest, Szepmüveszeti Museum.

who wanted to re-conquer the Kingdom of Naples, had precipitated their fall in 1494 and led to the creation of a republic under the leadership of the austere – some would say fanatic – Girolamo Savonarola. But the Florentines grew weary of his condemnations, his puritanism and his calls for the denouncement of libertines, and the Dominican monk-turned-reformer was burned at the stake in 1498.

Leonardo could not find work in Florence. The imaginative young man who had been Verrocchio's favourite pupil had been forgotten. And Florence had is own painters, engineers and architects. World-weary, and sickened by the turbulent events, Leonardo took to the countryside again. He became more and more isolated, no doubt regretting his life in Milan and the patronage of the Sforzas. But no matter! He knew that his duty was to his work, to use his creative ability, and in spite of the difficulties, he persisted in his efforts.

His retreats to the Tuscan countryside, which were frequent in the first months after his return, restored some of the inner strength that he had thought lost for ever. He was true to himself, in complete possession of his art and technical knowledge, and as full of visionary projects as ever.

We know that Isabella d'Este summoned him to Mantua, but Leonardo had little desire to be a mere court painter. In a letter dated 4 April 1501, Pietro da Novellara, private counsellor to the Duchess of Mantua, reported the failure of his mission to Leonardo: "His study of mathematics has left him with a dislike of painting. He is much involved with geometry and cannot bear the sight of his brushes; the mere thought of a paint brush throws him into a rage...."

But despite his aversion, he responded favourably to a request from Florimond Robertêt, Louis XII's Secretary of State, for a picture of the **Virgin**, which has since been lost.

Louis XII was the first French king to take an interest in Leonardo. When he invaded Milan in 1507 he asked Leonardo not to leave because he wanted to "commission pictures and perhaps a portrait."

However, after his return to Florence, Leonardo became ever more absorbed in his dreams, to the exclusion of all else. He found it difficult to accept the political changes that had undermined the city he knew. He felt disoriented.

He was still willing to play the game, and boldly proceeded to do so. But, where before he had been irritated by the long Neo-Platonic disquisitions of the court of Lorenzo de' Medici, now he missed them, just as he missed the

philosophical fire of Marsilio Ficino and Pico della Mirandola, and the visionary daring of the great architect Alberti. Did he still wear the short and colourful fashions of his youth? There is no way of telling. Leonardo, who was approaching fifty, must surely have changed, while retaining his imposing and elegant bearing.

One thing is certain: he was bored with painting. He resumed his study of Latin and mathematics, and his gruelling anatomical research. Yet he must have known that he could not live – not even subsist – without again devoting himself to the art of painting, which he possessed to the highest degree of perfection. It was painting that had made him famous, although he wanted to be recognized as an engineer, architect, mathematician and visionary inventor.

His father, Ser Piero, then in his late sixties, married for the fourth and last time and with a sixth child on the way, had become prosecutor for the Servite Order at the Monastery of the Annunciate. The mendicant friars had commissioned Filippino Lippi (1457 1504), a student of Botticelli famous for his **Apparition of the Virgin to Saint Bernard**, to finish two paintings for the high-altar of their church.

Quite possibly because of his father's position, the job was eventually passed on to Leonardo.

In his **Lives**, Vasari wrote: "Leonardo said that he would gladly do this kind of work, and, hearing of this, Filippino Lippi politely bowed out. To enable Leonardo to paint the picture, the friars took him in, giving him and his servants room and board. He kept them a long time in suspense, without starting anything. Finally he executed a cartoon depicting the Virgin, Saint Anne and Jesus."

During this period Leonardo was no longer in want. Not only did he earn a comfortable sum for this commission from the Servite friars, but he withdrew fifty gold florins from the six hundred that he had saved in Milan! Free from the financial cares that so often dogged him, Leonardo soon lost interest in the picture for the church of the Annunciate (which eventually became the famous **Virgin and Child with Saint Anne** now in the Louvre), and threw himself wholeheartedly into the study of mathematics.

In the spring of 1502, acting in the capacity of a military engineer, Leonardo entered the service of the young Cesare Borgia (1476-1507), the greatest – and perhaps the most brutal – soldier of fortune of his day, who was then at the acme of his power.

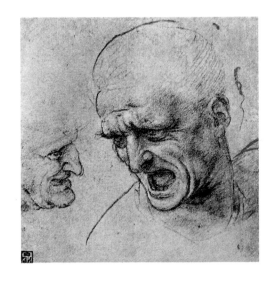

Expression studies for the Battle of Anghiari
Budapest, Szepmüveszeti Museum (fa. Scala).

This daring warrior-prince was well-educated, but recognized no other right than ruthless might allied with a cunning that justified any means as long as his ends were achieved. Cesare Borgia had in common with Ludovico Sforza the ambition to rule over the entire Italian peninsula. Pope Alexander VI, his father, had him appointed Marshal of the Vatican forces and elected Duke of Romagna, bypassing all the legitimate princes of the region – all this in the name of the "Holy Catholic, Apostolic and Roman Church!" Florence, although humanist, had too many financial interests at stake, and finally rallied to its powerful and fearsome neighbour, pragmatically signing a treaty that recognized Cesare Borgia as "**Condottiere** of the Republic."

Endowed with an intelligence that was as sharp as his appetite for power, Cesare Borgia stopped at nothing to consolidate and extend his power. Murder was often the shortest route between his wishes and their fulfilment.

Leonardo's deed of appointment to Borgia's service, a document which has been preserved, made him responsible for the inspection and upkeep of fortifications, coordinating the necessary modifications and drawing plans.

In May of that same year, Leonardo was in Piombino, elaborating a plan to drain the marshes, then travelled to Sienna, Orvieto, Pesaro, and Rimini. He was present also at the siege of Urbino and the sack of its magnificent library. From Pavia, Cesare Borgia sent him a pass ordering all his lieutenants, squires, captains, **condottieri**, officers, soldiers and subjects to grant safe passage to "our esteemed and beloved architect and engineer Leonardo da Vinci, who is invested with the mission of visiting all the citadels and fortifications."

In October Leonardo was summoned by his patron to Imola where he stayed at the Palazzo Sforza Riario. Then, in the company of Machiavelli, who modelled his Prince on the young, ruthless and calculating leader, Leonardo may have followed Cesare Borgia to Sinigaglia, where the latter lured his four major adversaries and had them strangled.

And so, Leonardo travelled throughout Central Italy, going from fortress to fortress, inspecting and drawing all the while. We can follow his progress in one of his sketchbooks (oblong in format and easy to put in the pocket) in which he noted whatever caught his attention.

Thus he left Urbino on 30th July. Two days later he was already in Pesaro, where he visited the library and copied drawings of machines from its manuscripts. On 8th August he

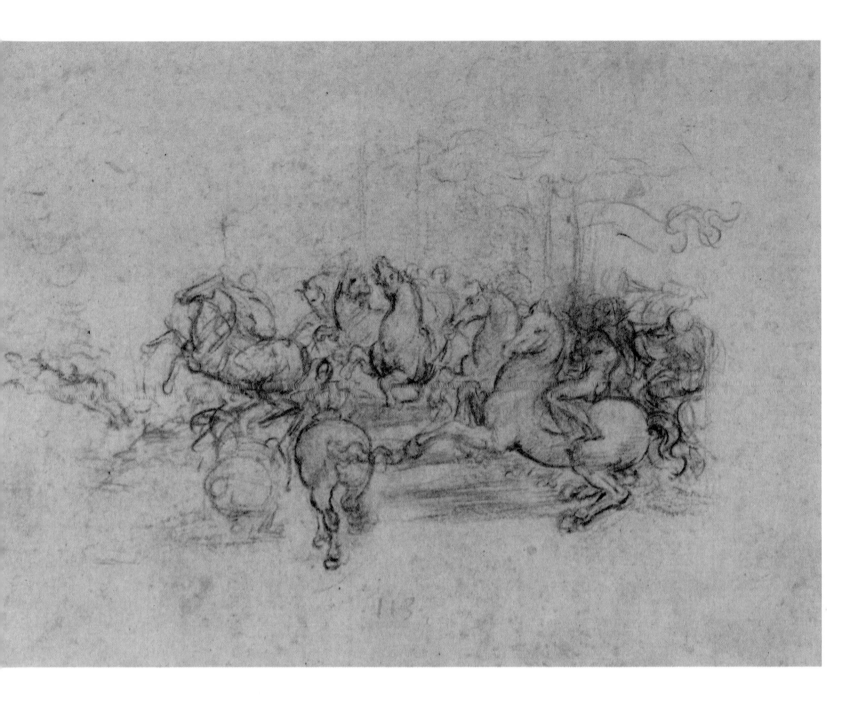

**Sketch of cavalry for
the Battle of Anghiari**
Windsor Castle, the Royal Library.

Fighting cavalry

Sketch for the **Battle .of Anghiari**.
1504-1505. Pen and ink, watercolour
shading. 147 x 155 mm. (6 ¹/2 x 6 in.).
Venice, Accademia.

was in Rimini, where he studied the fountains and the water-works.

Three days later he was in Cesena, sketching a wheeled conveyance equipped with a mechanical transmission that anticipated the gear box, and taking notes on growing grapes for wine. On 6th September, in Cesenatico, he drew plans of the bastions protecting the coast. He is said to have initiated a project for a port connected to the sea by a canal; a project that was realized some years later.

A list all of his comings, goings and doings would be boring. He went from Buoncevento to Casanova, then to Chiusi, Perugia, Foligno and Piombino, where he studied the waves, made some superb drawings of them and drew up plans for draining the marshes. Everywhere he went, he acted as an engineer taking endless notes for his reports, and methodically setting down whatever aroused his curiosity or contributed to his work. He had never drawn so much.

With his sketchbooks and ideas, he was fully in his element: fortresses, bastions, bridges, machines for peace and war, but also flowers, heads of people and superb maps, like the one he drew of Imola and its environs. At the same time, with his imagination at its peak, he also took an interest in fossils; and while studying the water-divide around Chianna and in the Upper Arno region, he looked for seashells to see if the area had been under water in prehistoric times. In this endeavour, as in so many others, he was amazingly prescient, anticipating by centuries the work of Lamarck (1744-1829) and Georges Cuvier (1769-1832).

These drawings were travel sketches, records and reference material for his life's work in progress, waiting to be fertilized by his marvellous intuitions. In every case, even in the briefest notes and quickest sketches, we find the profound imprint of his genius, the hallmark of his talent, expressed with an unerring technical precision that never settled for the banal or the conventional. Not a battlement or bastion has been left out; everything is there, down to the humblest detail, in a style of consistently high quality.

Between 1503 and 1506 Leonardo da Vinci again lived in Florence, which was then governed by Piero Soderini, who had himself proclaimed "**Gonfaloniere** for life," or Supreme Magistrate.

In Florence, which he had always considered as "his" city, Leonardo was active as a military architect and hydraulics engineer. He also re-enrolled in the painters' guild.

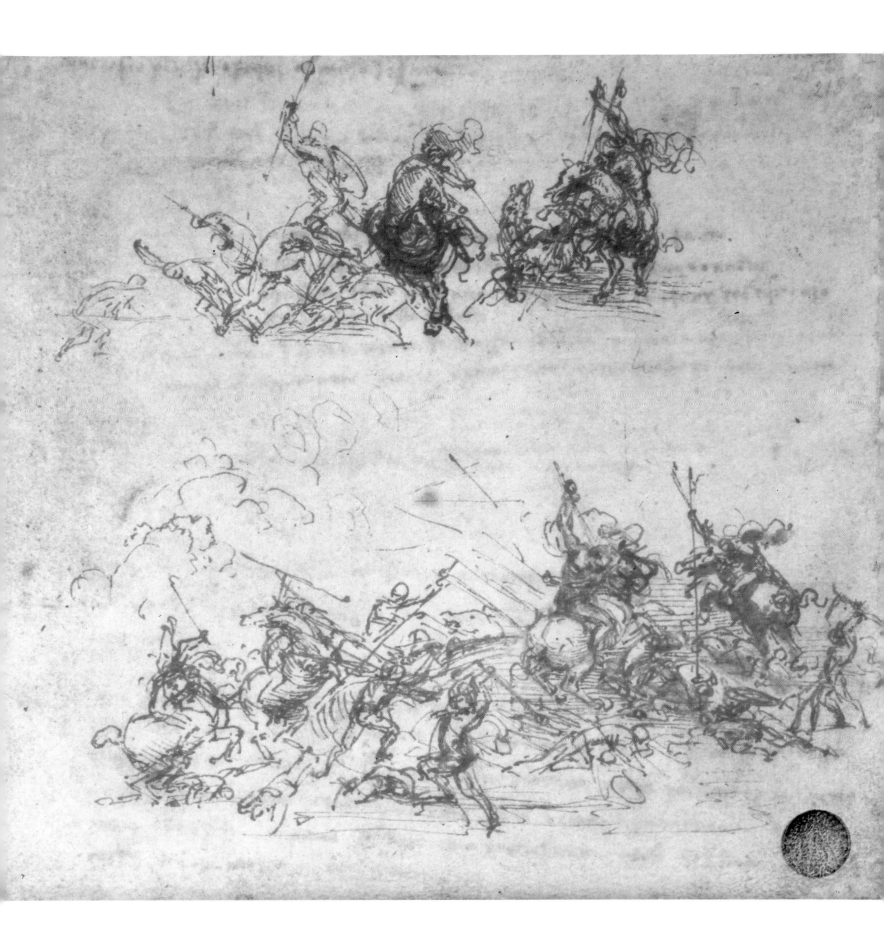

It was at the beginning of this new period in his life, on 23 July 1503 that, with the support of Soderini, he submitted to the Municipal authorities his great plan to divert the course of the Arno.

The idea was to create a navigable waterway that would connect Florence to the sea and thus allow it to become a major river port. It would also control the often catastrophic floods that plagued the city, drain the low-lying areas of the Arno Valley and produce the hydraulic energy needed for industry. But because of increasing hostilities between the rival city-states of Florence and Pisa, this grand scheme was soon relegated to oblivion. Another bitter disappointment for Leonardo.

But he was still well-off and could indulge his passion for horses, purchasing several of the most splendid breeds, although Salaï continued to be a drain on his purse, as we know from his meticulously kept account-books; in 1503, for example, he bought him a pair of rose-coloured breeches for three gold ducats, a considerable sum in those days.

On 23 July 1503, Florence stood on the brink of war. Leonardo was ordered to Pisa by Soderini to join Machiavelli in the Florentine camp and to "fill in the Arno and lift it from its bed." But his efforts to divert the river were to end in resounding failure. The result of the colossal undertaking was a vast artificial marsh that led to a terrible epidemic of malaria in 1504 and cost many Florentines their lives.

Back in Florence, the **Gonfaloniere**, somewhat wary of da Vinci's connections with the Borgia, and despite this latest fiasco, commissioned him to paint a major fresco in the great council hall of the Signoria, in the Palazzo Vecchio.

Taking advantage of the situation and exploiting the rivalry between Leonardo and Michelangelo the Florentine councillors pitted their talents against each other in this illustrious and solemn setting. Leonardo was charged with the execution of a giant mural, and Michelangelo, benefiting from the popularity of his **David**, was expected to respond in kind. The latter chose as subject the battle of Cascina, an episode in the war between Florence and Pisa when a group of Florentine soldiers left their weapons on the riverbank to go bathing and were furiously attacked by the Pisan enemy. Leonardo chose to depict the Florentine victory over Milan at the Battle of Anghiari in 1440. The similar subjects put the two rivals in direct competition.

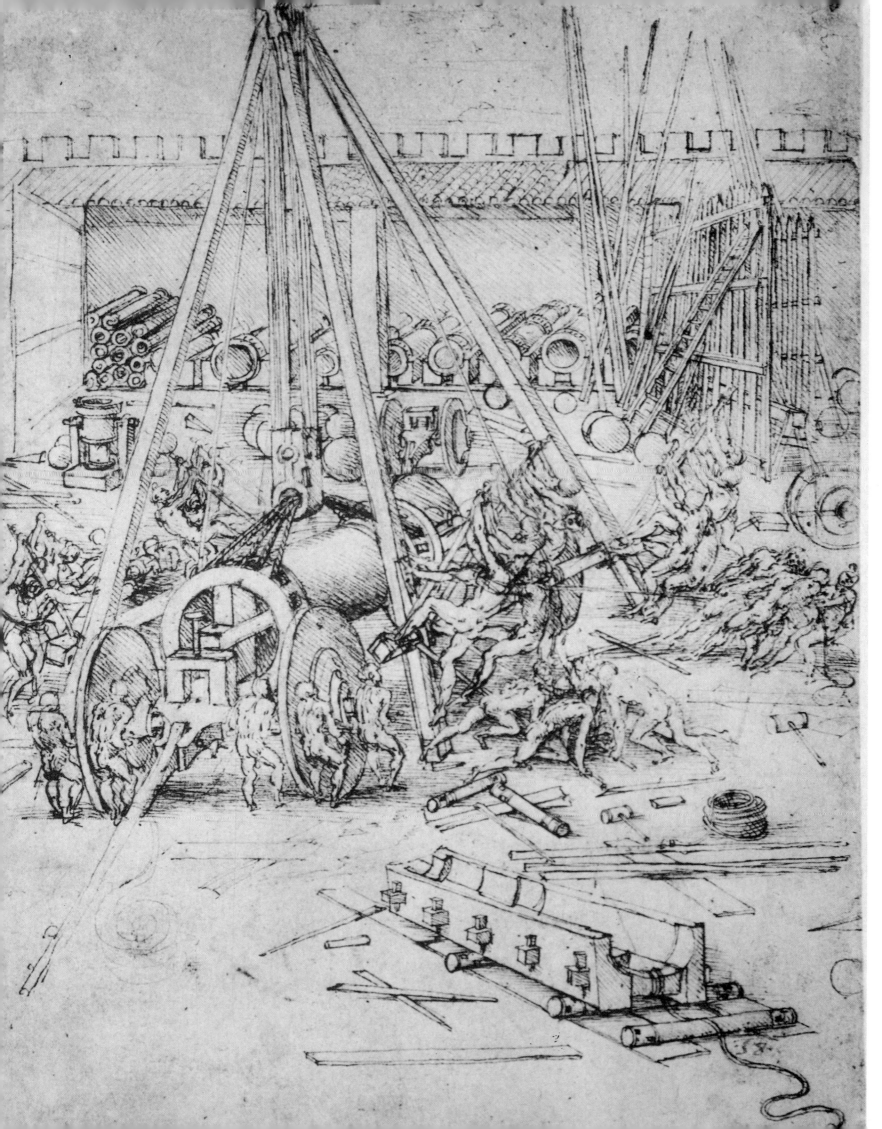

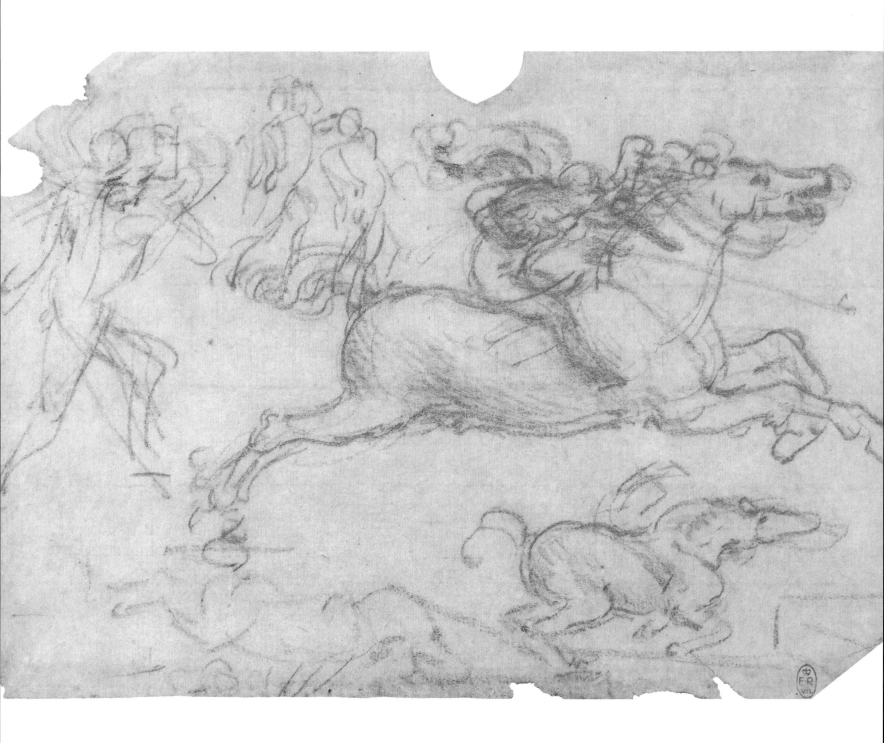

**Sketches for the Battle
of Anghiari**
Windsor Castle, the Royal Library.

The course of events that followed may be reconstituted as follows: Leonardo received his commission in October 1503, and a contract dated in May 1504; Michelangelo received his commission in July 1504, and later a contract (since lost). Buonarotti's preliminary cartoon was ready in early 1505; Leonardo's in April of the same year. The gambit of two rivals competing on the same project appeared to have succeeded.

Only Leonardo began work on his mural, and by autumn, all work had stopped. Both artists left Florence: one for Milan to work for the French (July 1506), and the other for Rome in the service of Jules II (March 1505). An extraordinary opportunity had been lost; a duel between two geniuses, one of the most formidable competitions in Renaissance art. However, the "Battle of the Cartoons," became a milestone in the cultural history of Florence.

Leonardo conceived a magnificent composition for his **Battle of Anghiari**; he describes it like another Stendhal in his famous narration of the Battle of Waterloo to Fabrice.

Let us read it in his own words:

"First you will have the smoke of the artillery, mixed in the air with the dust raised by the movements of horses and troops [....] This mixture of air, smoke and dust will be lighter on the opposite side; and as the combatants advance into this vortex, they will become less and less visible, and there will be less difference between their lit and shaded parts. Their faces and bodies, and their appearance, and the musketeers, as well as their neighbours, will be reddish. And this redness will diminish in proportion to the distance from its cause. And the figures situated between you and the light, if they are far off, will appear dark against a light field, and their legs will be less visible below, because the dust is thicker and more dense. And if you have horses fleeing from the melee, make small swirls of dust at a distance of one jump from each other, the most distant swirl being the least visible, but the highest, the most spread out, and the least dense; and the closest will be the most distinct, the smallest, and the most dense [....].

You will have a horse dragging its dead rider, leaving behind, in the dust and mud, the track of the body.

You will make the vanquished and defeated pale, with raised eyebrows; and on each side of the nose you will have several wrinkles arching from the nostrils to the corners of the eyes. The nostrils are raised – causing the wrinkles – and the arched lips reveal the upper teeth; the jaws widen in a cry

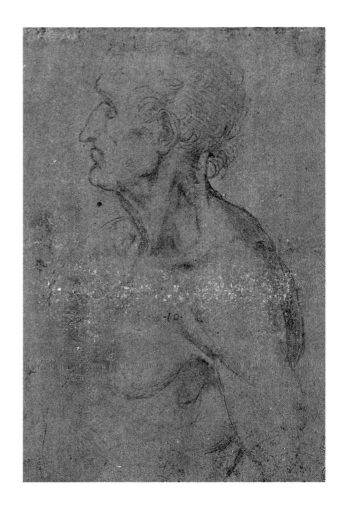

Profile of an Old Man
(probably from a dissected body).
Red chalk on red-toned paper.
196 x 145 mm. (7 3/4 x 5 3/4 in.).
Anatomical Studies, fol. 133v.
Windsor Castle, the Royal Library.

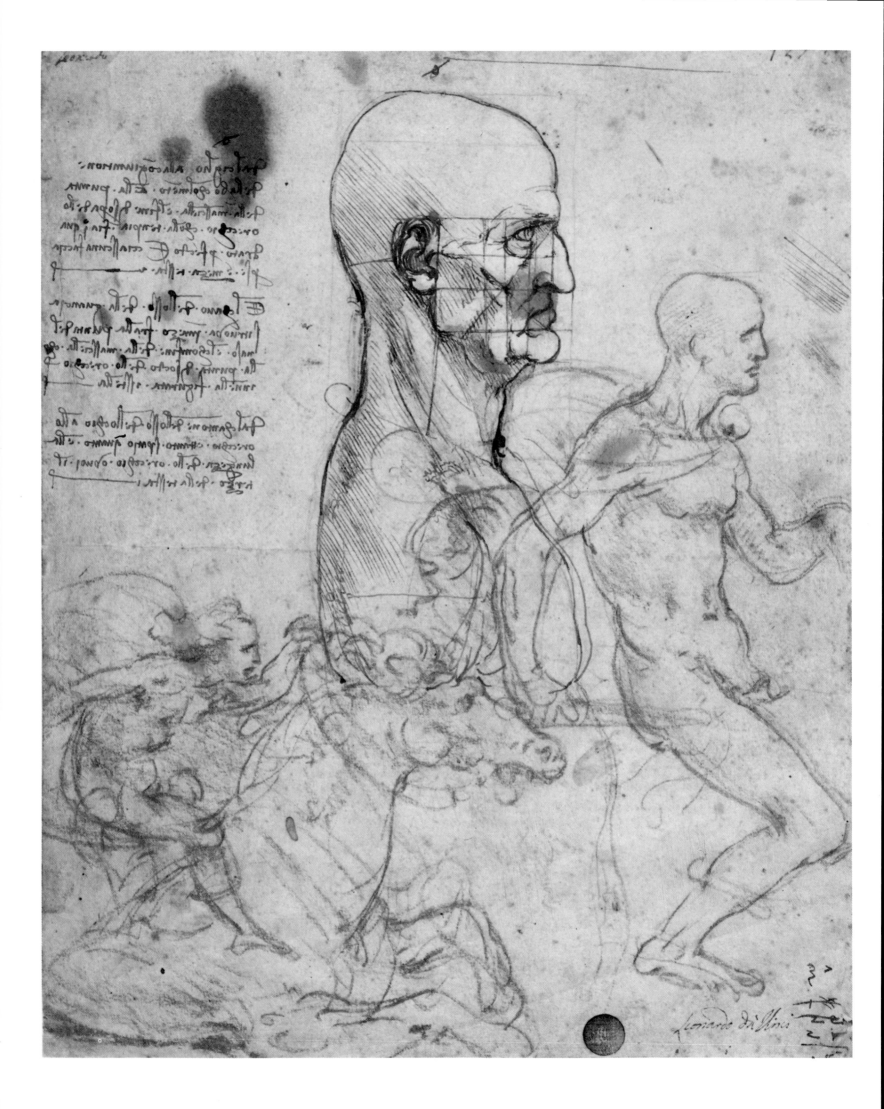

of pain. One hand should shield the anxious eyes, the palm turned towards the enemy; the other should be on the ground, to support the raised body. You will have others who shout, mouth open, in flight. You will have different sorts of weapons between the feet of the combatants, such as splintered shields, spears, broken swords, etc.; you will have dead bodies, some half covered with dust, others entirely...."

This analysis of a pictorial composition is astonishing: all-enveloping clouds of dust, confused melees, the terrible grimaces of the men and horses, shattered weapons and scattered bodies, the strangeness and horror of the postures and movements, chaos full of blood and sweat. Leonardo's vision of the battle is dazzling in its clarity; before painting, even before drawing it, he set down all aspects of the awesome fray. Then, with his artistic skills, he soon transcribed the horror into visual form.

What strikes us most today is that Leonardo had long grasped the principle of an essential balance between part and whole, between the detail of cruel actions and the overall chaos of battle. Yet no words can communicate what his great fresco finally depicted. In his drawn copy of Leonardo's **Battle of Anghiari**, Peter Paul Rubens (1577-1640) managed to reconstruct the intense violence that his predecessor had wanted to represent. Rubens' drawing is dated 1604 and was made after a poor sixteenth-century wood-engraving reproducing Leonardo's short-lived masterpiece. Even so, Rubens succeeded in expressing the tragic grandeur of Leonardo's composition better than many other artists who were able to work directly from the original fresco.

The rest of the story of the **Battle of Anghiari** fresco is a brief and sad one.

In late February 1505, with the cartoon finished, Leonardo made ready to transfer the sketch to the wall. But he wanted to give his work an extra measure of brilliance, and, as we know, he prided himself on his knowledge of chemistry. Thus, using a recipe culled from the writings of Pliny the Elder, he coated the walls with a special ground, then left for Fiesole at the invitation of Alessandro Amadori, a deacon and brother of his late father's first wife. There, forgetting for a time his duties as painter to the Signoria in Florence, he wrote a new treatise on the flight of birds, built a sort of glider, and may have made a test-flight from Monte Cecero.

Sketches for the Battle of Anghiari
Venice, Accademia.

Leonardo was not concerned to establish a canon, or set of formal rules, but to measure human and animal forms so well that he could determine the proportions of their respective parts. For Leonardo, the supreme good of Creation was Harmony: this was his ultimate goal. He took from the exact sciences only what he needed in order to create his works, not considering the study of proportions as an end in itself.

Once again, freed from the constraints of his commissions, he felt restored to himself, at peace, and ready to create new masterpieces.

Leonardo and his assistants undertook to finish the mural during the summer of 1505. In order to make the coating dry faster, he lit a great coal fire at the base of the wall. The lower parts dried well enough, but the upper parts remained moist, causing the paint to run, quickly reducing the painting to an inchoate mass of colour.

Leonardo must have been crushed. Witnesses report hearing him lament for hours on end over his lost masterpiece that he had executed not only with great talent, but also speedily. He had hopes of salvaging his vast composition. He told everyone that it was impossible for him to take up the work again, the shock was too harsh, the loss of face too bitter. He would soon go back to work; but he was still too confused, and did not know when he would start. Humiliated by this terrible accident, he would give no details when asked about his plans. He was understandably distraught, but he still believed in his **Battle of Anghiari**.

He was soon back in his laboratory, testing pigments, grounds and glazes. He needed distance, time to think and to undertake new projects. We have proof that he actively wanted to save his mural in the hall of the Grand Council, for he had a sturdy fence raised in front of the damaged work to preserve what remained. But no one really believed him. The Florentines were already split into two opposing factions and refused to accept that risk is the price of genius. Michelangelo had already left for Rome, but they shared his opinion that "the man can only imagine – he cannot create!"

The technical – and not pictorial – failure of the **Battle of Anghiari**, combined with the fiasco of the Arno project destroyed Leonardo's reputation in Florence. Soderini had by then lost all confidence in his contractor's abilities both as painter and as engineer. When Leonardo was bold enough to request payment of his fees, the **Gonfaloniere** had them sent to him in base copper coin – without a word. Outraged, humiliated and rejected, Leonardo sent the offensive wages back.

It was at this time that Leonardo painted the **Mona Lisa**. Executed between 1503 and 1505, this picture probably represents the likeness of the young third bride of Bartolomeo di Zambini del Giocondo, commander of the Florence police and a notoriously jealous old man. Legend has it that the

Studies of cavalry
Florence, Uffizi,
Department of Prints and Drawings.

painter, dressed in his usual knee-length rose cloak, relieved the monotony of the lengthy sittings by hiring jesters, singers and musicians to keep his sitter distracted and still enough for him to render her features in such fine detail that the brushwork is invisible to the naked eye.

Vasari greatly admired its realism. Before Leonardo, portraiture was often concerned with types, but here the painter concentrated on psychology: "Her eyes have the sparkle that can be observed in life. They are outlined with reddish and leaden tints that must be applied only with the greatest delicacy. The nose, with its lovely, delicate nostrils, is

truly the nose of a living person. The mouth with its red lips, and the scarlet of the cheeks are not paint but living flesh. If you look closely at her throat you can imagine that the pulse is beating."

Robust and contented, with full cheeks and a body rounded out by marriage and motherhood – she gave birth to a stillborn child – Mona Lisa appears in stark contrast to the tastes of the period, which preferred women with narrow shoulders and a smallish head poised on a slender neck, a type superbly represented in a work such as Botticelli's **Birth of Venus**. This does not mean, however, that the **Portrait of Mona Lisa** is

Figures in combat
(detail)
Venice, Accademia.

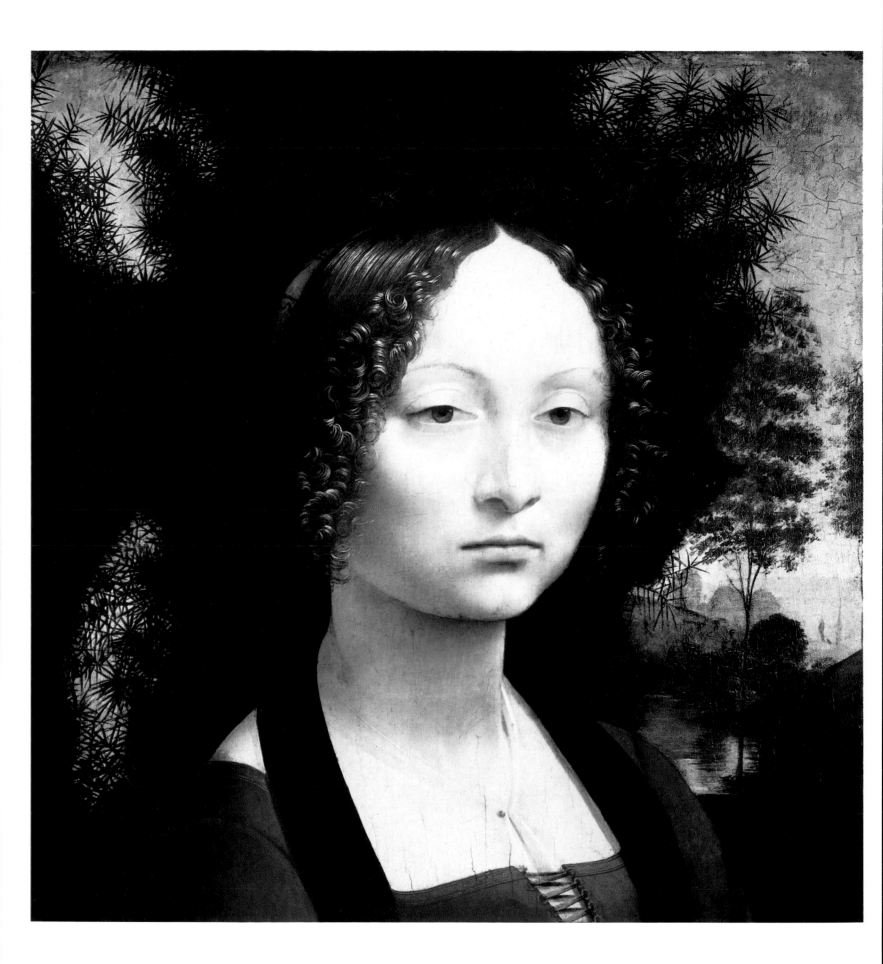

realistic or naturalistic. Like many other paintings of the Italian Renaissance, it has close affinities with the metaphysical ideas of Marsilio Ficino. The light in which she bathes is the light of her mystical body. This most famous painting of all time is an image of fascination and mystery incarnate. As Jules Michelet noted: "The picture beckons me; I am drawn to it as to a serpent."

At the time Leonardo was also working on the preparatory sketches for **Leda and the Swan**.

Portrait of Ginevra Benci (the Lady of Liechtenstein)
1474-1476. Oil on wood.
42 x 37 cm. (16 1/2 x 14 1/2 in.).
Washington D.C., National Gallery of Art.

Painted in 1475, this striking likeness of a young, almost adolescent, Florentine noblewoman is set against an emblematic juniper tree. Her enigmatic expression is a prefiguration of the *Mona Lisa*, which was painted thirty years later. The rocky landscape glimpsed below on the right adds to the overall mystery of this work.

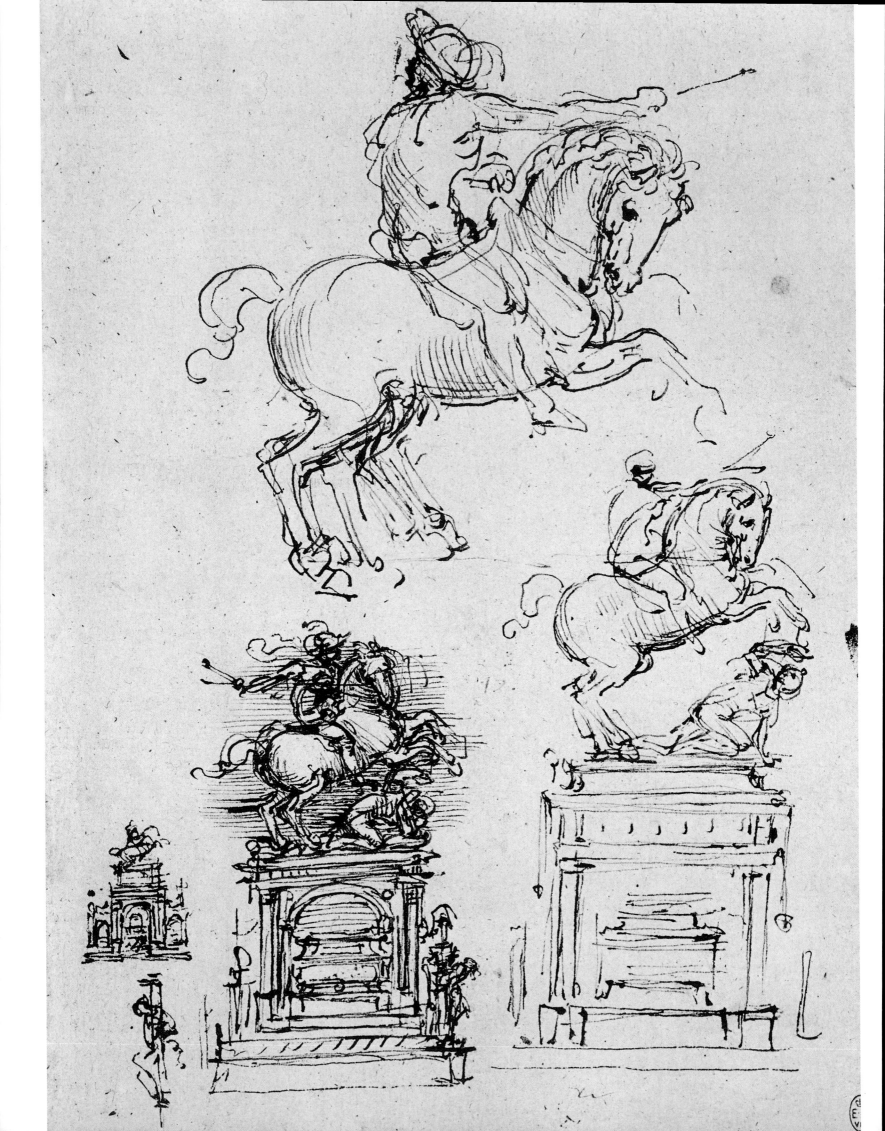

6

"I shall continue"

If, when Leonardo left Florence again after his double fiasco (the diversion of the Arno and the Battle of Anghiari), he had turned back to contemplate his life so far, he would have seen mostly ruins; his genius went hand in hand with misfortune. His most important projects had failed, his works remained unfinished or had disappeared, his friends had abandoned him, and his patrons were weary of him. Nonetheless, he wrote three proud words in his notebook: "I shall continue."

In Milan, a bruised Leonardo was magnificently received by Charles of Amboise, the French marshal and a lord in the grand Renaissance style. He was invited to re-channel rivers, build a city surrounded by gardens and aviaries, and to create an equestrian monument for Gian Giacomo Trivulzio, a Milanese nobleman who had decided to finance a monumental tomb in the church of San Navarro. This last commission, could have compensated Leonardo for the destruction of **Il Cavallo**, the model for the equestrian monument to Francesco Sforza, his aborted masterpiece.

But once again, although carefully planned and calculated, the Trivulzio memorial was never completed. But this new period in Milan saw Leonardo making remarkable progress in his research, especially in the field of botany. As for the Trivulzio monument, there is a very simple reason why it was never realized, once again a political one: the Duchy of Milan was preparing its defences for possible hostilities on its eastern borders, and so it was not the right time for great sculpture projects.

Sketches for the Monument to Marshal Trivulzio
Windsor Castle, the Royal Library.

This monument was commissioned for the Trivulzio funerary chapel in the church of San Celsio in Milan. It was never completed.

Overleaf

Studies of horses
Around 1490.
Windsor Castle, the Royal Library.

Study of a model for the casting of the Sforza Monument
Manuscript in the Biblioteca Nacional, Madrid.

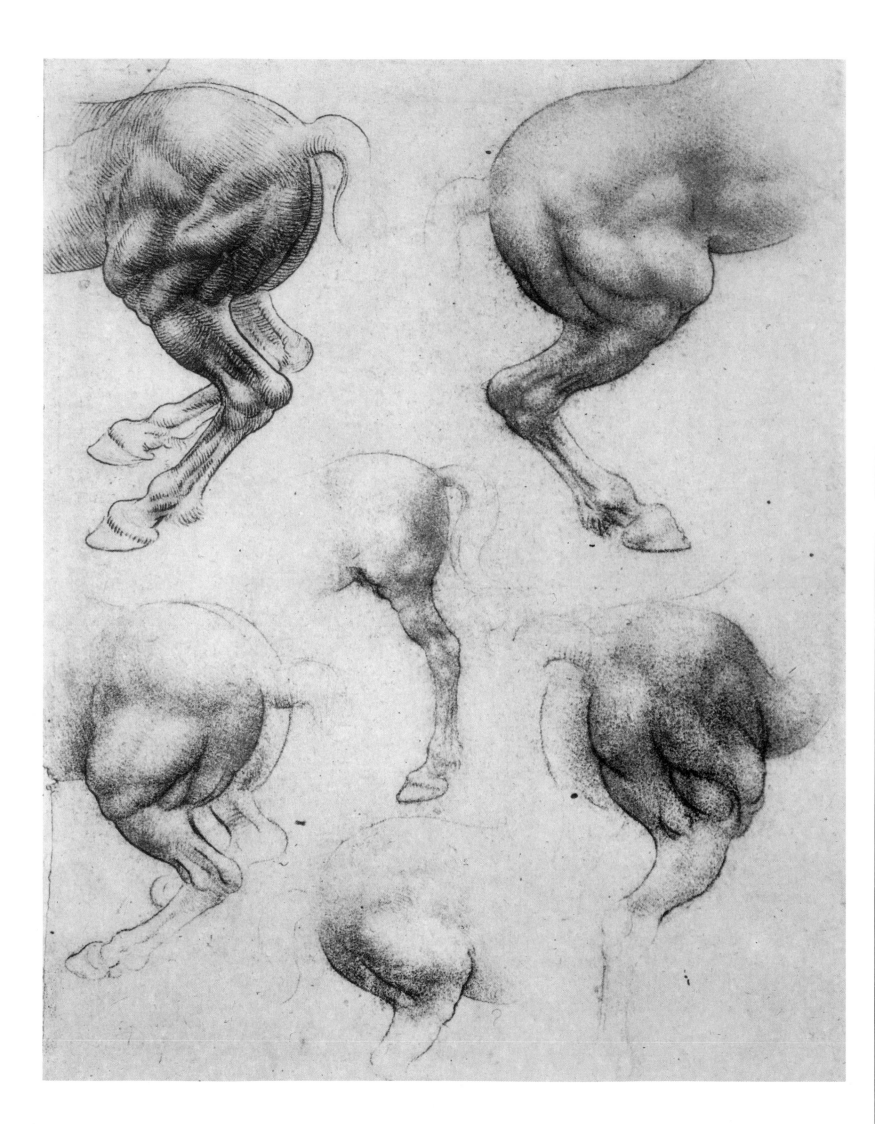

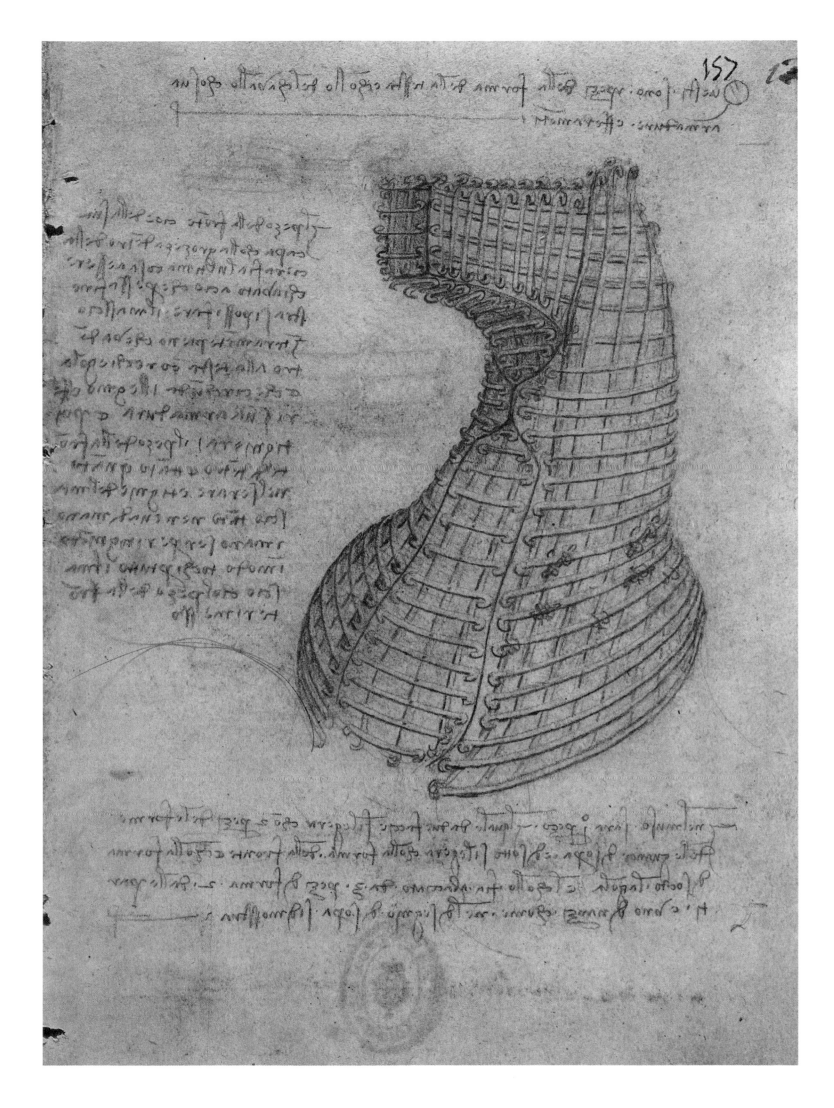

Principles of bird flight

fol. 8v. Turin, Biblioteca Reale.

"If the wing and tail are too much
against the wind, lower half
of the opposite wing and you will
receive the impact of the air;
in this way it will raise itself. If the tail
is under the wind, lift the opposite
wing and the bird will raise itself
as you wished, on condition that
the lifted wing is less oblique
than the one opposite.
And if the wing and breast are against
the wind, it will lower half
of the opposite wing, the wind will
strike it and push it upward, and
this will raise the bird again.
But if the wing and back are under
the wind, the bird will have to lift
the opposite wing and spread it in
the wind, and it will immediately raise
itself. If the bird's hind-parts are against
the wind, to create a balance of forces,
the tail will have to be placed under
the wind. But if the bird's hind-parts
are under the wind, if it sets its tail
against the wind, it will raise itself
again."

Leonardo continued to live in the company of Salaï (who had become his pupil and confidant), and several other friends. He was as frugal as ever, living on bread, wine, eggs, mushrooms and fruit. He gave the impression of following a set of guidelines, indifferent to the opinions of his contemporaries – or so it appeared. He continued to frequent the bird sellers in the flower market, to open the cages and set the winged creatures free, watching them as they rose into the sky, but no longer affected by the laughter and jibes of the crowds.

At a time when the caprice of fashion dictated ample, sombre dress, Leonardo continued to sport knee-length rose coats. Always meticulously groomed, he would curl the ends of his long moustache, above his long, undulating beard. He was a calm, restrained man not affected by the fashions or the political chaos of the day.

Not surprisingly, he wrote: "Patience is to insults what clothes are to the cold: the colder it gets, the more clothes you have to wear for protection." He had reached the age when he could subject his tumultuous passions to the rule of his will. He was above the fray, determined to remain aloof from the folly that raged around him. His close collaboration with so dangerous a man as Cesare Borgia, for which he has often been criticized, should be seen as a welcome opportunity to exercise his talents as an engineer, rather than in the context of any fascination for him. Leonardo was not curious about other people.

It was during this period that he enlisted the services of the fifteen-year-old Francesco Melzi, an elegant, likeable fellow, who from then on faithfully and fervently attended to the material needs of his master.

In 1507, when Louis XII made his entry into Milan, Leonardo was again asked to organize the festivities. He may have designed more of the marvellous machinery that had so delighted the public.

A new source of satisfaction was his friendship with the young scholar Marco Antonio della Torre and Jean Perréal (1460-1530), the court painter of the French king who was also an avid student of mathematics and the sciences, but best known for his portraits of Charles VIII, Anne of Brittany and Jean de Luxembourg. He continued to study the motion of the planets while working on the **Mona Lisa** and **Leda**, a bold standing nude with modestly downcast eyes, as well as on his **Virgin and Child with Saint Anne**, in which the wonderful combination of power and tenderness provoked the admiration of his contemporaries.

Top to bottom

Plan for a ribbed wing partially covered with taffeta
Ms B, fol. 74v. Paris, Bibliothèque de l'Institut de France.

Device with a crank for beating wings
Cod. Atlant. fol. 313 v-a.
Milan, Biblioteca Ambrosiana.

Experiment for wing lift
Ms B. fol. 88v.
Paris, Bibliothèque de l'Institut de France.

Leonardo was fascinated by the riddle of bird flight. Thanks to his keen observations, he was able to discover the importance of centres of gravity and lift. In an attempt to endow humans with this capability, he built a glider with articulated wings modelled on bats' wings.
In his enthusiasm, he noted: "for the first time, the great Bird will take flight... filling the universe with stupefaction, emblazoning the chronicles with his fame. Eternal glory to the place of his birth!"

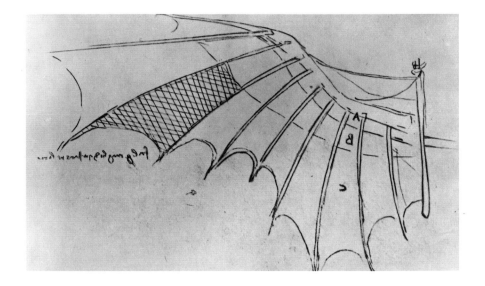

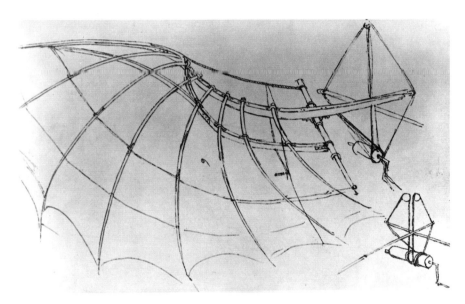

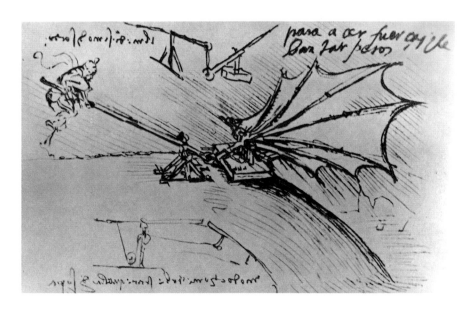

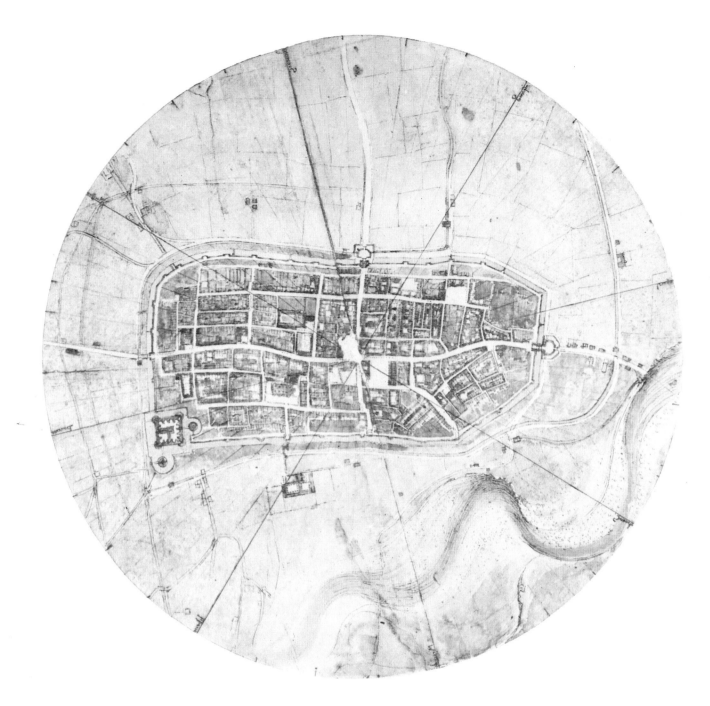

His intellectual and artistic efforts provided him with much-needed fulfilment and gave him a new lease of life. But new political storms were brewing in Milan. Louis XII returned to Italy and entered Milan in May 1509 and almost immediately led his troops against Venice, with Leonardo in his service as military engineer. Leonardo witnessed the Battle of Agnadel. Ever eager to collect information, scientific explanations, new devices and formulas, he interrogated all those he encountered in the field and transcribed everything in his notebooks. This second Milanese period, which lasted until 1513, was characterized by a more profound interest in pure science and a new enthusiasm for theoretical studies.

Leonardo received a regular stipend, but probably did little work as an engineer and so had ample leisure to

devote himself to his long and laborious scientific initiation. Giorgio Valla's **De expendentis et fugiendis rebus**, published in 1509, provided him with a valuable synthesis of Archimedes and Euclid, introducing him to Greek geometry and the entirely new approaches and solutions that it offered.

However, these happy years soon came to an end. His friend and protector Charles of Amboise died in 1511, and the ensuing French defeats forced them to withdraw from Milan. With the help of the Swiss, Duke Massimiliano Sforza recaptured the Lombardian capital on 29 December 1512.

Leonardo, accompanied by Salaï, Francesco Melzi and three other pupils, left Milan on 23 September 1513 to make the journey to Rome, where he had been called by Cardinal Giuliano de' Medici, the brother of Giovanni de' Medici, who had acceded to the papal throne on 11 March 1513 as Leo X.

In Rome, Leonardo and his suite were generously lodged in the Belvedere, a summer villa perched on a hill in the Vatican with splendid gardens. His new patron gave him with a monthly salary of thirty-three gold ducats, a considerable sum at the time. He also provided him with a fully-equipped laboratory so that he could build parabolic mirrors for military purposes in the manner of Archimedes, and hired the services of a German craftsman to assist him. Bramante, Michelangelo, Raphael, Sodoma, and many young artists were active in Rome at the time.

Leonardo's Roman patron, Giuliano de' Medici, was a perfect courtier, well-educated, sensitive, affable, a lover of poetry, with wide-ranging interests. Unfortunately, he was beset with ill-health. He was ceremoniously received in Rome and appointed Papal General but was unable to lead his troops during the campaign of 1515, and died in Florence in March 1516. This new loss was disastrous for Leonardo, now in his sixties, for he was neither much liked nor understood by Pope Leo X.

Leonardo's Roman sojourn lasted two years, from 1513 until 1515. It is interesting to note that in this case too he was summoned to the Eternal City as an engineer and not as painter. Unfortunately, the Sangallos, who had forged a veritable dynasty of engineer-architects, were all-powerful in these fields, and Leonardo was entrusted only with minor inspection trips. One mission took him to Parma in the autumn of 1514 to check the city's fortifications. It would seem that he

Plan of the town of Imola
Windsor Castle, the Royal Library.

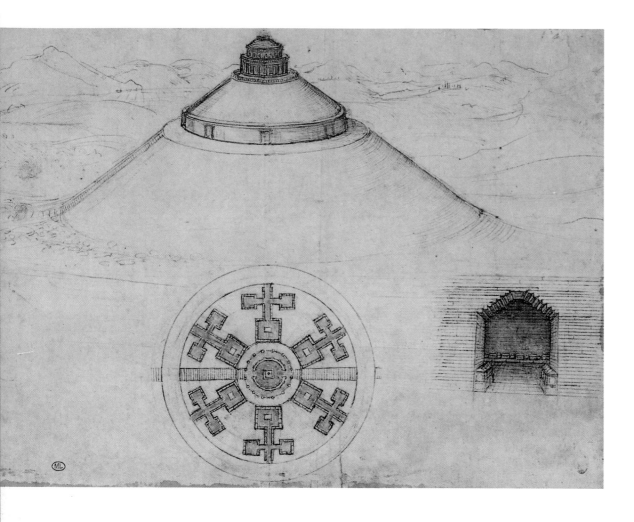

Left to right

**Plans for an Etruscan monument:
elevation, floor-plan, detail**
Pen and ink, grey wash, pierre noire.
19.8 x 26.8 cm. (7 ³/₄ x 10 ¹/₂ in.).
Paris, Musée du Louvre, Department
of Drawings.

Sections of a tower and fortress
Paris, Bibliothèque de l'Institut de
France.

**Church with longitudinal
floor-plan and a "preaching"
amphitheatre**
Paris, Bibliothèque de l'Institut de
France.

Leonardo's techniques were close
to the structural concepts and military
requirements of our own day, which
are constantly being re-examined to
adapt to the powerful offensive
capabilities of modern warfare.
The architectural forms conceived
by Leonardo held their own against
the might of artillery well into
the nineteenth century. The height
of these constructions was
progressively reduced and they were
made more massive, disappearing
below ground level, until they became
the concrete casemates and bunkers
that formed the defences
of the Maginot, Siegfried, and
Schröder lines.

Architectural sketch for a tower
Drawing with watercolour.
Paris, Musée du Louvre.

Opposite

**Section showing buildings
in a town with elevated streets;
below, a wheeled device**
Ms B, fol. 36v. Paris, Bibliothèque de
l'Institut de France.

did not participate in the construction of the great Roman fortresses that marked a turning point in the art of fortification, nor in the completion of the monuments being created to embellish the papal city.

In artistic circles, which were dominated by his arch-rival Michelangelo, Leonardo's style of painting was not appreciated. He was made to feel this, and, considering his great sensitivity and rather misanthropic bent, he must have suffered a great deal. There were continuous sarcastic barbs – fuelled by Michelangelo – alluding to non-existent equestrian statues and the dismal fate of his **Battle of Anghiari**. The paintings and the treatise on singing that he wrote in this period are all lost.

Then Pope Leo X was persuaded by his brother Giuliano de' Medici to commission a small picture with the comment that he did not expect it ever to be finished. According to Vasari, when the Pope heard that Leonardo was – yet again – attempting to perfect a new type of varnish, he exclaimed: "Alas! He will never come to any good: he thinks of his finish before he has even started!" Needless to say, the picture never saw the light of day.

In fact, while Michelangelo was considered as a master painter and sculptor, Leonardo was essentially recognized for his abilities as an engineer. We next see him strategically retreating into one of his favourite fields: hydraulics. For once luck was with him: Giuliano, who had acquired the unwholesome parts of the Pontine Marshes to the south of Rome, wanted to have them drained and the

Leonardo abandoned the traditional design of walled cities with fixed perimeters. His decentralized town-planning foresaw the outward development of cities into the countryside four centuries before open cities and suburbs became a reality. He defined the concepts of separate traffic flow using distinct thoroughfares, the reduction of urban density, the standardization of sanitary facilites, the balancing of residential and open spaces, and considered the proportions of house-height to street-width. He also thought about the evacuation of waste-water into rivers and the sea. He suggested solving the problem of increasing inhabitable space by elevating and superimposing streets. Da Vinci always superbly translated his futuristic urban schemes into a clear, visible form, anticipating many ideas that Le Corbusier worked out in his research on volumes and space.

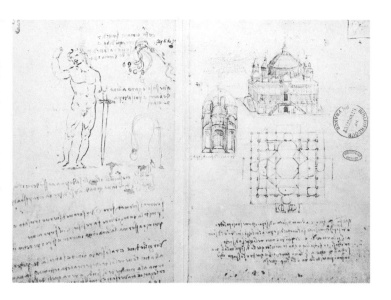

Floor-plan, elevation, and perspective drawing of a square, domed building with loggias on the façade
Ms Ashburnham, no. 2037, fol. 4v. Paris, Bibliothèque de l'Institut de France.

Opposite

Domed churches with radial floor-plan and studies of proportions
Ms B., fol. 17v.
Paris, Bibliothèque de l'Institut de France.

reclaimed land put to profitable use. This task was entrusted to Leonardo and his assistant, Fra Giovanni Scotti from Como.

Work began, and looked promising – when Leonardo fell ill. Giuliano de' Medici was also ill, and was soon to die. Leo X, who had always been opposed to the project, took advantage of his brother's ill health and put a complete stop to the works. In a last attempt to regain his favour, Leonardo presented the Pope with a copy of his **Treatise on the Voice** through the services of his secret chamberlain, Battista dell'Aqua.

But an atmosphere of disgrace and oblivion pervaded the Belvedere. The death of Giuliano de' Medici was a deep personal loss for Leonardo. Tired, world-weary, and surprisingly aged (he was sixty-four), he expected nothing from his fellow-men. Discouragement mixed with increasing bitterness finally drove him – perhaps for the first time in his life – into a sort of depression. It was then that he wrote these fateful words: "The Medici created me, the Medici have destroyed me."

Throughout his life Leonardo had encountered many worthy men who held positions much more important than any he had been offered: Donato Bramante (the architect associated with the new basilica of St. Peter in Rome), the Sangallo brothers (also well-known painters), and Michelangelo. Were they really more talented than Leonardo? Not at all. But they were more conscientious and more practical. Workhorses are often more successful than men endowed with superior gifts – and all the more so when they are so talented. Drawn by the appeal of honours and influence, some consolidate their territory and bitterly defend their conquests, while others, realizing the vanity of worldly ambitions, shrug their shoulders and walk away.

Leonardo had at least remained true to himself and endured his proud solitude, no matter how much he suffered. Whatever happened, he remained true to himself. Toeing the line, striving to please or not to displease, would have been out of character for him. What he wanted was to fly, to soar to the highest peaks. Baudelaire may well have had him in mind when he wrote these lines in **The Albatross**:

> Exiled amid the earthbound throngs,
> His gait hampered by his giant wings.

Vasari's account can serve as our conclusion to Leonardo's Roman adventures:

"He went to Rome with Duke Giuliano de' Medici on the election of Leo X, who had studied philosophy and especially alchemy. He walked a lot and out of a paste made with wax he

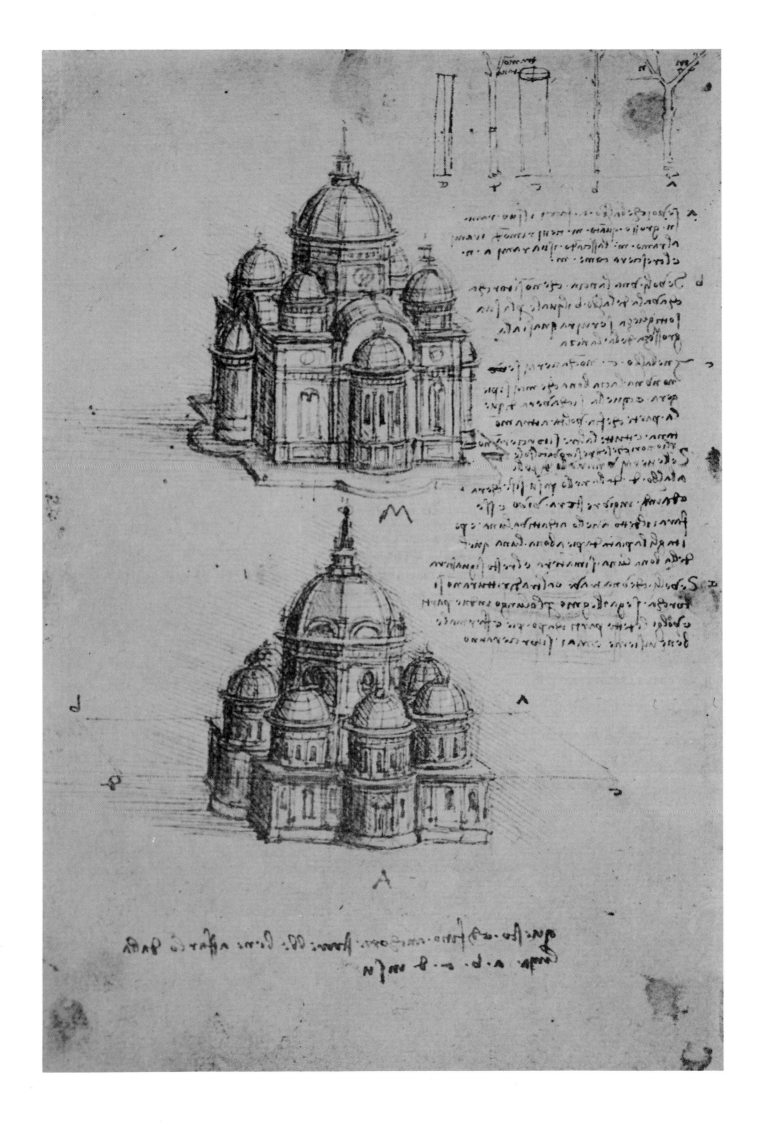

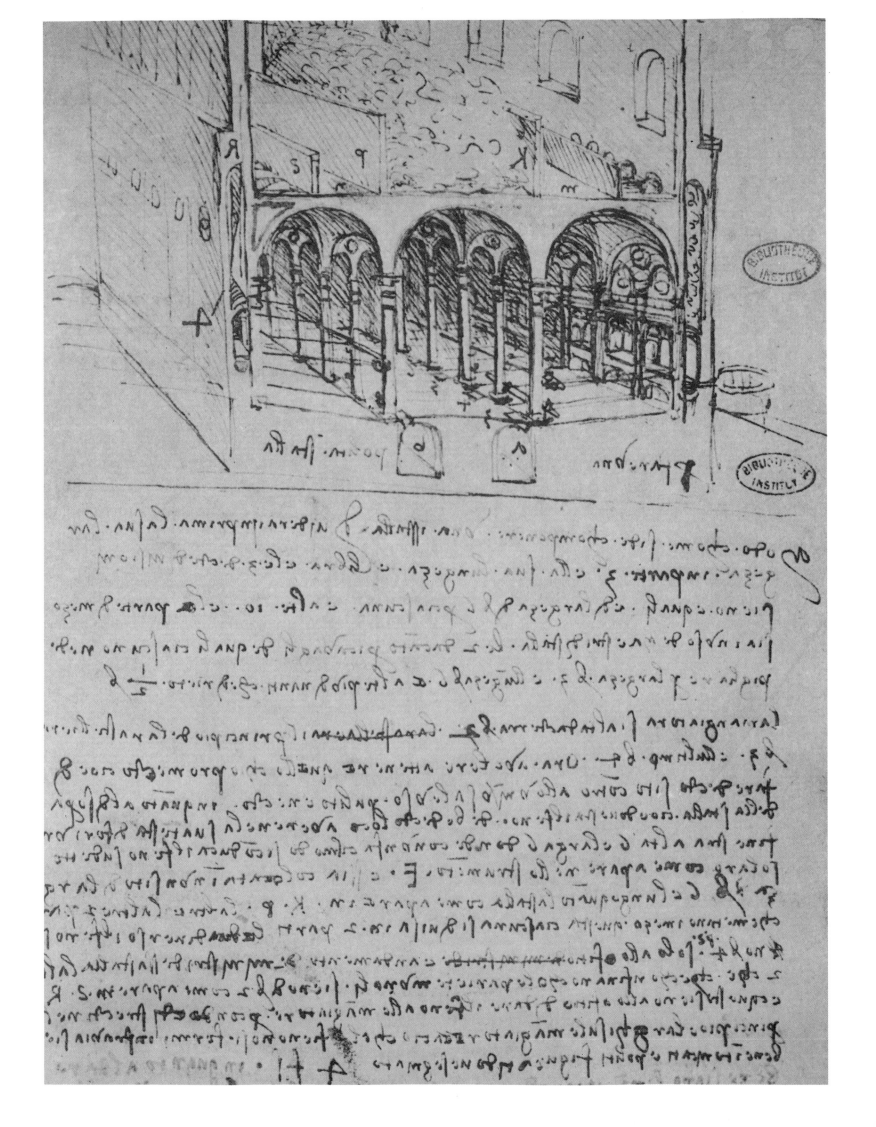

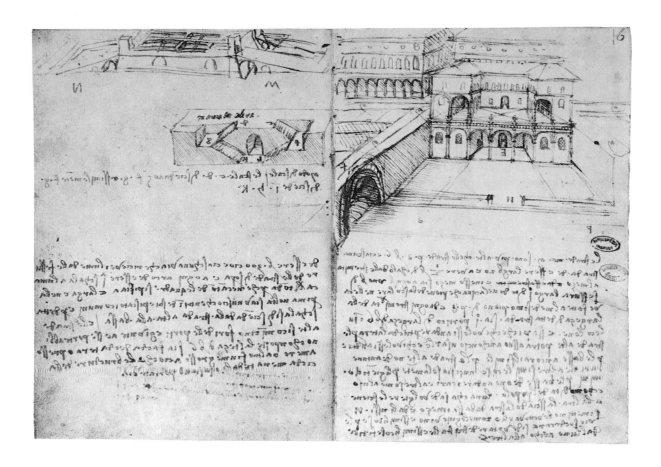

Above, from left to right

Sketches of staircases

**Thoroughfares and houses
in a town with elevated streets**
Ms B., fol. 16v.
Paris, Bibliothèque de l'Institut de
France.

Opposite

Project for stables
with an apparatus for the automatic
filling of feed-racks.
Paris, Bibliothèque de l'Institut de
France.

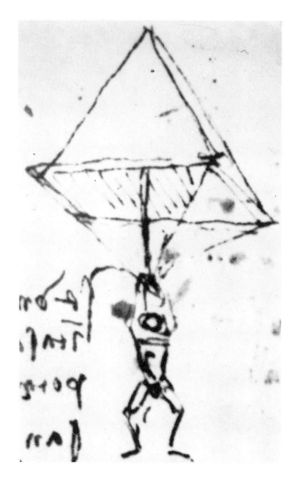

fashioned very light, hollow animals which flew when blown up, but fell as soon as the air escaped. On a curious lizard found by the vine-grower at the Belvedere he fastened scales that he took from other lizards and dipped in quicksilver so that they shimmered as it moved; he then gave it eyes, a horn and a beard, tamed it and kept it in a box to terrify his friends.

He would often clean the guts of a bullock until they were so small that they could be held in the palm of the hand. In another room he kept a pair of blacksmith's bellows, which he would use to blow one of them up until it filled the room, which was a large one, forcing anyone there to take refuge in the corners. He would compare these transparent objects full of air that took up so little room at the start and so much at the end with our personal energy. He perpetrated many such follies, studied mirrors, and made curious experiments in his search for oils for painting and varnish to preserve the pictures.

At this time he painted with infinite diligence and skill a small picture of the **Virgin and Child** for Baldassare Turini of Pescia, the notary of Pope Leo. But it is very damaged today, either because the ground was badly prepared or because of the strange mixture of grounds and pigments. In another small picture he depicted a marvellously beautiful and graceful boy; both works are now in Pescia in the possession of Giulio Turini, Esquire." (These works, now lost, have not been identified).

A final contest brought the two rivals, Leonardo and Michelangelo, together again in Florence. After having competed in the fields of sculpture and mural painting, the two masters were to be judged by their architecture. The Medici came back into power in 1515, and immediately made plans to restructure the urban fabric in a particularly sensitive area between the church of San Lorenzo and their adjacent palace. They asked Leonardo to draw plans for a new palace on the corner of the Via Larga and the Via di Pucci, opposite the Palazzo Vecchio. A drawing by Leonardo suggests that the sector would have been redesigned with a widening perspective to set off the façade of San Lorenzo. Giuliano, his faithful patron, was in Florence in the autumn of 1515, while Leonardo was working on the plans for a new type of palace with four corner turrets, which we know today only from a stray sketch among his notes. His design offered a new and arrogant expression of the new political might of the Medici – a cause for concern. It would have taken all of Giuliano's powers

of persuasion to push the plan through, but when he died in March 1516, it was immediately abandoned.

It was just at this time that Michelangelo, proceeding from triumph to triumph, was poring over his cartoons for a monumental façade for San Lorenzo, which had remained (and still remains) unfinished. Other artists were called upon to make sketches for this project, including Leonardo. Michelangelo, bent on ousting his rival from the lists at every turn, gave it his all. Leonardo, on the other hand, weary of such base disputes, seems to have let it go at that, and gave up trying to promote his ideas. Once again, he turned on his heels, forsook his sketches and let fate have its way.

Michelangelo's designs were approved in December 1516 – Leonardo had by then already decided to leave for France – but the project was abandoned in 1520. By then Leonardo had already died, never having learned of his cruel rival's failure.

Michelangelo, however, was not one to desist. He persisted in his hatred for Leonardo to the end of his days, and would never have acknowledged any debt to him. Proof of his enduring hostility to the man who was his worthiest rival may be found in an answer he made in 1546 (twenty-seven years after Leonardo's death) during the inquest on the "paragone," an attempt to determine the hierarchy between painting and sculpture. After stating that good painting tends towards effects of relief, which is the natural prerogative of sculpture, Michelangelo concluded: "He [Leonardo] who wrote that painting is nobler than sculpture – if that was all he understood, my servant could have discoursed better on the subject."

While these petty squabbles were taking place, the face of Europe was steadily changing. Weapons of war both new and old were forcibly reminding Italy that it was a much-coveted land.

The year 1515 marked a new – and ultimate – tuning point in Leonardo da Vinci's life. On New Year's Day he learned of the death of his royal protector, Louis XII. François I, his successor on the French throne, undertook the difficult reconquest of the Duchy of Milan, which had been ruled since 1512 by the son of Massimiliano Sforza supported by an army of Swiss mercenaries.

Events progressed swiftly. The French king sealed an alliance with Venice, rapidly took control of Genoa and defeated the combined troops of an anti-French coalition

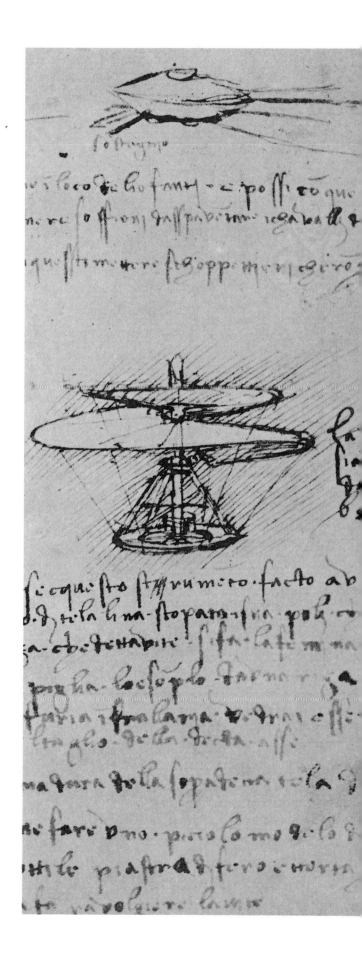

consisting of the Emperor Maximilian, Ferdinand of Spain, the Swiss cantons, Massimiliano Sforza, and, from July 1515, Pope Leo X himself. In September, François I won the day at the Battle of Marignan (now Melegnano) against some twenty thousand Swiss foot soldiers. Among the French heroes of that battle was Pierre du Terrail, master of Bayard, called "last of the knights." In his own way, with his abrupt and fanciful manners, Leonardo da Vinci was part of the same world.

For Leonardo, this new turn of fortune marked the end of his worries. Indeed, where Louis XII had been content to commission pictures from the illustrious painter, François I took a passionate interest not just in the pictures, but also in the conversation and visionary ideas of the Tuscan genius. He offered him what he has never received: a substantial stipend, a charming castle (the Castle of Cloux, near Amboise, owned by the Duke of Alençon, today called Clos-Lucé), and complete freedom to engage in the creative projects and research of his choice.

How could he have turned down so generous and open an offer? His native land, without ever neglecting him, had proved to be a harsh mistress for so free and unpredictable a spirit. Moreover, Leonardo had never been able to deal with the factional and cliquish strife that prevailed in Italy at the time.

The French king himself was not without charm: then only twenty-one years old (he was born in Cognac in 1494), he had a well-rounded background in the humanities, and had already given proof of great physical courage.

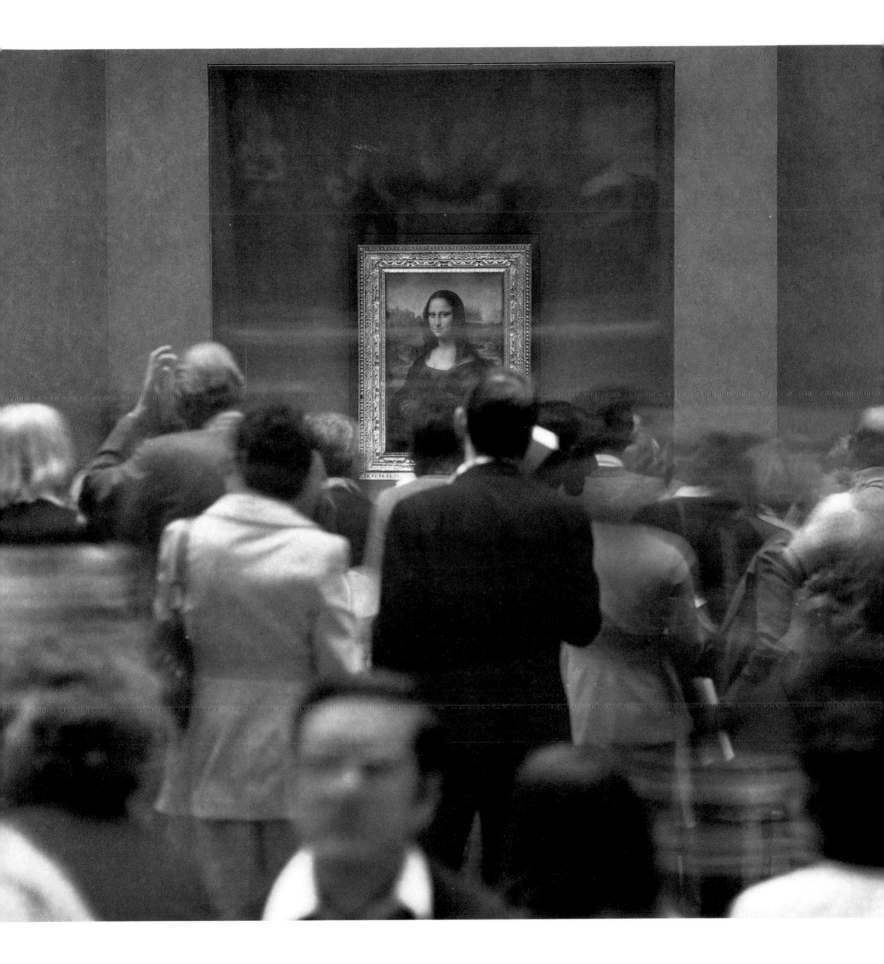

Opposite and right

Portrait of Mona Lisa
(detail)
1503 and 1506. Oil on wood.
77 x 53 cm. (30 1/4 x 20 7/8 in.).
Paris, Musée du Louvre.

Leonardo's Portrait of Mona Lisa is not only his absolute masterpiece, but also the most visited painting in the world. At the Louvre, where it is displayed behind bulletproof glass, it is visited annually by over five million sightseers from every corner of the globe. Painted between 1503 and 1505, it is probably a likeness of Mona Lisa, a Florentine woman who became the third wife of the old and notoriously jealous Bartolomeo di Zambini del Giocondo. Shown in frontal view, she appears somewhat portly; she was not exactly young either, being already in her thirties at the time. This portrait ran against the taste of the times for young girls of narrow girth, smallish heads on swan-like necks, and shown in profile, as we can see in many portraits by Botticelli and Ghirlandaio. Leonardo painted his sitter with such exceeding care that the individual brushstrokes are invisible to the unaided eye. It is of such perfect execution that many have been content just to admire its visual realism: the sparkling eyes, the delicately-shaped nose, the vermilion mouth so well harmonized with the flesh-tone of the cheeks – and of course the smile, on which so much of the painting's fame rests. This does not necessarily mean that it is a realistic or naturalistic work, however. The Mona Lisa corresponds rather to an ideal, like so many other pictures of the Italian Renaissance. It derives in no small degree from the Neo-Platonic philosophy of Marsilio Ficino, the official philosopher of the Medici Court and deacon of Florence Cathedral. The light which bathes the young woman is her mystical body, born of the interplay of darkness and light, or chiaroscuro, like the mysterious landscape of mountains and torrents that rises in the misty distance.

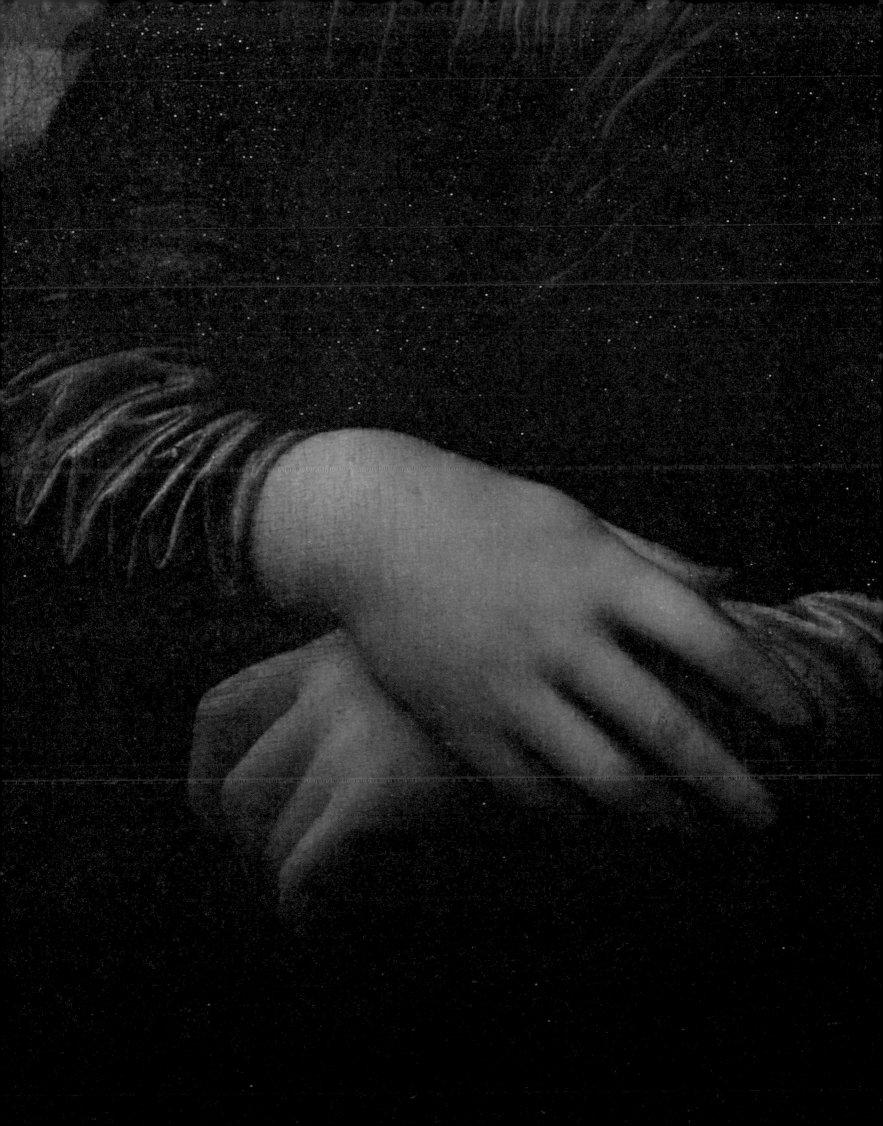

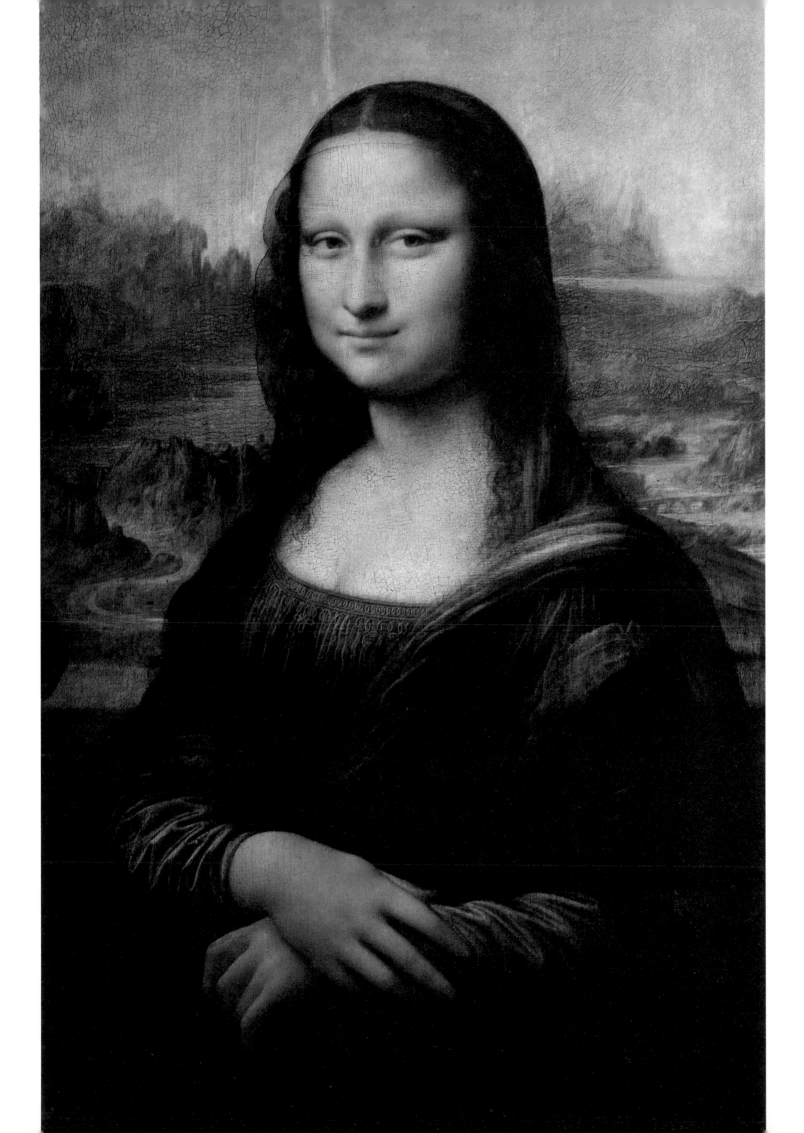

7

The abduction of the Mona Lisa

April 1516; the die was cast, and the last hesitations swept aside. Leonardo left Milan – and behind him, Salaï, his shadow for the last twenty-six years – and, accompanied only by Melzi and a servant, crossed the Alps and made his way northwards to the Loire Valley. In addition to his books and all manner of equipment, he brought with him the three pictures that he could not part with: his **Saint John the Baptist**, the **Virgin and Child with Saint Anne**, and "the portrait of a certain Florentine lady." These works, especially the latter, literally had to be smuggled into France. Fearing the justifiable anger of the patrons who had commissioned and paid for them – at least in part –, Leonardo resorted to the subterfuge of pasting over them compositional sketches for previous works. To perfect the camouflage, the whole was wrapped in canvas of poor quality.

Once he had settled at the Château de Cloux (which he always called the "Palazzo de Cloux"), he showed them to the Cardinal of Aragon who had come to visit him. It is not difficult to guess that this unnamed "Florentine Lady" must have been the **Mona Lisa**! After Leonardo's death, this master-piece was transferred to the royal palace at Fontainebleau, first in the bath-apartment, then in the picture collection in the painting pavilion.

Leonardo enjoyed the veneration and respect of all at the court of Amboise where he played the same role as at the court of the Sforzas three decades before. His "Palazzo de Cloux" was a splendid red-brick residence, with a slate roof, and a view of the Loire and its islands. He was awarded a fixed yearly

Portrait of Mona Lisa
1503 and 1508. Oil on wood.
77 x 53 cm. (30 1/4 x 20 7/8 in.).
Paris, Musée du Louvre.

Saint John the Baptist
1513-1516. Wood. 69 x 57 cm.
(27 1/8 x 22 3/8 in.).
Paris, Musée du Louvre.

This is the last known major work
in Leonardo's hand. The figure's
haunting beauty comes from
the ambiguity of its sexual identity.
The luminous face seems to be an
emanation of the darkness that
completely envelops it. The mysterious
gesture of the raised arm with upward-
pointing finger is not just of religious
but probably also of esoteric
significance.

stipend of seven hundred **écus** and given the title "First Painter
and Engineer and Architect of the King, State mechanician."

The courtiers faithfully copied his style of dress and
the cut of his beard – how could it have been otherwise?
Leonardo benefited from the King's favour; to imitate him was
just another way of expressing faithful obedience to the sove-
reign. Servility, it would seem, is eternal.

In his exile in the "garden of France," Leonardo
could be totally himself; he was free to dream, create, invent –
or at least try. Nothing in his writings from this time indicates
that he missed his beloved Tuscany. Yet we must assume that
he did. He was after all a foreigner in a strange land. He was
sincerely attached and grateful to François I, a refreshingly
young and cultivated monarch who was himself a great
admirer of all things Italian. Yet he seems to have withdrawn
even further into himself, as if still reeling from the blows of
fortune. He was full of dreams and projects that would never
be realized – how could he not have suffered?

At the age of sixty-five, unable to paint because of
rheumatism and a heart attack, he was as inventive as ever,
drawing castles, making plans for canals, and organizing feasts
and processions. In September 1516, on the occasion of the
festivities organized in Argenton by Marguerite d'Angoulême,
he made a mechanical lion which, when struck on the chest,
opened up to reveal a bouquet of lilies. In May 1518, he
staged a mock battle. Yet in the end, these vain pastimes tired
and saddened him. So much genius going to waste merely to
provide entertainment for conceited French nobles!

Although his right arm was paralyzed, he
attempted to paint with his left hand. The whitewashed walls
of his pleasant and peaceful home were adorned with his
beloved **Saint Anne** and **Mona Lisa**, and he continued working
on the **Saint John the Baptist**.

Although alone, he was not isolated. He received
frequent visits. The Cardinal of Aragon was impressed by the
impassive majesty of his prematurely aged countenance. In the
famous **Self-Portrait** in red chalk in Turin (which dates from this
time), Leonardo has the appearance of a tragic and hieratic
patriarch, not unlike the **Moses** sculpted by his flamboyant rival
Michelangelo. His flowing white beard and hair, his piercing,
deep-set eyes, broad furrowed brow, and bitter, downturned
mouth, recall the vicissitudes of his life.

During the visits of the Cardinal of Aragon, the
aged Leonardo, acting like an adolescent eager to show off his

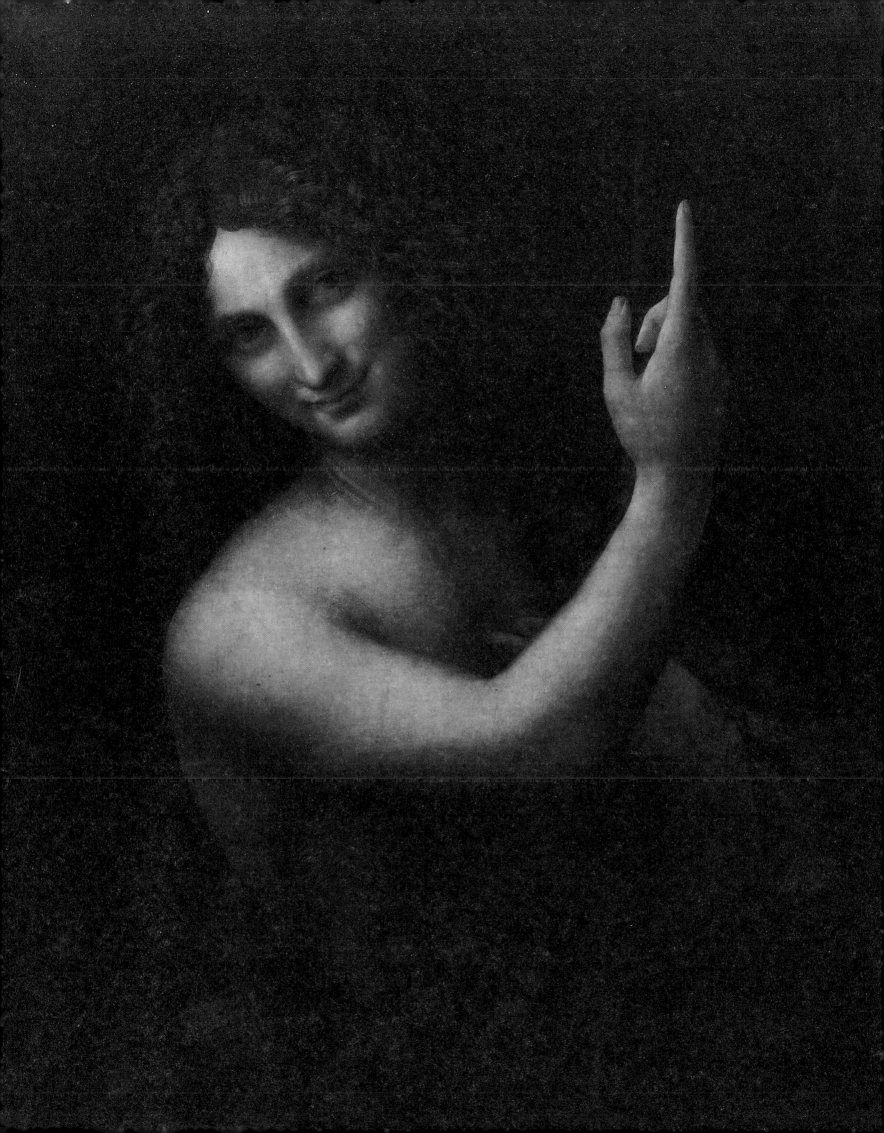

talents, would remember suddenly that he was a god, would run to the cabinets which contained his precious portfolios and, returning with his arms full and a halting step, would treat the prelate to a display of his endless series of sketches, drawings, anatomical studies, and plans for buildings and machines of all kinds.

Here, for example, was his **Treatise on Water**, his experiments on portable firearms; here, his research on human flight. He exhausted himself in explanations, in trying to explain to this man of high office but otherwise ordinary capacities what his genius had conceived and created.

All of this probably struck his powerful visitor as only so much raving, and he must have thought that this madman had been very fortunate indeed in finding such an attentive and charitable patron as the King of France. Exasperated, seeing that his visitor had no idea of what he was talking about, Leonardo would persist and point to the shelves of his library which were filled with his life's work. But all his efforts were to no avail; he had to resign himself to remaining misunderstood.

Leonardo genuinely liked the French king, and was infinitely grateful for his generosity, but he had no illusions. He was old and sick. He wanted to go on creating, and he knew that even his weakened state would permit it. But he also sensed that François I was holding him captive like a bird in a gilded cage, and that he would never be given the unrestricted freedom to act that a Sforza would quite naturally have accorded him.

Although he was weary and ill, and realized that the workings of the French court – powerful, vain and abstract – would be forever unfathomable to him, he tried to make himself useful. He wanted to purify the Sologne River, plant pine trees, fertilize the soil. He dreamed of a canal that would follow the Loire and go all the way to Lyons. He knew this would never be, but he had his comfortable retreat at the Château de Cloux. He was very bitter about it, but said nothing.

Since the French were not interested in essential things, he settled for a project that he worked out with François I for a magnificent modern castle, appointed with ballrooms, games rooms, reception rooms, and a pool for nautical jousts. His obsession with cleanliness and his disgust at the general lack of hygiene led him to pay special attention to the toilet facilities.

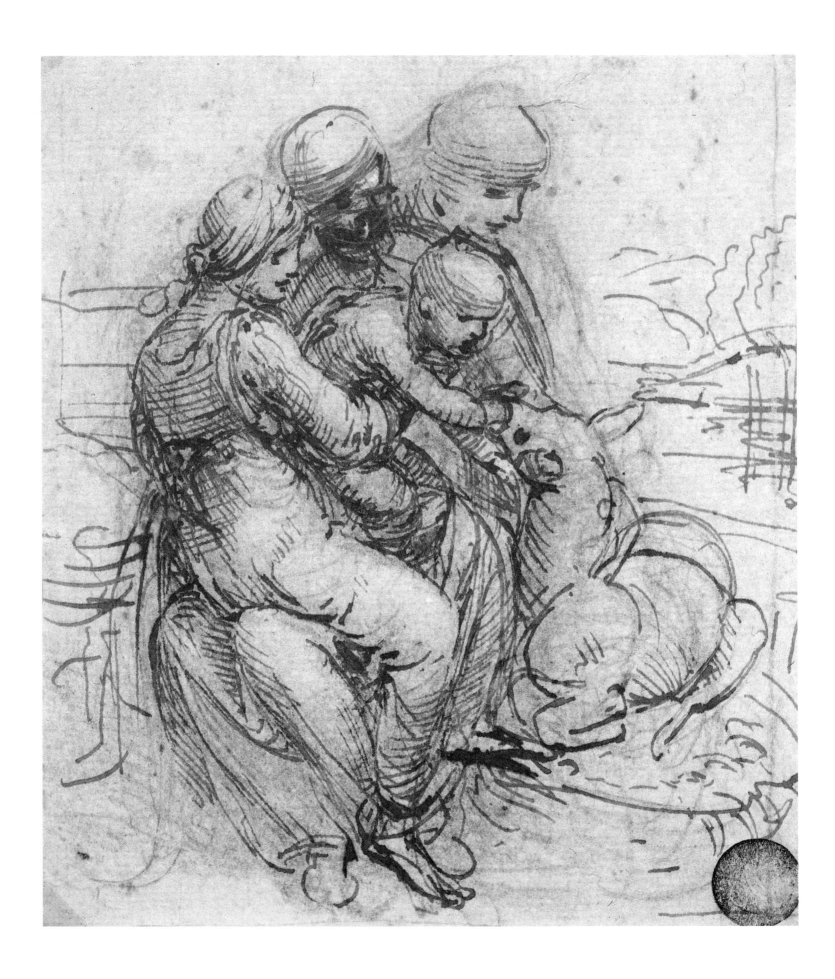

In the spring of 1518, Leonardo helped organize the festivities celebrating the baptism of the Dauphin and the wedding of Lorenzo de' Medici and Marie de la Tour d'Auvergne. Then, on 17 June, François I arrived at Cloux with an impressive suite. Leonardo created a blue canvas dome dotted with stars and planets reminiscent of the "Paradise" he had once designed in Milan.

Misunderstood, but held in great esteem by all and well-liked by the King, he spent his last days at Cloux in the company of his faithful Melzi and two servants, Battista, from Milan, and Mathurine, a French peasant maid.

On 23 April 1519, on the day before Easter, "considering the certainty of death and the uncertainty of its hour," Leonardo summoned Guillaume Boreau, the royal Notary from Amboise, and dictated his last will and testament. He bequeathed to "his blood brothers residing in Florence" four hundred ducats deposited at Santa Maria Novella. He left to Francesco Melzi "as compensation for his loyal services, all the books, instruments and drawings, relative to his craft as painter." To Battista, the latter's half-brother, he left one part of his vineyard on the outskirts of Milan, bequeathing the other part to the ungrateful Salaï. Finally, he donated seventy gold **sous** to the needy of Amboise. Nor did he forget Mathurine: she inherited two gold ducats and a black fur-lined coat.

He wanted sixty poor people carrying torches at his funeral, and left instructions for masses to be held in his memory, stipulating even the size of the candles.

On 2nd May 1519, Leonardo confessed, received the last sacraments, and, according to tradition, died in Melzi's arms. He was sixty-seven years old.

When he learned of Leonardo's death, François I wept for a long time.

Vasari described his death as follows:

"He was old, had been sick for many months, and feeling the approach of death, he wanted to follow the practices of the Catholic church and the holy Christian religion. Weeping, he repented of his sins and confessed.

As he could not stand up, he was supported by his friends and servants so that he could get up from his bed and devoutly receive the Blessed Sacrament.

Then the king arrived, for he often paid him friendly visits. Out of respect, Leonardo sat up in bed and described his illness and his symptoms, and said how greatly he had

The Virgin and Child with Saint Anne
1510. Oil on wood. 168 x 130 cm.
(5 1/2 x 4 1/2 ft.).
Paris, Musée du Louvre.

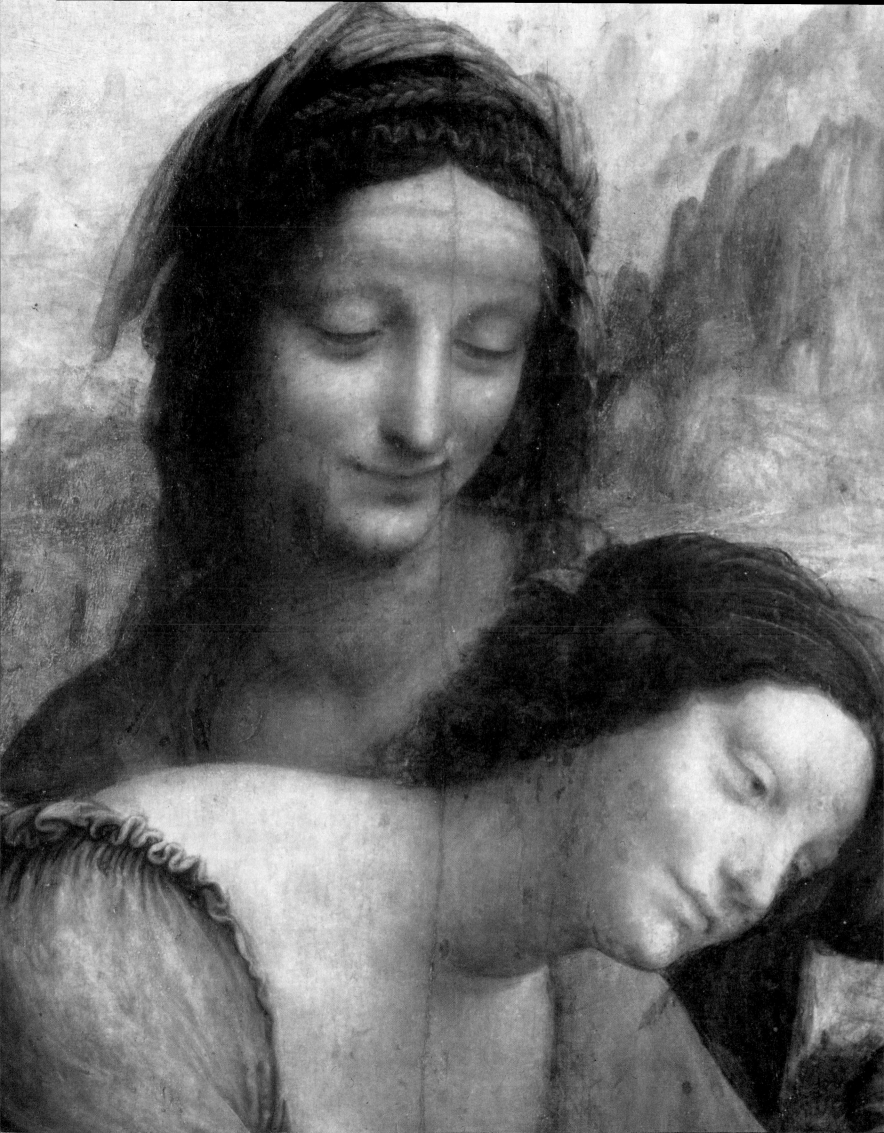

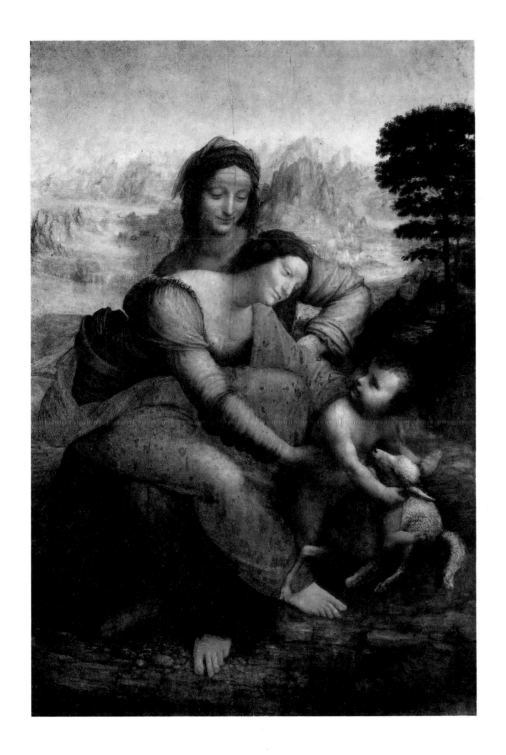

This painting owes its fame primarily to
Freud's psychoanalytical interpretation,
in which he erroneously used it as
evidence of Leonardo's presumed
homosexuality. It is a masterpiece of
mysticism and childlike grace.
Remarkable also are the tender
expressions of the Virgin and her
mother, Saint Anne, as well as the
curiously veiled atmosphere and the
wild, almost prehistoric landscape.

Project for the regularization of rapids on the Arno
Windsor Castle, the Royal Library.

This project for re-channeling the Arno was elaborated during a war between Pisa and Florence in 1503. The idea was sponsored by Machiavelli, who had met Leonardo during a stay with Cesare Borgia in Romagna. Both cities lie on the same river, the Arno; the first almost at its mouth on the Mediterranean Sea, and the second forty-five miles inland. The basic idea was to dig a canal to re-channel the river upstream from Pisa, thus depriving that city of water and access to the sea, and making it an easy conquest in the process. The project was begun, but never completed.

offended God and man in not having worked at his art as he should, and in allowing himself to be distracted.

He was then seized with a paroxysm, the harbinger of death; the king stood up and took his head to support him and show his affection by alleviating the pain. Leonardo understood that he could never receive a greater honour, and died in the king's arms, at the age of seventy-five.[1]

His death was a sad loss to those who had known him; there was never a man who gave so much honour to painting.

The splendour of his magnificent countenance comforted every sad soul, and his eloquence could sway even the most obstinate of men.

His strength could calm the most violent passions. With his right hand he could bend a knocker or a horseshoe as if they were made of lead.

In his generosity he welcomed and supported all his friends, whether rich or poor, if they had talent and ability.

1. In fact, Leonardo died at the age of sixty-seven.

Everything he did brought beauty and honour to the most wretched and bare dwelling.

Leonardo's birth was a great blessing to Florence; his death a great loss.

To the art of painting in oil he brought the new technique of **chiaroscuro**, which modern painters have used to bring vigour and relief to their figures....

Thanks to Leonardo, our knowledge of the anatomy of the horse, and of the anatomy of man has made enormous progress.

Thus, although he laboured more by word than by deed, his name and fame will live for ever.

Giovan Battista Strozzi wrote thus in his praise:

By himself Vinci vanquished
All the others, Phidias, Apelles,
And all their victorious host.

(Vinci costo pur solo / Tutti altri, vince Fidia, vince Apelle / E tutto il lor vittorioso stuolo.)"

Next pages

Crane for lifting dredged matter from the construction of a canal
Cod. Atlant., fol. 1v-b.
Milan, Biblioteca Ambrosiana.

Presumably a project for the construction of a canal from Florence to the sea. The canal was designed to connect the intermediary towns. Leonardo threw himself into a flurry of activity, devising pumps, sluice gates, tunnels, and gigantic siphons. He even made plans to displace mountains. A frightful storm completely wiped out the work that had already begun. This became yet another of Leonardo's unfinished projects.

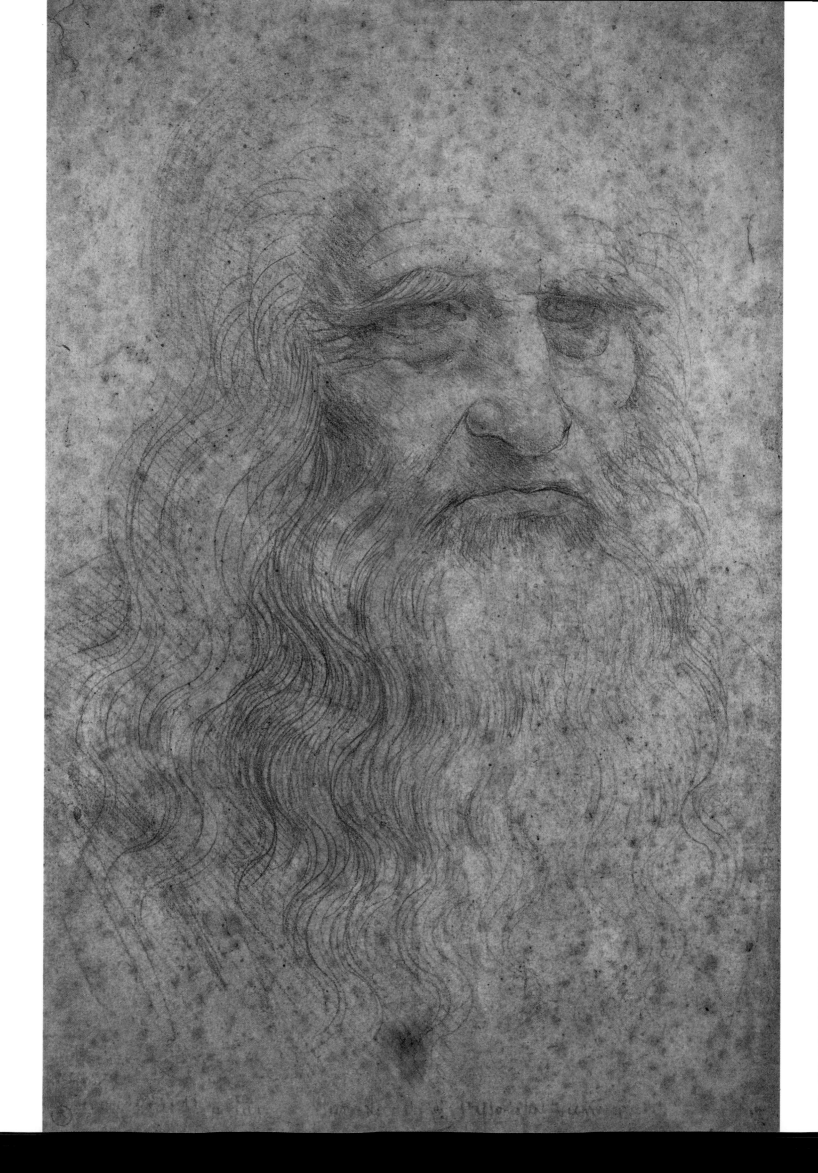

CONCLUSION

Io, Lionardo – I, Leonardo

T his was how Leonardo da Vinci signed his name, like a prince or an emperor. He was the Master, the Prince of Intelligence. Posterity should know this and never forget it. Yet Leonardo had nothing of the megalomaniac greedy for power or fame. He knew who he was; even if, at the ebb of his life, he was tormented and often bitter, there was always something beyond. Did he not write: "It is easy to become universal" ("**Facil cosa è farsi universale**")?

The "I" of his signature should not be taken as the exacerbated egotism which today often provides a passport for so many artists completely lacking in inspiration. On the contrary; here, it is the modest sign of a human being aware of the full extent of his genius, concerned with protecting himself from the violence and vulgarity of his contemporaries. The lapidary formula "Io, Lionardo" was an emblem, a hallmark, a shield and spear to defend the frontiers of his self, as if to say: "Here begins the expression of my being, of my dreams, and I deny access to all those who have not purified and liberated themselves of all worldly affectations. My motto: **margaritas ante porcos** ("Do not throw pearls before swine")." It has nothing in common with the deification of the self that was to characterize the Romantics.

What else can we say except that he stood far above the crowd. An intimidating human monument towering above the historical landscape, surveying us majestically, inventor, visionary, an errant and wounded soul, both vulnerable and complex. For beneath his severe, impassive and deeply-etched Saturnian mask (as in the presumed self-portrait

Self-Portrait
Drawing. Around 1512. Red chalk.
33.3 x 21.3 cm. (13 $^1/_8$ x 8 $^3/_8$ in.).
Turin, Biblioteca Reale.

This drawing is unanimously accepted as a self-portrait, although it is unlikely that the artist would have looked so old at this date.

at the Biblioteca Reale in Turin), there flowed the blood of an ardent heart and a vibrant spiritual life. Ever prepared to call everything into question, or, phoenix-like, reduce to ashes the creations and intellectual efforts that had absorbed him for years, and start all over again. For him, nothing was ever finalised.

He cut a fascinating figure, physically strong and handsome (as we know from the testimony of his contemporaries). His authority, beauty and strength radiated like an aura around his existence and his work. Young and alert, a dashing rider, with a marvellous voice which he accompanied with a lute of his own construction. His hair was long, blond and curly, his clothes superb. Nothing remains of this Leonardo of flesh and blood, only the flawed accounts of his biographers, Paolo Giovio and Giorgio Vasari.

Later, we saw him old and sad, filled with melancholy and bitterness, withdrawn and silent, weary and without hope. He was not so very old when he died, just incommensurably tired and incapable of taking an interest in the world and its passions. His last years, which he spent in France, are secret; he sought quiet and peace above all, perhaps in a universal harmony that would reconcile him with the passions and furore that raged all around him. He no longer wanted to speak, write, or paint: he aspired only to detachment, prayer and sleep.

Here was a man, one of the most extraordinary minds of all time, yet ridden with anxiety and constant doubt. Hesitant, he would feel his way, trying first this, then that, only to tire of it all, drop his tools and work, neglect his unfinished paintings on the wall or easel. He liked to walk, to escape, to escape us all. We thought he was in Florence, but he was in Milan. Then he was back in his studio eager to take on a new masterpiece; but soon again in flight, retreating to some wayside inn in Empoli, not far from the Arno. There, contemplating the flowing river, he already felt better, interweaving the intricacies of its winding course with the meanders of his fancy.

Because he worked at a much slower pace than other artists, Michelangelo could easily chide him for "not knowing how to finish." That's true. But how could he have "finished" anything, when all his endeavours as an artist, as a scientist and as a human being led to infinity, to that notion of great unity that mocks everything else?

Leonardo wanted harmony. He was constantly in search of that great equilibrium that expresses the splendours

of an ideal world, such as many of the other great Italian artists and thinkers of his day also imagined it. Yet he was not deluded by these seductive utopias. He needed to progress beyond his own visions and convictions, even beyond his own certainties. So exacting an attitude, which is almost a form of self-mortification, can ultimately only bring on confusion and intense suffering. One day, he gave vent to a cry of despair that is preserved in a marginal note in the **Codex Atlanticus**: Poor Leonardo, why did you go to so much trouble? ("**Lionardo mio, perche tanto penate?**"). It is a devastating document from a man who was generally not given to emotional outpourings or confessing his moods of depression.

To give an idea of the image of Leonardo that had already gained currency in the sixteenth century, let us quote Vasari again:

"The heavens can rain down the richest gifts on human beings naturally, but sometimes with lavish abundance bestow upon a single individual beauty, grace and ability, so that whatever he does, every action is so divine that he eclipses all other men, and it is clear that his genius is a gift of the gods and owes nothing to human effort. Men saw this in Leonardo da Vinci, whose personal beauty could not be exaggerated, whose every movement was grace itself and whose abilities were so extraordinary that he could readily solve every difficulty. He possessed great physical strength, combined with dexterity, and a spirit and courage invariably loyal and magnanimous; and the fame of his name increased not only during his lifetime but also after his death."

Nevertheless, it cannot be said that he was the **uomo universale**, the universal or Renaissance man, imagined by his contemporaries. To be sure, that is what he dreamed of. But we must consider, study, admire, and contemplate him, in the light of the artists and inventors who preceded him or were his contemporaries.

A genius? – yes. A giant? – yes. But nonetheless a product of his time and culture, of its traditions and experiences.

There is more beauty and more grandeur in a remarkable creative adventure well-grounded in its own time than in the childish exaltation of it as the expression of some future dimension that did not even exist at the time. For history is stubborn and collaborates only with those who mould mind and matter when the time is ripe.

Like the ancient horsemen of the Eurasian steppes who left behind a forsaken world and headed instinctively towards the empires that were to be, Leonardo stood on the brink of a civilization and attitudes that were still in gestation (he was one year old when the Turks captured Constantinople and forty when Christopher Columbus set foot in the New World).

He is seen as a product of European humanism, the same humanism that was to create the likes of Erasmus and Montaigne. But, as his love for animals demonstrates, for him man was not the sole inhabitant of the universe. Man was a humbler creature, subject to the mortal facts of life, a social being well suited for the free states and communities that thrived in Northern and Central Italy (as well as in Flanders).

We have also seen that this master painter was capable of making technical mistakes: his varnishes did not hold, and he ruined entire frescoes by experimenting with recipes of his own invention. His lucidity about his art often led to modesty: he considered himself as good as any other painter, but no more.

As for the famous "secret notebooks" which so many authors of the past have wanted to interpret as encoded or esoteric teachings destined for his pupils – or should we say "adepts"? – today, they represent an accumulation of straightforward notes and reminders addressed to himself for purely practical reasons. His ardent desire to learn and understand touch us and teach us more than the tenacious legends of tomes of alchemy, full of magic spells scribbled by the "divine Leonardo."

What then? Human, all too human? Perhaps, but just so and rightly so.

Baudelaire saw the man clearly when he wrote: "Leonardo da Vinci, a deep and dark mirror." Fittingly enough, the same poet also wrote: "Painting promises even what it conceals."

Would Leonardo have recognized himself in this investigative portrait, wiped clean of the burdensome legends, and lit only by the brilliance of his work? It would be presumptuous to respond too soon in the affirmative. A hint of an answer is to be found in one of his own notebooks: "Whether all these things were to be found in me or not, the hundred and twenty books that I have written will reveal; for their sakes I was hindered neither by avarice, nor by negligence, but only by time. Farewell."

Plant Study (Euphorbia)
(detail)
Windsor Castle, the Royal Library.

Opposite

Studies of a plant and oak branch
Around 1506.
Windsor Castle, the Royal Library.

Leonardo is after all the one who dared write: "**Facil cosa è farsi universale.**" Yet this product of the Early Renaissance, as yet uncontaminated by the vapours and hallucinations of the Baroque, also wrote: "Thirst not for the impossible."

History and the passage of time have made a "monument" of Leonardo. Nothing is missing, not even the misunderstanding of his contemporaries – that indispensable romantic touch for all creative geniuses – nor the melancholy of the sage, as reflected by the red-chalk drawing in Turin, which shows a hoary, prematurely aged man.

But how is one to visit this Leonardo monument? With difficulty, and by keeping a respectful distance. Barred by a red-velvet cordon, the crowds try to make out the picture behind the bulletproof glass. The teeming crowds of visitors try to catch a glimpse of the fabled **Mona Lisa**, but see mostly only their own reflection, as ghostly as the dark, hazy figure beyond. Then, having made their pilgrimage and participated in the ritual of admiration, they think they have seen Leonardo himself, and leave reassured.

But for centuries, scholars have been examining and studying his works, finding texts thought lost for ever, poring over them and annotating them, discovering behind the hieratic monument another Leonardo, still a da Vinci, and as remarkable as ever, but quite different from the canonized figure of legend.

Because of his will to overcome his terrible fear of the transitory – not to say the derisory – which brings nature into being only to topple it back into nothingness, Leonardo seems to have sought refuge in a quest for the permanent and eternal. Not some metaphysical eternity – a Christian idea that was scarcely suited to his Platonic and Aristotelian values –, but rather the representation of something eternal. And this eternal thing was purely and simply light, the radiant energy that gives form to everything in the universe. In his own words: "To plunge things into Light is to plunge them into the Infinite."

This was the mature Leonardo speaking. The Leonardo who seems to have experienced in his lifetime a luminous intensity that was not of this world. Light became his primary concern as a painter. But was this "Light" something different from the **noûs**, or **logos**, the creative spirit postulated by Plato and then taken up by the Neo-Platonists whom he had met in the circles frequented by Marisilio Ficino, Pico della Mirandola and their patron Lorenzo de' Medici?

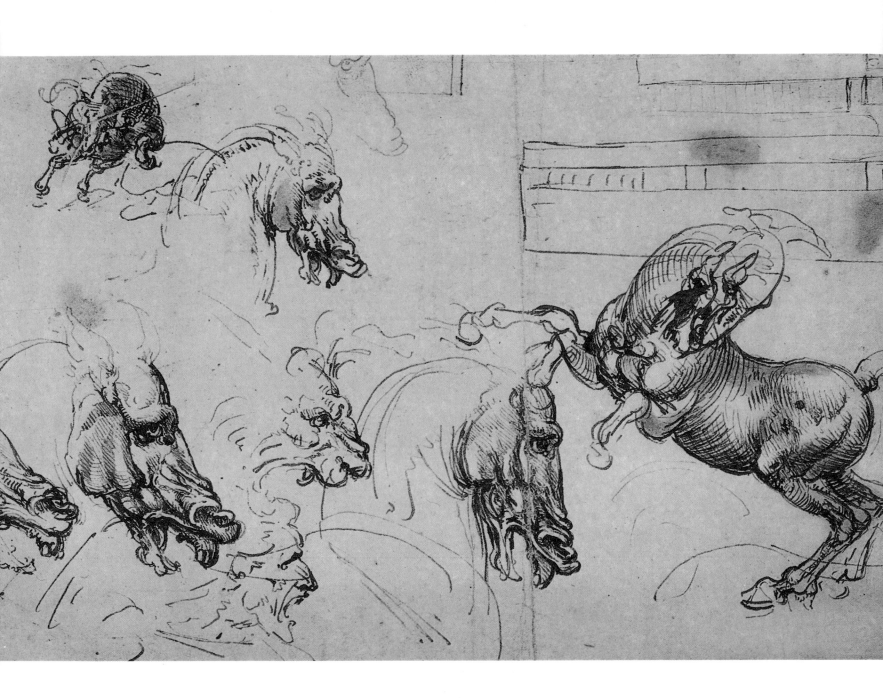

Who better than he knew that everything in the realm of science and practical action is condemned to be devoured by Time? Only the work of Art, the ideal expression of beauty, will endure. But only if it already contains the principle of infinity and eternity as embodied in light. That was his quest as a visionary. For him, all things were created by light, which was the uncreated, the never-ending inspiration of all beginnings.

What we learn from Leonardo above all has nothing to do with science – or science fiction – but with the inexpressible centre of that maze of mysteries called Creation: in a word, Harmony. How did he come to it? He does not say. This journey, which was akin to a spiritual journey of initiation, never found its way into his notebooks. Which is as it should be, for it is ineffable, a portrait of the soul drawn in invisible ink.

This is the Leonardo we have endeavoured to bring to life.

Rearing Horse
Red chalk.
153 x 142 mm. (6 x 5 ⁵/₈ in.).
Windsor Castle, the Royal Library
(fa. Scala).

This sketch is related either to the Adoration of the Magi or to the Battle of Anghiari.

Opposite

Studies of horses for the Battle of Anghiari
Windsor Castle, the Royal Library.

LEONARDO DA VINCI

Selected notes on Painting

The Difference between Painting and Sculpture

The painter must keep ten things in mind to ensure the success of his work: namely, light, shadow, colour, volume, form, placing, distance, proximity, movement and repose.

The sculptor must consider only volume, form, placing, movement and repose. He does not have to concern himself with light or shadow, for nature produces them herself in his sculptures. Nor with colour. As to distance and proximity, he attends to them only a little. He uses linear perspective, not that of the colours, in spite of variations in colour and sharpness of the contours according to their distance from the eye.

Sculpture is a simpler form of statement and requires less mental effort than painting.

Literature and drawing

What words can you find, O writer, to equal in your description the complete figure rendered here by drawing? Because of your ignorance of the latter, you have only a confused description and can give only a feeble idea of the true form of things; you are deluded when you think that you can fully satisfy your audience when it comes to evoking a mass enveloped by a surface.

I enjoin you not to encumber yourself with words, unless you address yourself to the blind: if you want to address yourself through words to the ear, and not to the eye, discuss

such things as substance and nature; do not trouble yourself with things of the eye, to try and make them pass through the ear; you would be far surpassed in this by painting.

With which words would you describe this heart without filling an entire volume? The more detail you give, the more confusion you will create in your audience; you will need commentaries or references to experience, but in your case there is not much of it, and it touches on only a few aspects of the subject you would encompass completely.

He who despises painting loves neither knowledge nor nature

If you despise painting, which alone can imitate all that is visible in nature, you most certainly despise a subtle invention which, by its complex and philosophical reasoning, examines the quality of forms, oceans, places, plants, animals, grass, flowers, all bathed in light and shadow. And this knowledge is truly the legitimate daughter of nature, for it was engendered by nature, but, to be exact, we shall call it the granddaughter of nature, for nature has produced all visible things, and from them painting is born. We shall therefore rightly call it the granddaughter of nature, related to God.

Variety of characters in compositions with figures

In compositions with figures, the characters must differ in complexion, age, colour, attitude, corpulence, build: fat, thin, tall, short, proud, courteous, old, young, strong and muscular, weak and with few muscles, happy, melancholic; with curly or straight hair, short or long; with alert or vulgar movements; and vary the costumes and colours and all other things necessary for this composition. It is a cardinal sin for the painter to create faces that look alike, and the repetition of gestures is also a great fault.

The mirror is the painters' master

To see if your painting conforms to what you are depicting, take a mirror and look at the reflection of the model in it; then compare this reflection with your painting, and examine closely the entire surface to see if the two objects are similar... Since the mirror can, through line, light and shadow create an illusion of relief, you, who have among your paints, shadows and light that are stronger than those in the mirror, if you know how to combine them, your work will doubtless appear similar to reality as seen in a large mirror.

Study of Drapery
Pierre noire and Indian ink wash touched up with white.
Paris. Musée du Louvre. Department of Drawings.

Painting and its elements

Painting consists of two main parts: the first is form, that is to say, the line which defines the forms of bodies and their details; and the second is colour which is enclosed by line borders.

Painting consists of two main parts: the outline which surrounds the forms and painted objects, which we call drawing; and shadow. But drawing is of such excellence that it explores not only the works of nature, but also an infinity of others beyond it.... Thus we would conclude that drawing is not only knowledge but also the divine power capable of reproducing all of the Almighty's works that are visible.

Against the Greek manner

The most praiseworthy form of painting is the one that most resembles what it imitates. I say this against painters who presume to correct the works of nature, those, for example, who depict a one-year-old infant, whose head should be one fifth of its height, and who make it one eighth; and while the width of its shoulders is equal to that of the head, they make the head half as wide as the shoulders; and in this way, they endow a small one-year-old child with the proportions of a man of thirty. And they have so often seen and practised this error, and its use has become so ingrained in their corrupt judgement that they persuade themselves that nature and those who imitate nature are guilty of a gross error for not doing as they do.

Light and shadow

Shadow is the absence of light or simply the opposition of opaque bodies that intercept the rays of light. Shadow is of the nature of darkness; light is of the nature of splendour. They are always combined on the body, and shadow is more powerful than light, for it can completely exclude light and deprive bodies of it entirely, while light can never eliminate all shadows from bodies, at least from opaque bodies.

Shadows can be infinitely obscure or display an infinity of nuances in the light tones.

Shadows are the manifestation by bodies of their forms.

The forms of bodies would not show their particularities without shadow.

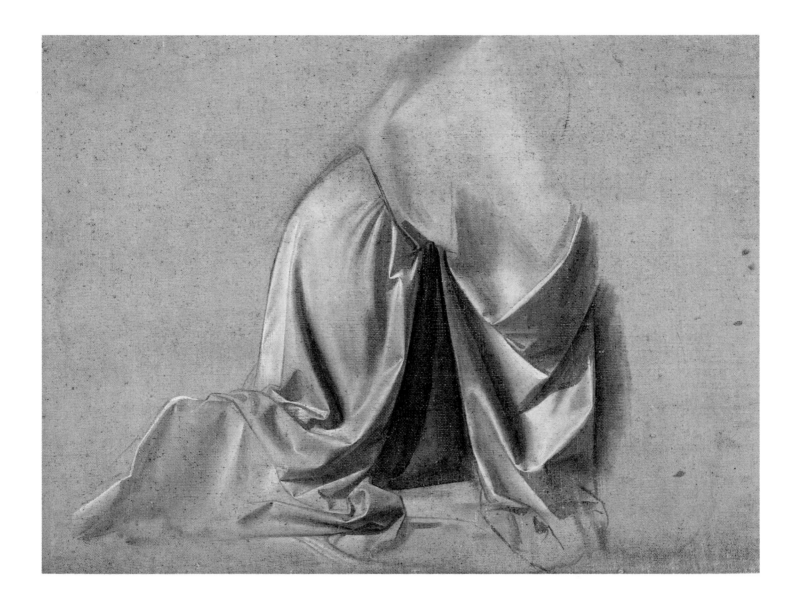

Shadows should always partake of the colour of the bodies they conceal

No object appears to us in its natural whiteness, because the place in which it is seen makes it, for the eye, seem more or less white according to whether the place is more or less dark. We learn this, for example, from the moon, which in daytime appears with so little brightness in the sky, and at night with such brightness that it disperses darkness like the sun or daylight. This is due to two things: the tendency of nature to show coloured images more perfectly, the more different the colours; and, secondly, the pupil is larger at night than in daytime, as has been proved....

Drapery study for a kneeling figure in right profile
Paris, Musée du Louvre, Department of Drawings.

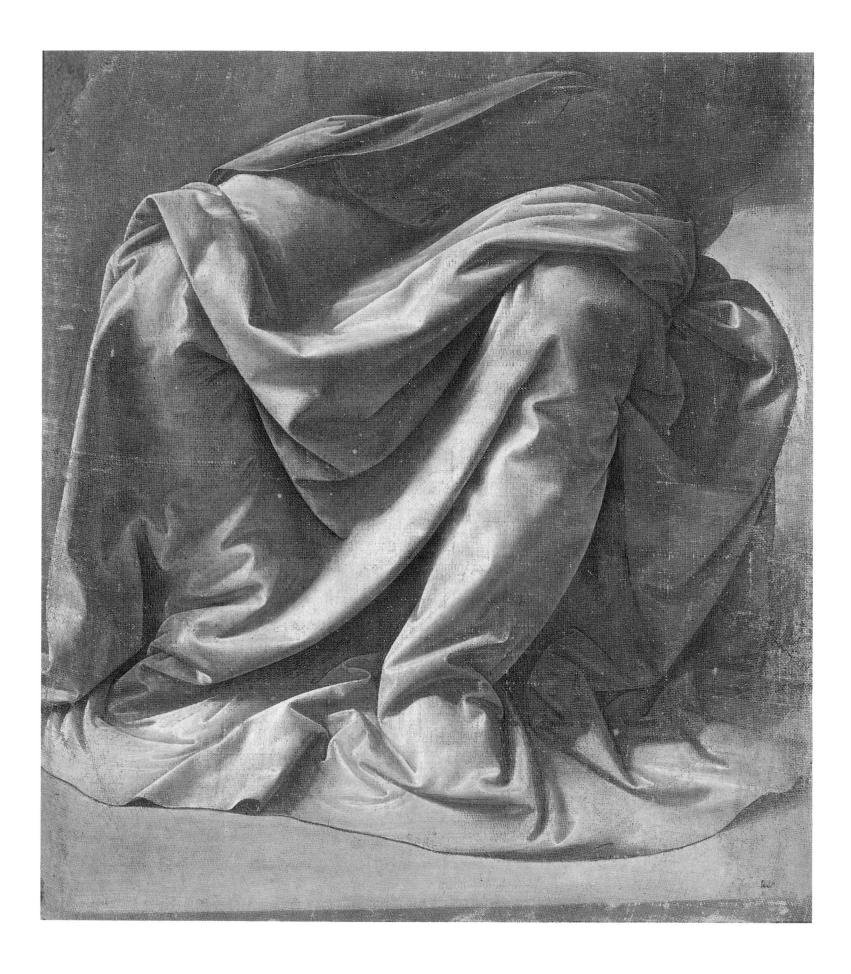

Linear perspective

Perspective is the rational law according to which experience shows us that all objects send their images to the eye following pyramidal trajectories; and bodies of the same size will make more or less narrow pyramids according to their respective distances. I call "pyramidal trajectories" the lines which come from the surfaces and contours of bodies and arrive, after a long distance, at a small common point; a point is something that cannot be divided in any way, and this point, situated in the eye, brings together the summits of all of the pyramids.

The blue in the distance

There is another kind of perspective which I call aerial, for the differences of the colour of the air can make us distinguish the respective distances of many buildings, the bases of which are cut by a single straight line, as when we see them above and beyond a wall; let us assume that they appear to be all the same size, and that you want to show that some are more distant than others, and represent them in a fairly dense atmosphere. You know that in such an atmosphere, the most distant objects, such as mountains, appear, because of the great quantity of air that lies between them and your eye, as blue as the air when the sun rises. You will therefore give the nearest building above the wall its real colour, and the more distant one you will make less distinct and bluer. And the one that you want to show even farther, that one you will make even bluer; and the one which lies five times more distant, make it five times bluer. And with this rule, it will be obvious which of the buildings that appear to be the same size is the more distant and so (in reality) larger than the others.

Tone and value

Different colours can receive from the same shadow an equal degree of darkness. It is possible for colours of all sorts to be transformed, by a given shadow, into the colour of this shadow.

This is proved by the darkness of a cloudy night, in which no form or colour of any object can be distinguished; and since the darkness is only the deprivation of incident or reflected light which allows us to distinguish all the forms and colours of bodies, it is inevitable, when light is entirely eliminated as a cause, that the effect or perception of the colours and forms of these bodies also disappears.

Study of drapery covering legs
Brush and bistre touched up
with white on canvas.
Paris, Musée du Louvre,
Department of Drawings.

Possibly related to the Florence
Annunciation.

The ideal lighting for each colour

You must observe under which aspect a colour appears at its finest in nature; when it receives reflections, or when it is lit, or when it has medium shadows, or when they are dark, or when it is transparent.

This depends on the colour in question, for different colours are at their most beautiful under different aspects; thus we see that blacks have the most beauty in shadow, whites in the light, and the blues, greens and browns in medium shadow, the yellows and reds in the light, the gold in reflections, and the lakes in medium shadow.

The beauty of colours

To make a beautiful green colour, take the green (in powdered form) and mix it with bitumen and in this way you will make the shadows darker. Then, for lighter greens, mix green and ochre, and for those even lighter, green and yellow; and for brilliance, take pure yellow. Then take some green and Indian saffron together and make a veil of it to cover the whole.

To make a beautiful red, take some cinnabar or red chalk or burnt ochre for the dark shadows, and for the light shadows red chalk and vermilion, and for brightness pure vermilion, and veil it with a delicate lacquer.

To make oil good for painting: one part oil and one part turpentine (distilled once), and another part of twice-distilled turpentine.

Transparency

If you want to give colours their greatest beauty, first make a preparation of very pure white; and I say this for transparent colours, for in the case of those which should not be transparent, the white preparation is useless. This can be learned for example from a coloured glass which, when placed between the eye and air in the light, is of great beauty; this does not occur when they are seen against darkened air or something black.

How to recognize a good painting and by which qualities

The first thing to consider, if you wish to recognize a good painting, is whether the movement is appropriate to the state of mind of the person who is moving; secondly, whether the more or less pronounced relief of objects placed in

the shadow is adjusted to the distance; thirdly, whether the proportions of the parts (of the body) correspond to those of the whole; fourthly, whether the choice of positions is appropriate to the type of actions; fifthly, whether the detail of the figures corresponds to their character, that is, delicate limbs for delicate people, strong for the strong, fat for the fat, etc.

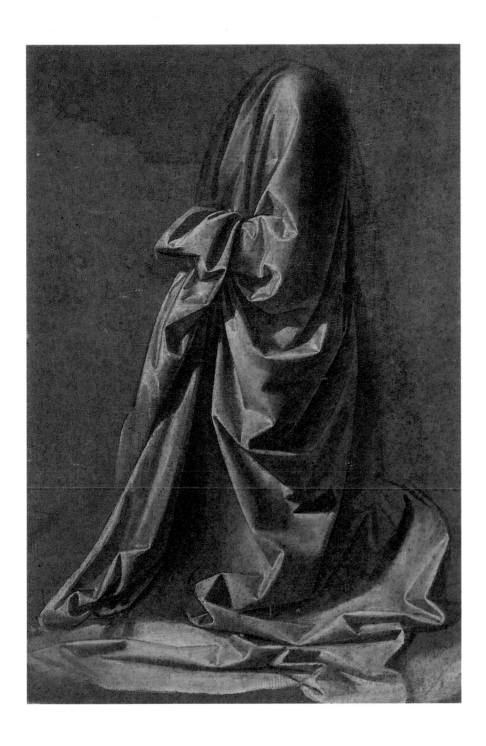

Study of Drapery
Private collection.

How to study human movement

Human movement may be understood through knowledge of the parts of the body and the entire series of the positions of limbs and articulations; then, set down by means of some stenographic notation the actions of people, with their particulars, without them noticing that you are observing them; for if they realized it, this would intrigue them and the act in which before they were completely absorbed will lose some of its force; for example, when two angry men are in the midst of an argument, each thinking that he is right, they agitate their eyebrows and arms and other limbs with much vehemence, making gestures that are appropriate to their words and intentions. You would not be able to obtain this result if you asked them to act out this anger or some other passion like laughing, crying, pain, surprise, fear, etc. And so take care always to carry with you a sketchbook of gelatine-coated paper and with a silverpoint briskly note these movements, and note also the attitudes of the bystanders and their positions; and this will teach you how to make compositions. And when your sketchbook is full, lay it aside and keep it for your projects, then take another one and continue. And this will be very useful for the art of composition, on the subject of which I shall write a separate book which will pursue the study of the figures and the separate limbs and their various articulations.

Of laughter and tears and what distinguishes them

You will not give to the face of someone crying the same movements as to the face of someone who is laughing, even though (in reality) they often look alike; for the right method is to differentiate them, as the emotion of laughing is different from the emotion of crying.

With those who weep, the eyebrows and mouth change according to the different causes of their tears; for the one is crying out of anger, the other out of fear, and some out of joy or a tender feeling, others out of anxiety, for pain or sorrow, and yet others out of pity or grief from having lost a relation or friend; and among these weepers, some seem desperate, others restrained; some only shed tears, others cry out, and some lift their eyes skyward and lower their hands with the fingers joined; some are timid, their shoulders hunched to their ears, and so on, according to the causes mentioned.

The one shedding tears raises his eyebrows on the inner side, and contracts them, and creates wrinkles between

and above them; the corners of the mouth are turned down; but the one laughing has them turned up and his eyebrows are separate and raised.

How to paint fabrics

Figures wearing a coat must not let their forms show through so that the coat appears to rest on the flesh (unless you want to make it appear so); but you must consider that in between the coat and flesh there are other pieces of clothing which prevent the naked forms of the limbs from appearing or from being visible through the coat. As for the limbs that show through, make them thicker, so that the clothing under the coat is evident; you will reveal the exact dimensions of the limbs only in the case of nymphs or angels, which are represented draped in fine cloth, adhering to and moulding their limbs in the wind.

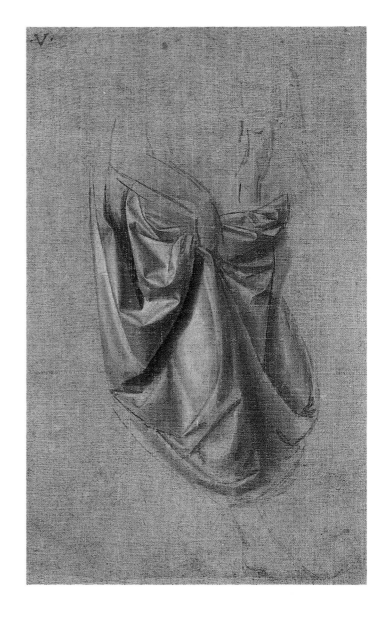

Study of Drapery
Rennes, Musée des Beaux-Arts.

BIBLIOGRAPHY

**Study of an angel's head
for the Virgin of the Rocks**
Silverpoint touched up with white
on cream-coloured paper.
181 x 159 mm. (7 1/8 x 6 1/4 in.).
Turin, Biblioteca Reale.

ALBERTI, Leon Battista, **On Painting** (1540), English ed. by J.R. Spencer, Yale University Press, New Haven, 1959

BAYER, Raymond, **Une esthétique de la grâce: Léonard de Vinci**, Paris, 1953.

BERENSON, Bernard, **The Study and Criticism of Italian Art**, III, London, 1916 (pp. 1-37: titled, Leonardo da Vinci, an attempt at a revaluation).

BRAMLY, Serge, **Léonard de Vinci**, Paris, 1988

BRION, Marcel, **Léonard de Vinci**, Paris, 1952.

BURCKHARDT, Jakob, **The Civilization of the Renaissance in Italy**, trans. S.G. Middlemore, Albert and Charles Boni, New York, 1935.

CHASTEL, André, **Art et humanisme à Florence au temps de Laurent le Magnifique**, Paris, 1959.

The Genius of Leonardo da Vinci. (Ed.), Leonardo da Vinci on Art and the Artists, Orion Press, New York, 1961

CLARK, Kenneth (Sir), **Leonardo da Vinci: An Account of his development as an artist**, Penguin Books, London, 1958 (1929)

CONSTANTINO, Maria and REID, Aileen, **Léonard de Vinci**, Paris, 1992.

DELUMEAU, Jean, **La civilisation de la Renaissance**, Paris, 1967.

DUHEM, Pierre, **Etudes sur Léonard de Vinci... Ceux qu'il a lus et ceux qui l'ont lu...**, 3 vols., A. Herman, Paris, 1906-1909.

FREUD, Sigmund, **Leonardo da Vinci: A Study in Psychosexuality**, trans. A.A. Brill, New York, 1916.

GILLE, Bertrand, **The Renaissance Engineers**, Percy Lund Humphrey, London (courtesy M.I.T. Press), 1964.

GOLDSCHEIDER, Ludwig, **Leonardo da Vinci. Life and Work, Paintings and Drawings**, Phaidon Press, London, 1959.

GOULD, C., **Leonardo the Artist and the Non-Artist**, London and Boston, 1975.

GREEN, André, **Révélation de l'inachèvement, Léonard de Vinci**, Paris, 1992.

GUILLERM, J.-P., **Tombeau de Léonard de Vinci...**, an interpretation of Leonardo's work through the centuries, especially in the nineteenth and twentieth, Lille, 1982.

HUARD, P., **Léonard de Vinci, dessins anatomiques**, Paris, 1968.

MEREJKOWSKY, Dmitri, **Le Roman de Léonard de Vinci**, Paris, 1930.

MAC CURDY, Edward, **The Notebooks of Leonardo da Vinci**, 2 vols. Jonathan Cape, London, 1977 (1938)

PANOFSKY, Erwin, **Meaning in the Visual Arts**, Doubleday, Garden City, New York, 1955.

PELADAN, J., **Les manuscrits de Léonard de Vinci, les quatorze manuscrits de l'Institut de France, extraits et descriptions**, Paris, 1910.

SARTORIS, Alberto, **Léonard architecte**, Paris, 1952.

TACCOLA, Mariano, **L'art de la guerre**, Paris, 1992.

Tout l'œuvre peint de Léonard de Vinci, Flammarion, Paris, 1968.

VALLENTIN, Antonina, **Léonard de Vinci**, Paris, 1930.

VASARI, Giorgio, **The Life of Leonardo da Vinci, Florentine Painter and Sculptor**, (1568, from **The Lives**), Engl. trans. in Goldscheider 1959.

WIND, Edgar, **Pagan Mysteries of the Renaissance**, Faber and Faber, London, 1958

Leonardo's manuscripts

Institut de France, Paris
Ms. A, 43 pages, 21.2 x 14.6 cm.
Ms. B, 84 pages, 23.5 x 17.6 cm.
Ms. C, 30 pages, 22 x 21 cm.
Ms. D, 10 pages, 16 x 22.2 cm.
Ms. E, 80 pages, 15 x 10 cm.
Ms. F, 96 pages, 14.5 x 10 cm.
Ms. G. 93 pages, 14 x 9.5 cm.
Ms. H, 142 pages, 10.4 x 7.4 cm.
Ms. I, 140 pages, 10.2 x 7.4 cm.
Ms. K, 128 pages, 9.8 x 6.5 cm.
Ms. L, 90 pages, 10.1 x 7.5 cm.
Ms. M, 94 pages, 9.8 x 7 cm.

Bibliothèque Nationale, Paris
Ms. Ashburnham, 34 pages, 24 x 21 cm.

British Museum, London
Codex Arundel, 283 pages, 22 x 15 cm.

Biblioteca Ambrosiana, Milan
Codex Atlanticus, 403 pages, 60 x 45 cm.

Victoria and Albert Museum, London
Codex Forster, one thousand pages.

The Royal Library, Windsor Castle
Anatomical Studies. Codex Leicester, 36 pages, 29.5 x 21.8 cm.

Biblioteca Nacional, Madrid
Codex Madrid

Biblioteca Reale, Turin
Codex on the Flight of Birds, 18 pages.

Castello Sforza, Milan
Codex Trivulzianus, 51 pages, 19.8 x 13.7.

BIOGRAPHY

Clos-Lucé

It was most likely in 1506 that Leonardo accepted François I's invitation to live at the Château de Cloux, today called Clos-Lucé.

1452: Leonardo born in Vinci (Tuscany) on 15 April, the illegitimate son of the notary Ser Piero da Vinci and a peasant woman called Caterina. His childhood was spent in the country.

1457: a fiscal declaration by Leonardo's grandfather mentions that Leonardo lives with his grandparents, his father and the latter's wife.

First Florentine period

1469: Death of Leonardo's paternal grandfather. His family moves to Florence. Leonardo accepted into Andrea Verrocchio's studio.

1472: Leonardo, aged twenty, listed as a member of the Guild of St. Luke in Florence.

1473: First signed and dated (5 August) drawing by Leonardo; collaborates on the head of an angel in Verrocchio's **Baptism of Christ**.

1476: 8 April, Leonardo accused of sodomy in connection with the Saltarelli Affair. The case is dismissed on 7 July.

1478: 10 January, Leonardo commissioned by the Municipal Council to paint an altarpiece for the San Bernardo Chapel at the Signoria. Begins the portrait of Ginevra Benci.

1480:Leonardo works on the restoration of the gardens of the Piazza San Marco in Florence, and for Lorenzo de' Medici. He receives a commission to paint an **Adoration of the Magi** for the high altar of the church of San Donato in Scopeto.

Of his early works, only the **Portrait of Ginevra Benci** (Washington D.C.) and the small **Annunciation** in the Louvre remain.

First Milanese period

1482: Letter to the Duke of Milan, Ludovico Moro (the Moor), in which Leonardo offers his services as painter, sculptor, civil and military engineer, and musician. He moves to Milan without having finished his **Adoration of the Magi**. Probable date of his **Portrait of a Musician** and of the **Lady with an Ermine**.

1483: 25 April, Leonardo signs a contract for the **Virgin of the Rocks,** commissioned by the ecclesiastical authorities of Milan. Probably begins studies for the equestrian monument to the Condottiere Francesco Sforza, Ludovico's father.

1484-1489: In addition to working on his commissions, Leonardo devotes himself to architectural studies and projects, and even to plans for a flying machine. A very hypothetical trip to the East is dated around 1485.

1490: Leonardo stages banquets and a wedding feast for the Court. Begins work on the equestrian statue of Francesco Sforza.

1491: July, Leonardo takes the ten-year-old Gian Giacomo Caprotti da Oreno, known as **Salaï,** into his care.

1493: a giant model of the Sforza equestrian monument, known as **Il Cavallo,** is displayed in the courtyard of the Castle of Milan.

1494: Leonardo works on the organization of the farmlands of the dukes of Milan near Vigevano. Preliminary studies for the **Last Supper.**

1495: Leonardo begins painting the **Last Supper** and decorating the rooms of the Sforza castle.

1497: Leonardo responsible for the decoration of the **Sala delle Asse** in the Castle of Milan.

1498: Leonardo listed among the "engineers of the ducal chamber."

1499: Louis XII's invasion of Lombardy compels Leonardo to flee Milan; sojourns in Vaprio and Mantua, where he executes two portraits in charcoal of Isabelle d'Este. Moves on to Venice.

1500: Returns to Florence.

1501: Exhibition of the first cartoon for the **Virgin and Saint Anne** in Florence.

1502: A planned trip to Turkey is cancelled. Leonardo enters the service of Cesare Borgia, Duke of Valtellina, and takes part in the Romagna campaign as an architect and general engineer. Inspects Cesare Borgia's fortresses.

Second Florentine period

1503: Back in Florence between March and June. Competes with Michelangelo in the commission for a wall-painting in the Signoria (**Battle of Anghiari**). According to Vasari, begins the **Portrait of Mona Lisa** and **Leda and the Swan.**

1504: 9 July, death of his father.

1505: Leonardo abandons work on his **Battle of Anghiari,**

Leonardo's bedroom

This is the room in which he lived and died, on 2 May, 1519, exhausted by work and illness, at the age of 67.

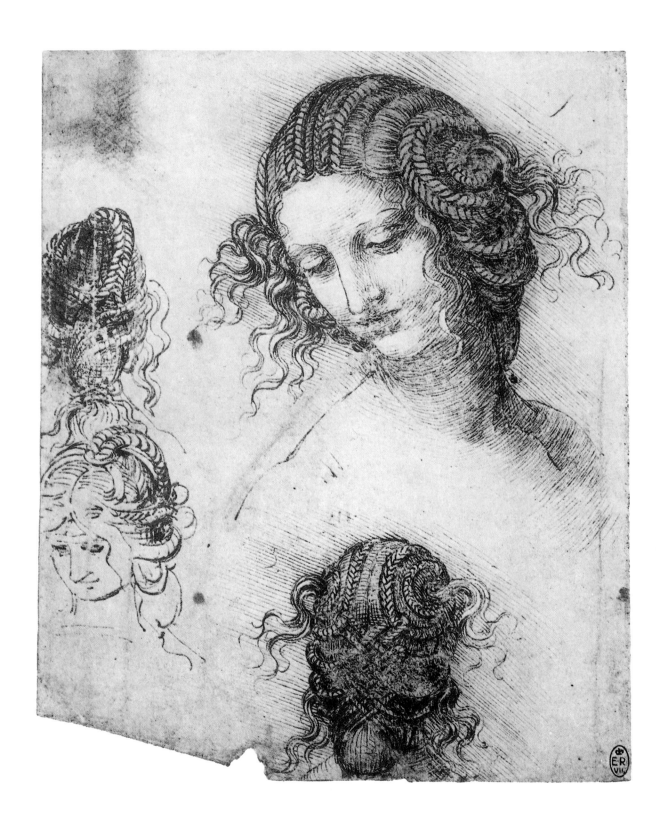

Studies for the head and hair of Leda

Drawing, pen and ink over charcoal.
200 x 162 mm. (7 7/8 x 6 3/8 in.).
Windsor Castle, the Royal Library.

adding credence to his reputation as an artist who never finished his works.

1506: Florence, Leonardo begins collecting notes on mathematics and physics. In June, leaves Florence for Milan at the behest of Charles d'Amboise, Marshal of France and brother of Georges d'Amboise, a cardinal and influential figure of the Italian Renaissance. Executes his second version of the **Virgin of the Rocks** and works on the **Virgin and Saint Anne**.

Second Milanese period

1507: The Signoria permits Leonardo to enter the service of King Louis XII, who appoints him his Court painter and military engineer.

1510: Leonardo works on anatomical plates and research on mechanics.

The Roman period

1513: 24 September, Leonardo leaves Milan for Rome, accompanied by Melzi, Salaï, and two servants. Enters the service of Cardinal Giuliano de' Medici, the brother of Pope Leo X. Lives in the Belvedere, a spacious villa put at his disposal by the pope. No major commissions permitting him to measure himself against his two illustrious rivals, Raphaël and Michelangelo.

1515: Probable date of the **Saint John the Baptist**. François I enters Milan on 11 October.

The French period

1516: Death of Giuliano de' Medici, Leonardo's patron. In autumn, he leaves for France, taking with him the **Portrait of Mona Lisa**, the **Virgin and Child with Saint Anne**, and **Saint John the Baptist**, which are all now in the Louvre.

1517: Leonardo is in Amboise in April. He is invited by François I to live at the Castle of Cloux (Clos-Lucé). He suffers from partial paralysis of the right hand, but can still draw.

1518: Leonardo probably contributes to staging the festivities held in May on the occasion of the Dauphin's baptism and the wedding of Lorenzo de' Medici to the French king's niece. Leonardo organizes festivities in honour of François I at Cloux. Works on the project for a canal connecting the Loire and Saône rivers.

1519: 23 April, Leonardo dictates his last will and testament, and dies on 2 May. He is buried at Amboise.

PHOTO CREDITS